THE ART OF DIGITAL FABRICATION

STEAM Projects for the Makerspace and Art Studio

Erin E. Riley

Constructing Modern Knowledge Press

Published by Constructing Modern Knowledge Press, Torrance, CA USA

cmkpress.com

This and other Constructing Modern Knowledge Press books may be purchased at cmkpress.com. See the website for information on bulk purchases, volume discounts, or purchase orders.

Editor: Sylvia Libow Martinez

Layout and cover: Erin E. Riley

Typography: Lemon Milk, and PT Sans

ISBN: 978-0-9975543-3-5 (paperback)

ISBN: 978-0-9975543-9-7 (hardcover)

NOTE: Some of these projects call for tools and materials that can be dangerous if used improperly. Always follow manufacturer's guidelines, safety rules, and use common sense.

Special thanks to: Brian McGovern, my husband, for his tremendous support and encouragement; my family for the promoting of art, making, and problem solving when I was young, which I carry with me today; Sylvia Martinez in her mentorship and guidance through this project; my colleagues at Greenwich Academy and Teachers College, FabLearn Fellows, and the maker education community for inspiring this work. Thank you to Molly King, Mark Feiner, Ann Decker, Sean Lahey, and Mr. and Mrs. Alexander Jackson for their support and leadership in making design and engineering an integrated part of the Greenwich Academy curriculum.

Thank you to all of my students for bringing their enthusiasm and imagination to the lab every day.

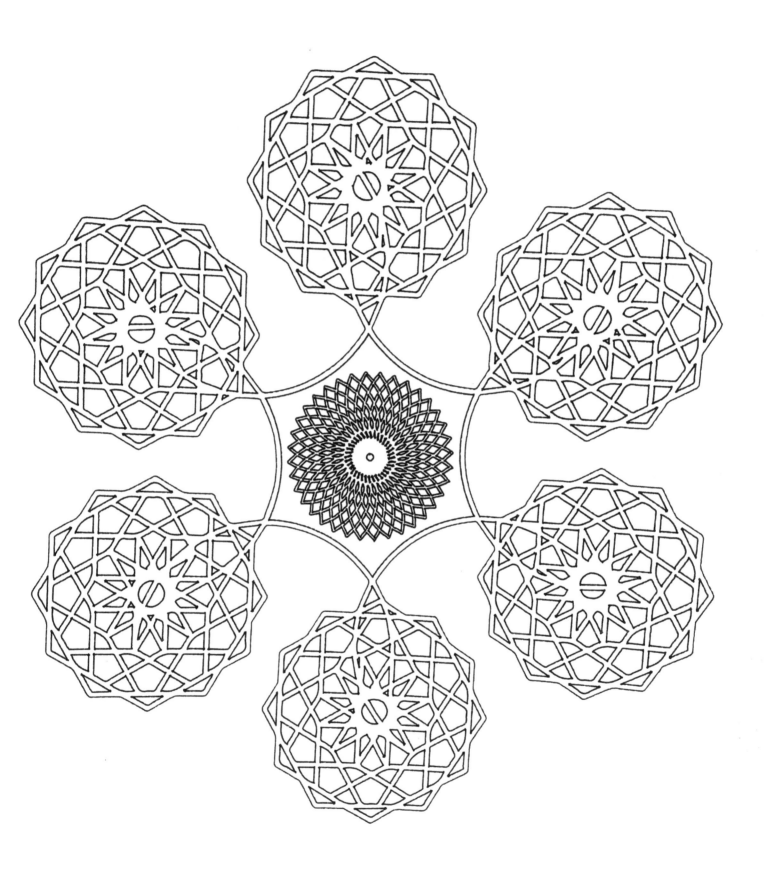

for O & S

CONTENTS

PIXELS

ART MATERIAL AND PROCESS INVENTORY

RESOURCES

PROJECT CROSS-REFERENCE

PROJECT	PAGE	DIGITAL FABRICATION AND MAKING TOOLS	SIMILAR ART-MAKING PROCESS	MATERIALS
ANIMAL BOX	97	Laser cutter	Building with cardboard	Cardboard, plywood, glue, and hardware
BREAK OUT OF THE BOX	100	Laser cutter	Building with cardboard	Plywood and a variety of materials
CATCH-ALL DISHES	103	CNC	Carving clay or wood	3/4-inch plywood
DESIGN WITH RULES	40	CNC	Rules-based art	Paper, markers, and Sharpie attachment for CNC, foamcore
DRAW TEXT WITH VINYL CUTTER	30	Vinyl cutter	Technical drawing	Paper, pens
DRAW WITH EXTRUSION	32	3D printer	Relief drawing	Filament
EMBROIDERY PATCH	116	Digital embroidery machine	Digital painting	Felt, stabilizer, embroidery thread, fray che
ETCHED TINS	56	Vinyl cutter, drill press, rivet gun	Chemical etching	Salt water, 6V battery, metal tins, wax
GLITCH ART	120	Large format printer	Design by accident	Collage supplies
INTERACTIVE GINGERBREAD	79	Laser cutter, microcontrollers	Interactive mixed-media sculpture	Cardboard, gingerbread sheets, electronics craft materials
LIVING HINGE SKETCHBOOK	45	Laser cutter	Hardbound book binding	Bookmaking supplies
MACHINE DRAWING	24	ShopBot, vinyl cutter, 3D printer, laser cutter	Non-objective drawing	A variety of materials, paper and pens for vinyl cutter drawing
PET STICKER	76	Vinyl cutter	Stenciling	Vinyl, transfer tape
PIXEL-ART PAINTINGS	112	2D printer	Pointillism, mosaics	Plywood, ModPodge, painting supplies and tools
POP-UP DRAWINGS	73	Laser cutter	Paper engineering	Railroad board in two colors, Sharpie mar
SILKSCREEN CLAY	69	Vinyl cutter, vinyl, transfer tape, ceramic tools, kiln	Fresco	Vinyl, transfer tape, silk, clay, and glaze
3D FILAMENT RELIEF DRAWINGS	50	3D printer and 3D filament pen	Drawing, textiles, and weaving	3D-printed thins
3D MODELING AND MATH	88	3D printer	Positive/negative space sculpture	Filament
3D-PRINTED STACKS	82	3D printer, drill	Mixed-media sculpture	Wood block, dowel, filament
3D PROTOTYPING AND SCALING	107	Laser cutter, CNC, calipers	Woodworking	Plywood, glue, and hardware
3D PUZZLES	61	3D printer	Positive/negative space sculpture	Filament
PATTERNING	66	Laser cutter	Positive/negative space sculpture	Flat laser-cuttable materials
UPCYCLED LASER-ENGRAVED BOOK	35	Laser cutter	Coptic binding	Bookmaking supplies, spray paint, recycle papers, ephemera
WEBCAM MACROSCOPE	126	Laser cutter, hand building tools	Hand-painted film	Petri dish, hardware, 12-megapixel webcam supples and scraps

SOFTWARE	SUMMARY OF PROCESS
...obe Illustrator	3D drawing of idea, prototype creation from cardboard, design flat shapes and joinery in Illustrator, separate raster, score, and cut elements for the laser cutter
...obe Illustrator	A collection of laser-cut boxes for a variety of applications such as in sculpture, as a housing for electronics, or as a surface for display
...obe Illustrator and VCarve Pro	Set up CNC, create POCKET and PROFILE toolpaths, cutting and milling with CNC
...obe Illustrator	Drawing from instruction-based rule prompts, pen tool for drawing vectors, creating a CAM toolpath, set up and drawing with the CNC
...obe Illustrator	Print a pen holder or place a piece of tape around the pen, prepare machine for plotting, turn font into outlines and add a fill to shapes, draw with the vinyl cutter
...tle Blocks	Use code to make a 3D design that can be extruded
...obe Photoshop and SewArt	Make a color graphic from a black-and-white graphic, digitize raster graphic, prepare fabric for embroidery, run digital embroidery machine
...obe Illustrator	Using calipers, making a vinyl sticker, saltwater etching techniques, using rivets to attach metals
...obe Photoshop and TextEdit	Altering code and image
...obe Illustrator, MakeCode, Arduino	Overview and organization of group project with Arduino
...obe Illustrator	Draw a vector design in Illustrator, running the laser cutter, constructing a living hinge sketchbook
...obe Illustrator, Beetle Blocks, TurtleArt, ...cessing	A collection of machine drawing ideas for a variety of applications, drawing with toolpaths, vector paths, extrusion, light and mark making with the laser cutter, turning font into outlines, drawing with the vinyl cutter
...obe Illustrator	One page step-by-step outlining how to make a sticker from drawing idea to vector graphic
...cessing App	Using pixel-by-numbers app, scaling in Illustrator, transfer printout onto wood for painting
...obe Illustrator	Introducing 2D-3D concepts, example of early grades integrated art project, turn Sharpie drawing into a vector
...obe Illustrator and TurtleArt	Designing in TurtleArt, rolling clay slabs, making a vinyl sticker, transferring a design to a screen, silkscreening glaze
...obe Illustrator and Tinkercad	Raster design into a 2D vector file, SVG to STL (3D model file), STL to GCODE (code for running 3D printer), Brim vs. Raft, using 3D filament pen
...kercad, Fusion 360, Cura	Design for 3D printing efficiency and minimal clean up, from Tinkercad to Fusion 360, designing hollow and connecting parts, scaling from negative space
...enSCAD, Tinkercad, Cura	3D model shapes in Tinkercad and OpenSCAD, build a base, mixing materials, casting and surface treatments
...obe Illustrator	Scaling up and down for prototyping on the laser cutter for the CNC
...ion 360, Tinkercad, Adobe Illustrator, ...a	Cartesian geometry, extrusion, Boolean operations, functions, variables, designing for positive and negative space, fits and tolerances, printability
...tleArt, TurtleArt Converter, Patternodes	Cartesian geometry and patterning, SVG conversion, parametric patterning
...obe Illustrator and Photoshop	Removing the white space around an image in Photoshop, spray paint acrylic, Coptic book binding
...cktime, Photobooth, webcam apps	Teardowns, building a microscope enclosure, film and still image capture

Project Cross-Reference (vii)

DIGITAL FABRICATION MACHINES

DIGITAL FABRICATION MACHINES TURN DIGITAL DESIGNS INTO PHYSICAL THINGS

The machines used in this book and shown here are commonly used in digital fabrication labs or makerspaces. They include the vinyl cutter, 3D printer, digital embroidery machine, laser cutter, and CNC machine.

Design software creates digital files that tell each fabrication machine how to control its tool. Each fabrication machine has a unique tool: blade (vinyl cutter), plastic extruder (3D printer), sewing needle and thread (digital embroidery machine), laser beam (laser cutter), or cutting bit (computer numerical control, or CNC machine). Some designs can be sent directly to the machine with the proper formatting. This is the case with many laser cutters. Other machines require an additional step with software that prepares the design for the machine and generates a toolpath. This is the case with slicing software for the 3D printer and CAM (computer-aided machining) software for the CNC.

Each machine has a broad menu of material possibilities for fabrication. See *Material Inventory* on page 132. Like appliances in a kitchen, each machine performs different tasks, and makers can create parts that come together in the creation of a project.

VINYL CUTTER

Overview: Vinyl cutters are machines that cut with a blade and plot (machine drawing) if you attach a pen. The vinyl cutter cuts adhesive-backed vinyl, which can be used for stickers and stencils and heat transfer vinyl for application to fabric. The *Roland GX-24 Vinyl Cutter* was used for the projects in this book.

Craft cutting machines: Desktop craft cutting machines are also popular in makerspaces. Craft cutters are more versatile in the materials they can cut. Along with vinyl, certain models can cut foam, leather, fabric, and other materials. Materials are held in place with a mat and the blade is adjusted for material thickness. Craft cutters can be outfitted with a pen, making it possible to combine drawing and cutting within the same job.

3D PRINTER

Overview: 3D printers are desktop machines used for additive manufacturing. FDM (fused deposition modeling) is the most common 3D printing technology used in makerspaces. A motor drives a thin rope of thermoplastic filament through a hot nozzle where it deposits molten material onto a bed, layer by layer. The *Ulimaker 2+ 3D Printer* was used for the projects in this book.

Tinkering: Of all the machines used in our lab, the 3D printers require the most tinkering. With many variables at play, from design, slicing (generating tool path), and machine settings, the process for generating a successful print can be a slow one. This should not hold people back from using 3D printing with students. It's an exciting technology that students love learning and understanding through the process of iteration and troubleshooting.

DIGITAL EMBROIDERY MACHINE

Overview: Computerized embroidery machines are specialized sewing machines used to stitch a digital design on fabric or paper. Fabric is stabilized on a hoop to prevent buckling and tearing. The *Brother PE770 Embroidery Machine* was used for the projects in this book.

Digitizing designs: Special software is required to turn raster graphics (JPEG, PNG) into stitch patterns. This process, called digitizing, creates a color map of the design—based on the degree of detail desired—and orders the stitching pattern and thread.

Designs can also be generated with code. TurtleStitch (turtlestitch.org) is a web-based programming language, based on Snap! for creating embroidery patterns. Files generated from TurtleStitch can be output directly to the digital embroidery machine.

LASER CUTTER

Overview: Laser cutters are desktop or free-standing machines that execute precise cutting and engraving processes with a high-power laser that burns or vaporizes material. The *Epilog CO2 Laser Machine* was used for the projects in this book.

Safety: Laser cutters have certain safety considerations that users must take into account when setting up their shop and workspaces. It is important to follow the manufacturer's instructions and take the following into account: (1) laser safety, (2) air quality, and (3) fire hazards. Class 2 lasers, like those used in the Epilog machines, are considered safe for normal use. Check the safety features for your machine as well as fume exhaust and filtration set-ups for your space. Check machine focus and settings, and use air assist to reduce flaming on the surface of your material.

CNC MACHINE

Overview: Computer numerical control (CNC) machines use subtraction as the method for cutting and forming material. The removal tool is a router bit spun by a motor and is used to create 2D and 3D objects. The *ShopBot PRSalpha* was used for the projects in this book.

Feeds and speeds: Cutting tool manufacturers publish "chip load" ranges for materials used on the CNC. Chip load is the thickness of the material removed from each edge of the router bit while cutting. Use a chip load calculator to determine feeds and speeds—important variables used in operation of the machine. Optimizing these settings ensures safe cutting, reduces the chance of material heating up, and prolongs the life of the tool. CNC machines range in size and are available as desktop to free-standing machines.

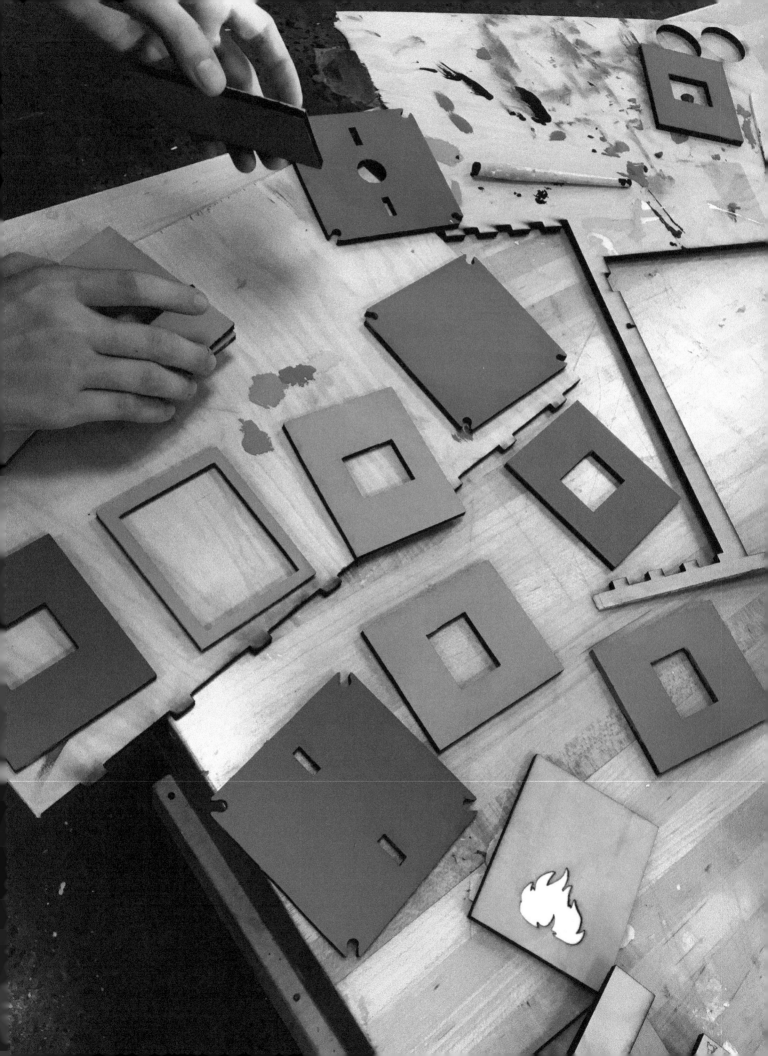

PREFACE

NEW TOOLS HAVE A WAY OF INSPIRING POSSIBILITIES

Beautiful discoveries emerge when the machine exactness and computer precision of the makerspace merge with the often messy, possibility-rich world of the art studio. For the artist, when new tools and techniques for making things become available, new processes are born. Through digital fabrication we discover that materials can be formed and behave in ways we are not accustomed to using hand tools—giving the maker the power to cut sharp angles on a surface of wood that even the finest scroll saw cannot handle, or form perfectly rendered polyhedrons out of solid plastic. Art and craft materials get woven into supply stocks and trash becomes treasure as scraps are sorted and repurposed. It is here, that material "tinkering" takes place and new art processes are born.

Digital fabrication merges digital design and the real world. The pathway for moving from "idea" to "form" requires balancing the constraints of machines and the physical world with what's imagined in the mind of the maker. While viable machine toolpaths become an important product of the design process—mistakes along this pathway are another form of material tinkering—errors and miscalculations give rise to discoveries and understanding. Playing with tools and materials drives innovation and creativity, and it is this kind of thinking that all educators hope to foster in their students. As STEM labs and makerspaces begin to populate schools, there is a real opportunity for all teachers to unlock the creative side of this work and provide understanding, through the joy of art making, of how art fits in with STEM to make STEAM.

There are many resources for digital fabrication and maker technologies for teachers wanting to develop skills applicable to art, design, and STEM disciplines. This book aims to contribute to this resource pool and is designed for all educators, regardless of discipline, who have access to digital tools and fabrication equipment. The project ideas and guides in this book are grounded in the materials and processes of the art studio, remixed with new possibilities with digital fabrication tools. It is my hope that these projects are just a start, and new ideas will spring forth.

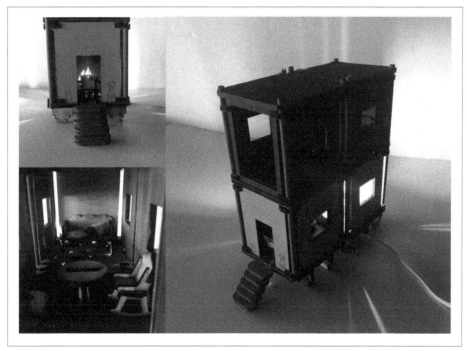

Construction by grade eight student using laser-cut parts and LED light.

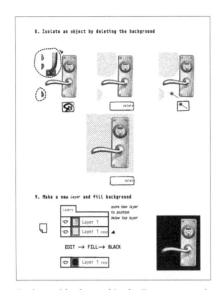
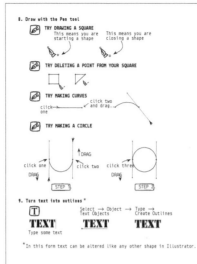
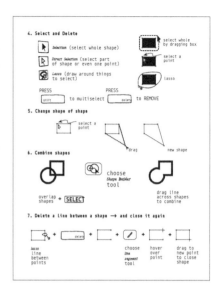

Design guides located in the Resources section of this book.

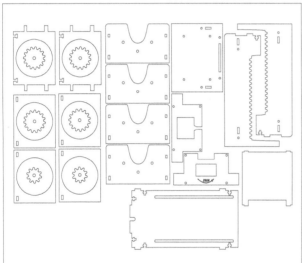

Digital files can be downloaded from artofdigitalfabrication.com.

Erin Riley @eeriley99 · Nov 7

Heat press collage, sewing, and circuits. IDB, Imagine, Design, Build
@gwichacademy #makered

Follow projects in development on Twitter at @eeriley99.

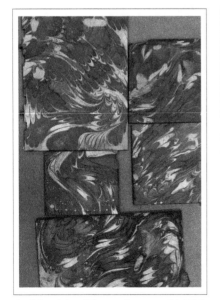
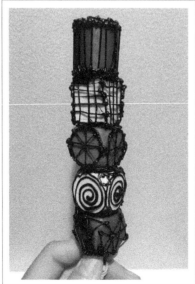
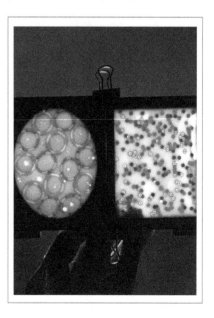

Art Material and Process Inventory highlights creative use of materials for fabrication.

ABOUT THIS BOOK

ORGANIZED WITH THE ARTIST AND MAKER IN MIND

While digital fabrication tools are central to many of the projects, the chapters are organized by process and written in artists' language. There are several organizational aspects of the book that will help readers find the resources they need.

ABOUT THE ARTICLES

This book came together over the course of a number of years. Some of the original articles were written for the FabLearn Fellows blog, but all are self-contained articles exploring ideas related to practice and springing up through the process of everyday teaching. They bring together larger ideas introduced through maker education and arts education communities.

ABOUT THE WORK

The artwork in this book was created by makers ranging in age from elementary to college age. The majority of the work featured was made by students at the Greenwich Academy Engineering and Design Lab (EDL). Work made in the Creative Technologies Certificate Program at Teachers College is noted. The EDL was established in 2013 to encourage and foster community using creativity and new technologies across diverse curriculum. The lab is a space for taking ideas and bringing them to form as STEM, art and design, and humanities projects. Students have access to many of the same materials and tools you would find in a traditional art studio. These combined with maker technologies such as computers, electronics, microcontrollers, and digital fabrication machines extend the possibilities of what a student can imagine and create.

ABOUT THE PROJECTS

The projects presented in this book are intended to be both practical and inspirational. Readers can follow the instructions with step-by-step details about specific processes in the areas of software, materials, and machine operation. However, I do not see these projects as strict recipes but as starting points that you and your students will make their own. The work that happens in a makerspace is nonlinear, open ended, and driven by personal interest, and it has been my experience that students want to make personal, unique work. As with the makers whose projects have inspired my spin-offs and new takes, it is my hope that teachers will (1) mix-and-match ideas and materials, (2) substitute different tools and workflows, and (3) take ideas from these pages and apply them to other maker projects in art, design, or engineering.

The **Project Cross-Reference** lists projects by digital fabrication tools, supplies, and software. Color coding highlights certain process details in each project chapter.

The **Art Material and Process Inventory** is intended to spark creativity and encourage the mixing of materials and processes within digital fabrication.

Digital fabrication machines used in this book are commonly found in labs or makerspaces. See pages viii–ix for an overview and notes on each machine.

Digital files accompanying each chapter can be found at artofdigitalfabrication.com.

Recent **projects in development** can be found on Twitter at @eeriley99.

Design guides for the main design software programs demonstrated in this book are located in the Resources section. These photocopy-friendly guides, with corresponding checklists, can be given to students as they self-guide through each design program. Note: This book goes back and forth between metric and imperial units based on available materials and tools and software preferences.

See notes, references, and resources related to each chapter in the Resources section.

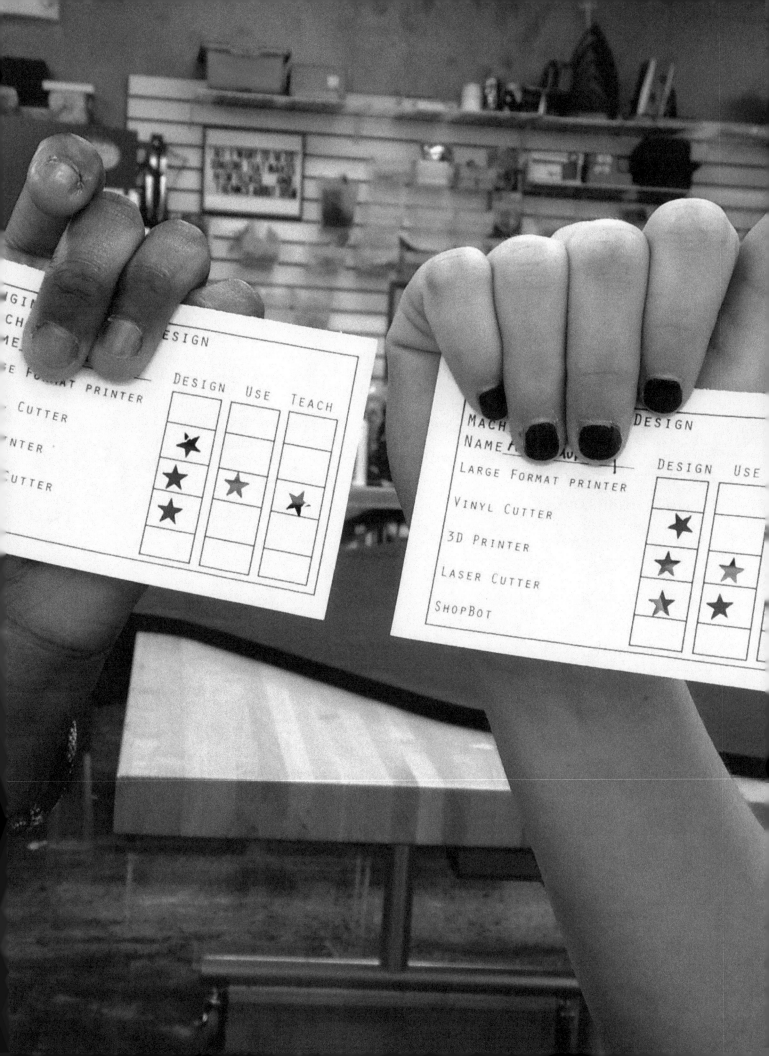

DIGITAL FABRICATION AND ART MAKING

LEARNING, MAKING, AND ART

LEARNING THROUGH MAKING

People learn best through creating and sharing the objects they make. Every time one makes art with any kind of material—clay, cardboard, or computer code—we form ideas and bring them into the world. While these ideas are being expressed, a parallel process is taking place, simultaneously unlocking previous understandings and experiences and connecting them to new ones. This web of knowledge that builds through "doing" is a cornerstone of progressive education. In the United States, progressive education builds on theories of education giants like John Dewey and Jean Piaget. Seymour Papert, who worked with Piaget, expanded these ideas with the learning theory of constructionism, underscoring the expressive power of computers used as creative tools. Yet in many schools, art is not considered a serious subject, and certainly not combined with opportunities for learning modern digital design and fabrication. This is a mistake and a missed opportunity.

DIGITAL MATERIALS FOR ART

With the enthusiasm around the maker movement and its growing influence on education, an exciting opportunity exists—to push through the increasingly porous boundaries around traditionally siloed disciplines and open up new pathways for making art using digital technologies and fabrication. Digital fabrication

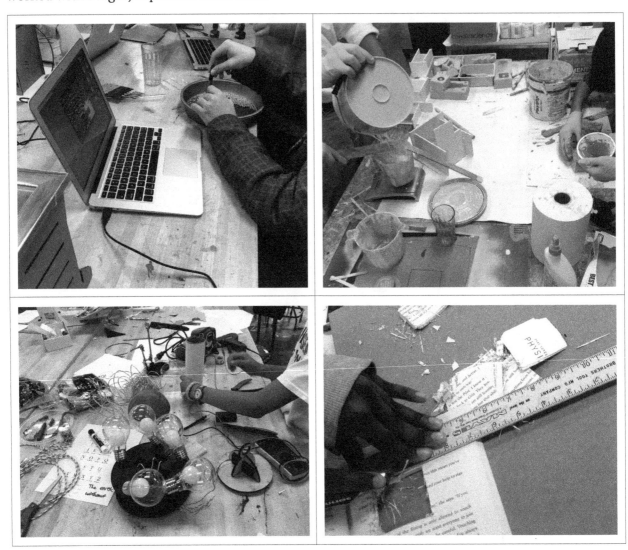

Middle and high school students making projects with physical and digital materials.

machines developed for engineering and commercial design have direct applications in art and design in a school setting. Educators can now fold the knowledge of tools and materials for art into the discourse and advancement of ideas in making. In support of STEAM initiatives and as the field of art and design continues to expand, it seems fitting that artists look to the design processes used in engineering, architecture, and commercial design to inform their process.

ART + STEM + TECH

The artist, researcher, and teacher Rama Hoetzlein charts a lineage from fine arts to contemporary forms in new media art. What this graphic suggests is that with digital technology come new tools for discovering and expressing ideas. If we were to continue to expand this timeline to include the junctions where engineering, computer science, and STEM (science, technology, engineering, math) disciplines overlap, we would see how cross-pollination has blurred the lines

between discrete areas of study. Many of the technology tools needed for new media forms enter the space through computer science and engineering. Digital fabrication, resulting in tangible artifacts from a digital design origin, also springs from computer science and engineering technologies. Art is the natural partner in multidisciplinary spaces with digital tools, tapping into a timeline of history of accumulated knowledge of materials and creative work practice dating back for millennia. STEAM (STEM + Art) is of great interest to schools, and art programs can be engines of innovation.

TRUE TO ART

Advances in technology have created a framework for interdisciplinary collaboration. With more support behind the idea of STEAM, art has a voice in the larger discussion of modernizing education. While materials available for making art expand, it is important to keep firm roots in what makes art a rich place for material exploration, idea generation, divergent thinking, and expression.

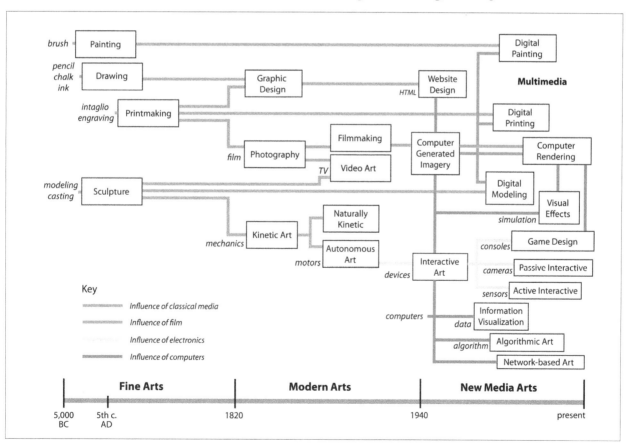

Figure from the article "What Is New Media Art?" by Rama Hoetzlein, from ramakarl.com © 2009.

Our role as teachers within STEAM initiatives, maker programs, and as interdisciplinary practitioners is not to decorate other's projects. Instead, we should continue to bring what is essential and powerful about art into the work students do. Art provides a place for youth to make personal things that they care about. Through artwork, students can assert their ideas and wishes, and feel proud of the skills they develop through the heart and hand. Artists, with their understanding of materials and aesthetics, have much to contribute to making.

(left) Figure from RYB color chart from George Field 1841, from commons.wikimedia,org; (right) green and red squares in color and grayscale.

DESIGN AT THE CENTER

Regardless of how one identifies themselves as a creative maker, design is at the center of all forms in making. As students make, how do they understand what they are discovering?

John Maeda, artist, technologist, designer and educator, defines three types of design in his yearly Design in Technology report. "Classical design," is the type of design most people are familiar with. These designers make objects and products. The chairs we sit in, the magazines we flip through, the Post-it Notes I jot my ideas on while writing this article all fit within this category. "Design thinking" puts humans at the center to drive innovation, and is in a state of evolution. Companies like

Pepsico and Nike employ design thinking strategies to their process to bring better products and ideas to the marketplace. "Computational design" exists in digital spaces through algorithms. Computational designers might work on app design, the internet of things, artificial intelligence, or machine learning. Similar to the "New Media Art" timeline, Maeda's classifications for design can help us see where the material meets the digital in making practice.

The principles and elements of design, a system of visual building blocks underpinning a work of art, provides one approach to understanding formal design decisions that art programs employ today. These design rules branch into science and math. Color theory

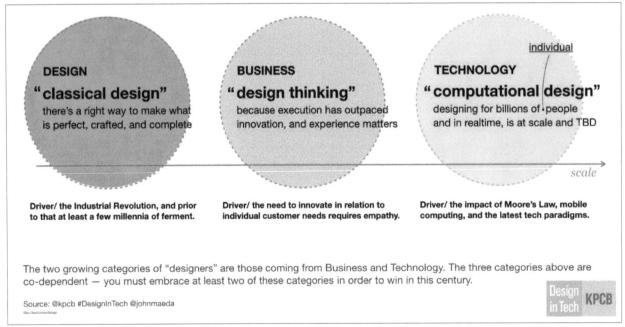

Figure from the blog post "The Three Kinds of Design" by John Maeda, from computationaldesign.org.

and optics guide decisions about which colors to juxtapose for a given effect. Viewers can be persuaded to see something new when their visual world is intentionally manipulated. In his geometric abstractions, Joseph Albers showed us how color is relative. Our eyes perceive the same color as completely different hues when placed next to opposing color fields. Similarly, how value and color are perceived in their intensity of contrast can "fool the eye" when converted to grayscale. Like a painting professor once told me, "Color gets all the credit, but value gets the job done." What we sometimes discover is the depth and detail from high-color-contrast image is lost when the corresponding values in the image are low contrast.

This set of rules is still relevant to designers today; however, with digital design, these rules can be defined algorithmically and executed precisely by computers. Today, game designers can apply procedural design to program color palettes in their virtual worlds. Light in color follows different rules from pigment. The RGB color system of digital technology works additively, where equal intensities of red, green, and blue create white light. LED lights, a programmable unit of color, can equal the power of paint in its ability to evoke emotion and place. Contemporary artist James Turrell creates artwork that makes the materiality of the digital undeniable. His light-filled spaces envelop the viewer as their eyes adjust to an alternate color reality.

Design rules can provide a framework for describing space in compositions. Entire worlds can be built using Cartesian coordinates, bringing a representation of three dimensions onto a flat surface or screen. Artist M.C. Escher worked with isometric projection techniques to create illusions and spaces that appear to fold in upon each other using this mathematical gridding system on paper and in print. Today, "impossible objects" can be found in the digital world through puzzle games like Monument Valley.

Sometimes artists want less control in their process, not following a set of design rules, choosing instead to see what unfolds, free from the pressure of a preconceived result. Serendipity plays a role as the designer engages in "misthetics," finding beauty in mistakes or random actions. Artists have found ways to work with technology as active partners in random design through programming algorithms while letting the machine generate the art. The artist pulls out the best solution from what is generated. Similarly, data bending by modifying image

 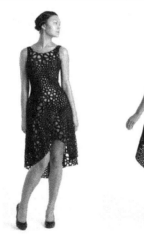 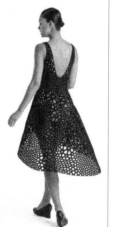

Examples of variance, constraints, rules, and elements of chance in art and design: (left) Surrealist automatism drawing by André Masson, commons.wikimedia.org. The free-form drawing is constrained by the length of the arm. (middle) Kinematics Dress. 2013. by Nervous System (est. 2007), Jessica Rosenkrantz, Jesse Louis-Rosenberg. Laser-sintered nylon. Image courtesy of Steve Marse. The Museum of Modern Art, New York. The customizable dress that uses a folding simulation to optimize 3D printing and make it possible to print as one part. (right) Committee on Architecture and Design Funds; Rosa Menkman Glitch Art, from commons.wikimedia.org. Corrupted files can bring unexpected,aesthetically pleasing results.

text creates corrupted information within digital files, giving rise to glitch art. Even high-tech approaches to making can introduce an element of chance much like automatism did for Surrealist artists in the early 20th century.

Much has been written about a Renaissance approach in teaching and learning in support of STEAM initiatives. There are many historical examples of cross-pollination between STEM and art, from Leonardo da Vinci's inventions and Frank Gehry's architecture, to Steve Jobs's focus on functionality and aesthetics in product design. When technology meets creative making process, there will always be people who look for ways to bring these approaches together.

DIGITAL TO FORM

Digital design parallels physical design. Pixel painting in Photoshop can vary brush style, paint opacity, and layering. Digital information mirrors the push/pull responsiveness of physical material. Pixels are the painterly application of digital information and on screens, and in print, artists are liberated to color outside the lines.

Moving beyond screens and designing for digital fabrication machines like 3D printers, laser cutters, vinyl cutters, and CNC machines allow us to translate art processes to new tools. Designs are output as machine instructions and must generate viable toolpaths. Students have the opportunity to test their designs in the physical world through fabrication. Mistakes in measuring, scale, and transformations show up in the fabricated model. Mistakes may result in failed prints, machines cutting in the wrong place, or machines not working at all. Or mistakes may result in something completely unexpected and wonderful.

Pablo Picasso famously said, "Learn the rules like a pro, so you can break them like an artist." Once artists learn the rules, and how to design for and operate machines, they can start looking for opportunities to work in relationship with the machines and materials in new and inventive ways. Artists carry on the same research and exploration that is central to artist practice with a new set of tools.

COMPUTER AS AN EXPRESSIVE TOOL

Since computers have come into existence, artists have found creative applications for computers in their work. We can be inspired by exciting work in digital technology and build upon the pedagogies that put children at the center of their learning.

Artists like Vera Molnár, who began working at the edge of the digital frontier of early computers, gave us some early examples of what was possible with digital forms through algorithmic design and plotter drawing. In education, Logo, a programming language developed by Seymour Papert, Cynthia Solomon, Wally Feruzeig, and others, brought design ideas to digital graphics and into the physical world using the Logo Turtle drawing robot. Their vision of computers as tools to unlock the curiosity and creative potential in our youth paved the way for educators in art to adopt digital tools for creation.

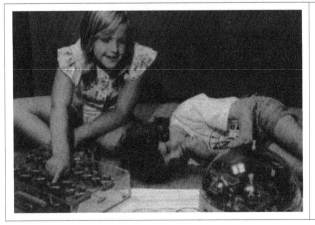 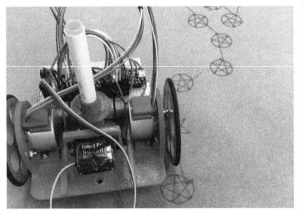

(left) Papert Logo Turtle; (right) Logo Turtle from Josh Burker, Brian Silverman, and Erik Nauman.

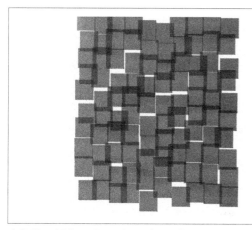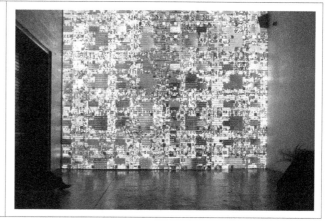

(left) Vera Molnar: Interstices, plotter drawing, ink on paper, 22 x 25 cm, 1986, Courtesy of the artist and DAM Gallery; (right) Casey Reas: KNBC, custom software, digital video, computer, projector, dimensions variable, sound by Philip Rugo, courtesy of the artist.

Digital tools available to students are continuing to develop at a rapid pace. Artist Casey Reas, whose installations, prints, and software have inspired a new wave of creative technologists, co-created Processing, a programming language tailor-made for visual learners and artists. This is just one example of user-friendly computing tools for exploring digital media, fabrication, and visual design.

JUST ATOMS, BITS TO ATOMS, JUST BITS

Neil Gershenfeld's Center for Bits and Atoms at the Massachusetts Institute of Technology, brought a new kind of technology to the mainstream through the introduction of "fab labs," or fabrication labs, where people around the world learn to make anything they need. Columbia University's Transformative Learning Technologies Laboratory, headed by Paulo Blikstein, takes this idea to school, conducting research in schools around the world as they build and integrate digital fabrication into school environments.

In addition to the learning that happens on the path from design to object creation, I see a rich opportunity in art programs to wed the knowledge of art materials with digital process, and I encourage all art teachers who have access to technology to consider how they might bring it to their studios.

There needn't be concern around abandoning materiality for digital forms. Fabrication produces objects from tangible materials, and the art studio is a rich source of these materials for projects. Digital materials add to a vast menu of options for bringing impactful, personally meaningful objects and ideas into the world.

Art students who haven't been exposed to possibilities with technical tools can be introduced to artists working in new forms, who challenge and inspire them to think differently about art making. We can equip our students with a new language for speaking about technologies in relation to their work that is true to our fundamental methods of how we make and teach art.

ART LEADERSHIP IN STEAM

Around the world, STEAM (science, technology, engineering, art, and mathematics) is at the center of the conversation about school improvement. Across the United States, educators are aligning the goals of the National Core Arts standards, Common Core, and the Next Generation Science Standards. In the last three years, fourteen articles in the *Art Education Journal* of the National Art Education Association (NAEA) have been published on the topic of STEAM. At a recent NAEA conference in Seattle there were 134 sessions with STEAM in the title. The convention theme, "Art + Design = STEAM," invites us to break down what STEAM means, consider how it fits into contemporary art practice, and how art educators can be leaders in the movement.

What does STEAM mean from an artistic perspective, and how can artists and art educators inform this movement? In a recent issue of *Art Education*, editor James Haywood Rolling Jr. called STEAM an acronym for education imagination, "The art studio is one of the very few spaces in school or society where widely divergent outcomes are encouraged and never-before-imagined design solutions are valued." Imagination and creativity, cultivated in the art room, are prized in an era that is dependent on innovation. I first heard about adding the A to STEM in 2012. The movement, led by the president of the Rhode Island School of Design, John Maeda, was a call to action to include the arts and the process of design into STEM: "Design creates the innovative products and solutions that will propel our economy forward, and artists ask the deep questions about humanity that reveal which way forward actually is." Art and design, equal partners with STEM, need each other for our future.

At SXSWedu in 2017, in a panel titled *Is Art School Squelching Creative Rebellion?*, four professionals in the fields of art and design, research, and entrepreneurship discussed

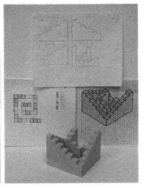

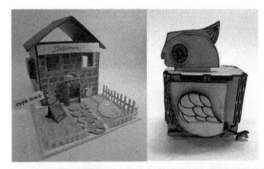
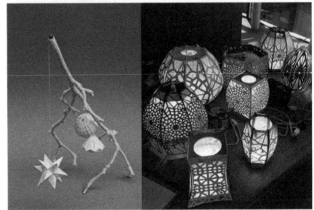

Projects made in the art studio vs. a makerspace highlight the similarities in process.

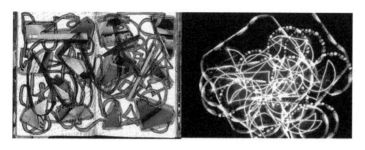 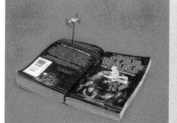 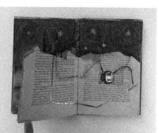

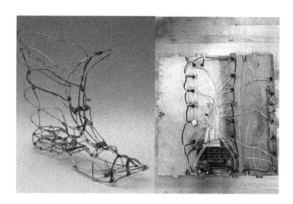

Projects made in the art studio vs. a makerspace highlight the similarities in process.

the higher demand for creative workers in a changing job market. One question posed was "Do we need to expand the definition of creativity?" Are we doing our students a disservice by creating a narrow measure for success in the arts? Is success in the commercial gallery world the only worthy pursuit post-art school, or should we be on the front end of creative training applied to other fields desperately in need of creative thinkers? Organizations are looking for people trained in precisely the skill set that art class fosters like the willingness to tackle open-ended problems, practice flexible thinking, and offering unique solutions. Some authors like Daniel Pink have argued that the Master of Fine Arts is the new MBA because our world needs more right-brained thinkers.

Members of the scientific community also recognize the importance of integrating art into STEM. Robert Root-Bernstein's study, "Arts Foster Scientific Success," indicates eminent scientists have a greater rate of avocation in the arts and supports putting "STEAM into STEM."

Art and technology have always been intertwined. Early pigments made from berries and charcoal from fire were humans' first paints. Each innovation fuels the next; the camera obscura permitted artists to create realistic perspective, photography unbound the painter from representation, and computers challenged artists to data bend and gave rise to glitch art. So while we make a case for art to enter the conversation around STEM, we should also be making a case for STEM to enter art.

In her 2014 FabLearn keynote, "Thinking About Making," Leah Buechley, designer, engineer, and educator who headed the High/Low Tech Group at Massachusetts Institute of Technology, defines making as the essence of what it means to be human. She challenges educators to include, celebrate, and share rich traditions of craft, folk art, music, DIY culture, and visual arts with students. Her examples show that "STEM is everywhere" if we expand the narrow definition of making towards one that is more inclusive, diverse, and equitable.

Thinking about how we define making should be concurrent with broadening the definition of creativity in the arts and opening the door of possibilities through STEM. Talk about

breaking down silos should be supported with real-world work to share with our students. We should be looking for examples of technology-rich artifacts, old and new, at dynamic, interdisciplinary intersections.

In art we are seeing more examples of the "enginartist" working to incorporate creative technologies and problem-solving methods into practice. While some artists are working at the edge of emerging technologies, Buechely looks at what is already woven into cultures and making traditions. In an analysis of a crocheted doily, Leah Buechely invites us to think about the maker's design process. The designer takes a one-dimensional object and turns it into a three-dimensional object. The radial design, which grows out of a central point, requires planning and math to calculate integer numbers in regular repeatable color patterns around the circle. The technology needed to execute this process may not always be apparent on the surface of a work, so it is up to us to consider what learning and technical know-how goes into the execution of an artifact. Another example highlighted in this talk includes the work of data artist and sculptor Nathalie Miebach, whose work uses scientific data to form beautiful, woven sculptural objects. To interpret digital information and bring it to physical form is another way artists are working across disciplines to make engaging, artistic expressions.

In her talk titled "Techno-Vernacular Creativity and Innovation," at the 2018 NAEA Conference in Seattle, artist, researcher, and STEAM advocate Nettrice Gaskins showed examples of how teachers can expand the framing of maker activities for underrepresented students by connecting lived experience to new contexts. In the 2018 film *Black Panther,* based on the 1960-era Marvel comic character, Shuri, resident tinkerer and Princess of Wakanda, takes the lead on technology projects that advance and protect the African nation. Gaskins explores how characters like Shuri are important to young black girls in maker culture. Like Buechley, Gaskins's culturally situated making highlights the innovation, creativity, and beauty found in vernacular traditions and puts them at the forefront of the conversation around best practices with teaching STEAM.

So how can art educators be leaders in STEAM? How do we move from being interested, to invested, to impactful and put STEAM into action in our art rooms? Currently, there is tremendous support for making in schools driven by the maker movement, and art teachers have the maker community behind them. In her book *Making Science: Reimagining STEM Education for Middle School and Beyond,* Christa Flores gives us an interconnected web graphic for understanding learning theories and maker education. Her diagram brings together the many voices who advocate, and have advocated, for children to learn and create through making. In a recent conversation, Sylvia Martinez, co-author of *Invent to Learn: Making, Tinkering, and Engineering in the Classroom* and champion of creativity and making, distilled in a sentence how art fits into making. "Art," she said, "is the verb." Art is the expression of an individual's ideas and point of view. Art is the pathway for taking an idea and bringing it to form. Art also holds the key to our students' hearts. In our studios, we provide the conditions for students to make things they love. The voices who have been influencing policy to include making in schools support the work artists do in the studio with students.

Art teachers often work outside of pre-determined curriculum and standardized testing constraints. This is the perfect environment for open-ended projects and collaboration across disciplines. Finding partners in more traditional STEM courses to co-plan and develop STEAM projects models a way of working collaboratively and prepares students for the world outside of school—one that is connected, complex, and dynamic. As the maker movement and STEAM gain momentum, art is poised to be an important voice in the conversation. Artists do not need to be outside of the maker movement but leaders within it.

DIGITAL FABRICATION TOOLS AND LEARNING

While conceiving an idea and bringing it into a tangible form is significant, it is important to be able to articulate its value within an educational setting. It's also important to reveal the many stages in digital fabrication, especially illuminating the often hidden design process where much of the learning takes place.

Digital fabrication tools can parallel predigital output for making things. A laser cutter or a computer numerical control (CNC) router cuts designs in a manner similar to a scroll saw. A sculptor builds up clay in an additive approach just as a 3D printer lays down lines of plastic, or chisels marble just like the CNC milling machine carves wax with a subtractive approach.

The parallels between manual and digital process are clear, and any maker working with

Students ready for action in the fabrication lab.

their hands can see how digital tools extend possibilities starting from a language we are already versed in. In a effort to understand the tangible learning developed through design and digital fabrication and connect it to studio practice, I mapped out the processes one goes through to develop 2D and 3D digital designs.

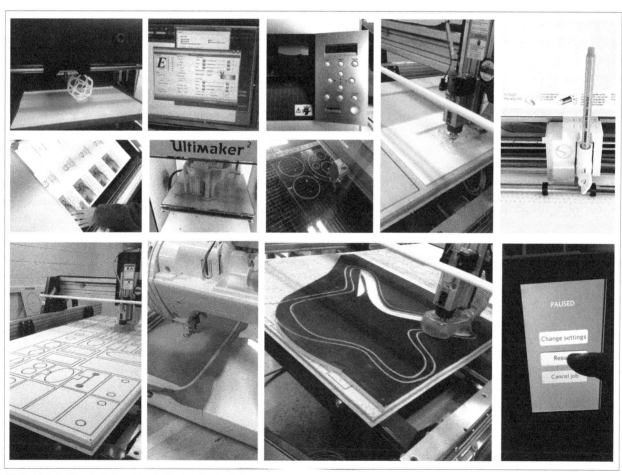

Digital fabrication tools in action in the fabrication lab.

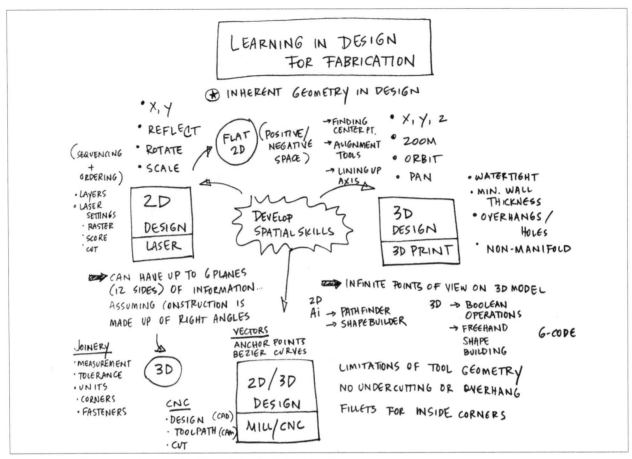

A concept map of learning outcomes gained from design for digital fabrication.

In the studio, a fold bisecting a paper is an alignment tool; slip and score brings together two pieces of clay as does a union in Boolean operations; a slot and tab in cardboard provides a sturdy joint similar to a "T" joint on the laser. Finding these connections reveals a skill set around materials that can directly be translated to the making of form through digital means. Digital design adds precision, scaling, cross-machine capabilities, and reproducibility to the mix.

Those incorporating these tools into their work with students know that digital fabrication is the merging of the human with the technical. The result is a creative product formed from their ideas and executed through a series of complex design decisions. Through 2D and 3D design and making, students develop multiple skills, not only in growing proficiency with 2D and 3D design, but also in spatial development and a variety of mathematical concepts.

Students' learning goes beyond acquiring skills and includes strengthening critical thinking as an outgrowth of working through design and fabrication problems. Gaining facility, refining one's ability to be mindful, and active learning isn't limited to digital fabrication; making in general promotes curiosity-driven, self-directed, creative learning.

SKILLS-BASED LEARNING: 2D AND 3D DESIGN AND SPATIAL DEVELOPMENT

So what hard skills does one actually learn from digital fabrication? What does the process of digital design and production, including controlling the machine, teach children? An online forum for teachers with access to digital fabrication tools, the K–12 Fab Labs and makerspaces Google group (K12makers. com) addressed a similar topic. Themes that emerged included the development of spatial reasoning, math concepts, and 2D/3D design. Many of these teachers saw many layers of learning embedded in the design-to-making process.

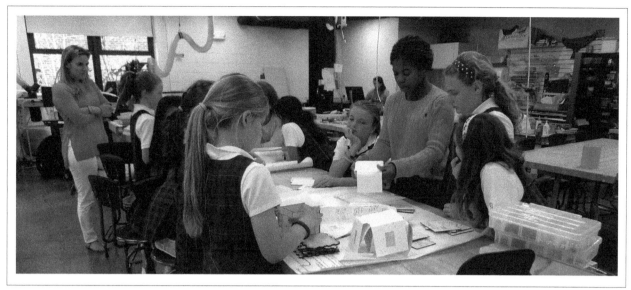

Grades four and eleven working together on digital fabrication problems.

MAKING BRINGS TOGETHER EMBODIED KNOWLEDGE AND LEARNING

Before we had an engineering and design lab at Greenwich Academy, Ann Decker, STEM educator and colleague, and I had discussions about how to help our students develop spatial skills. As an art teacher, I was interested in how a person could internalize a set of skills that would enable them take what they envisioned in their mind and bring it into the physical world through drawing and making. For STEM, Ann was interested in how skills developed through building could support understanding in technical subject areas. We knew making, regardless of subject area, required students to envision, design, and produce artifacts. This translation, from mental understanding to physical understanding, and vice versa, supported our common educational goals.

Our initial focus on spatial skill development was supported by research that suggests that spatial ability is a learnable skill, and one associated with success in math and science. Traditionally, boys have more entry points to develop spatial ability through construction and manipulative toys. Being at a girls' school, we felt we needed to correct that imbalance by bringing personal, creative building experiences to even our youngest students.

What we found as we built our program was that our students did develop better spatial skills, but it went well beyond that. The hard skills students acquired were broad and crossed disciplines far beyond what we had imagined. We also found that soft skills, arguably just as important, were also substantial. Using different tools and techniques gives students experiences approaching design problems in multiple ways, and reinforced these new skills.

DESIGN AND FABRICATION LEARNING

The pages that follow (pages 14-15) outline some of the real skills students develop as they engage with design and digital fabrication. The skills acquired have real-world applications in engineering, art, design, science, computer science, and math. These skills have been organized by machine and process.

MAKER POWERS

While design and fabrication skills are an important outcome of this work, the culture of a makerspace itself helps students become independent learners driven by curiosity and intrinsic motivation. With our youngest students I like to refer to these skills as *maker powers*. The two-page spread on pages 16-17 identifies some of the *maker powers*. Download a printable poster-sized file of Maker Powers at artofdigitalfabrication.com.

3D PRINTING

Beginners can jump right into 3D printing with the help of user-friendly software like Tinkercad. The solid geometric forms students build with are watertight and error-free, which can alleviate frustrating printing problems. Complex forms are built up through manipulating positive and negative space and grouping. The learning curve for machine operation is low, and students can easily get involved in the entire design-through-fabrication process. Once students are comfortable navigating the digital 3D design space, they can translate their ideas into the 3D world. After a successful introduction to 3D printing, students are motivated to attempt more complex projects.

DESIGN LEARNING

- **Math:** measurement, units, scale, ratio, rotating, mirroring, Boolean operations, and precision
- **Spatial reasoning:** navigating the 3D design environment, designing on all sides (X, Y, and Z), alignment tools, geometric shape building, dividing and combining

FABRICATION LEARNING

- **Machine operation:** machine settings, raft, supports, infill, trade-offs of precision vs. print time
- **Designing for the machine including its limitations:** slicing a model into smaller parts that get attached later, designing supports like cones that can be cut off later, reorienting the model for better support
- **Science behind the process:** the technology of additive processes, slicing, G-code
- **Materials science:** plastics, strength, hardness, manufacturing

LASER CUTTING

The laser cutter makes 2D and 3D objects. A laser cutter cuts (or etches) material in two dimensions, and flat objects can be made three dimensional by joining the pieces after they are cut. Designing for the laser cutter involves planning and generating these multiple pieces. Students quickly begin 2D design by converting hand-drawn designs into vectors and outputting them to the laser. The next step is to learn to draw with basic 2D design program tools such as the shape-drawing tools, pen tool, and shape-builder tool in Adobe Illustrator. When moving from 2D to 3D on the laser cutter, joinery comes into play. Here students learn a timeless pre-digital skill that requires them to consider width of material; visualizing how flat pieces unfold and potentially fit together engages spatial skills.

DESIGN LEARNING

- **2D math and spatial reasoning:** navigating 2D design environment (X and Y), geometric shape building, dividing and combining, measurement tools, units, scale, ratio, rotating, mirroring, positive and negative space, and precision
- **Graphics:** vector design, alignment tools
- **Ordering, sequencing, and visualizing:** layering for the sequence of etching and cutting
- **2D → 3D math and spatial reasoning:** joinery, visualizing the translation of 2D to 3D (from shape to form)

FABRICATION LEARNING

- **Machine operation:** machine settings—stroke, fill, hairline, RGB black
- **Science behind the process:** laser technology, optics

CNC MILLING

A CNC machine cuts materials by moving a cutting tool to remove material and create an object. The laser cutter and the CNC share many of the same design considerations; both require use of layers and sequencing when planning cuts, carving, drilling, and milling. There are limitations inherent in the geometry of the cutting tool that do not allow for undercuts and corners. It is also more complex on the machine side with the additional step of selecting appropriate cutting tools and using separate software to generate toolpaths.

An added level of learning on the CNC machine is the finish work involved with a woodworking project. Parts are tabbed into the material and require removal and filing. Some projects generate parts that later need connecting, clamping, filing, and sanding.

DESIGN LEARNING

- **2D math and spatial reasoning:** navigating 2D design environment (X and Y), alignment tools, geometric shape building, dividing and combining, measurement tools, units, scale, ratio, rotating, mirroring, positive and negative space, and precision
- **Graphics:** vector design, alignment tools
- **Ordering, sequencing, and visualizing:** layering for sequence of drilling, milling, and cutting
- **2D → 3D math and spatial reasoning:** joinery, visualizing the translation of 2D to 3D (from shape to form)
- **3D math and spatial reasoning:** navigating 3D design environment, designing on all sides (X, Y, and Z), alignment tools, geometric shape building, dividing and combining, measurement tools, units, scale, ratio, rotating, mirroring, Boolean operations

FABRICATION LEARNING

- **CNC routing and engraving software:** toolpaths, drill, profile, pocket, V-carve, 3D modeling, slicing, tool geometry, feeds and speeds, G-code, measuring
- **Machine operation:** loading stock; zeroing X, Y, and Z; switching tools
- **Science behind the process:** CNC and milling technology

Gear Cov

Stage

Gl
Ho

m scr

ex nut (8)

m screw (4)

nut (4)

Glass Stage (2)

Your **MAKER POWERS** grow when your imagination transforms into a real-life project.

Think of your **MAKER POWERS** as a force for good!

BRAVERY

Be brave when you face new challenges

HARD PROBLEM SOLVER

Use your superpowers to solve hard problems and then even harder problems

CREATIVE THINKER

Think for yourself and look at the world from different perspectives

SELF-BELIEVER

Never give up! You have the can-do spirit required to make a plan and get the job done!

TEAM BUILDER

Work well with others. Compromise is a true superpower!

THE POWER OF MAKING WHAT YOU CAN IMAGINE

HELPING STUDENTS UNDERSTAND SPACE

Several years ago while teaching an upper-level drawing class, I noticed that some of my students were struggling to understand 3D space on the 2D drawing plane. In an effort to help these and future students, I reimagined a way of keeping track of studio projects based on where they might be organized by their 2D- to 3D-ness on a spectrum, and identifying the sorts of visualization that would be involved as they cross into other spatial forms. My notes— part curriculum development, part brainstorm, part webbing structure—took the form of mind maps and at the time helped to organize my ideas. This became a way of thinking about art, design, and making activities that I use in the Engineering and Design Lab and art studio today.

(left) Notes for 2D-to-3D curriculum development and mapping in visual art, files ca be found at artofdigitalfabrication.com; (right) grade eight student isometric drawing.

2D → 3D

Thinking about projects in terms of where they fall on the 2D-to-3D spectrum can help us facilitate maker experiences that develop student visualization of space. Understanding positive and negative flat space (2D design), 3D space represented on a flat plane (perspective systems), how flat objects translate into 3D shapes when folded or constructed (2D-to-3D design translation), and 3D objects in-the-round (construction) are foundational skills in fine art, design, and engineering.

Additionally, everyone has a preference for how they approach the spatial world when problem solving. Observing student choices in open-

Form designed in 3D space and output as a 3D physical object.

ended design challenges can provide a window into the 2D-3D preferences of students. When asked to express an idea for a design, some students will gravitate towards making something in 3D while others will choose to draw, and yet others will skip visuals entirely and describe their ideas through words. These go-to methods of representation are a great place to start. Design challenges can be crafted to stretch students beyond their preference and force the brain to visualize the next step.

THE MIND'S EYE

Moving back and forth between 2D and 3D approaches encourages mental visualization and strengthens spatial skills. Providing opportunities to practice translating mental imagery into the physical world empowers makers. An architecture student might learn this process, first capturing an idea in two dimensions by drawing a quick sketch of a structure, then developing the visual idea to include floor plans, elevations, cross sections, and linear perspective renderings. Eventually the idea is brought into the physical world through the creation of a 3D model. The student utilizes mental visualization moving from 2D-to-3D representation, first by drawing, then with physical construction to execute a design idea. A reverse approach is used in a project designed for middle school students titled *Think like an architect, Draw like an engineer*. In this lesson, students build 3D models using LEGO bricks and then are challenged to draw isometric drawings of the models. These models are torn down and peers rebuild the model from plans. (A link to this article can be found in the Notes section.) In GAMES (Greenwich Academy Makers and

Engineers), fourth grade "big sisters" design and build a dream toy for their first grade "little sisters." After they interview their little sisters, they start with 2D drawings. Feedback from peers informs the next step, a prototyping process. The first idea is constructed with prototyping materials, specifically materials that are easy to cut, build with, and ideally, inexpensive or recycled. The prototypes are shared with their little sisters for feedback. New sketches are made, and revisions are noted. Students find themselves back in a mental mode where they imagine, visualize, and make decisions about how to bring these ideas to 3D form. Material boards are set up displaying prototyping materials side-by-side with materials that are available for the final toy constructions. Students start to think about materials and ask (1) What materials are like those I used in the prototype but more permanent, refined, or aesthetically pleasing?; (2) What are the appropriate tools for cutting, forming, and attaching?; and (3) How should I connect my materials in a way that is lasting? The final stage in this project brings the design back to the 3D world as students construct their toys. The sequence is 2D sketch → 3D prototype with recyclables → 2D revisions → 3D translation of materials → 3D construction.

LINKING THE EYE, HAND, AND MIND

It is standard teaching practice in the art field to describe drawing as an exercise in linking the eye to the hand. Alternating visualization and concretization is a critical piece of developing this pathway. The pathway is extended by adding the miraculous ability of the mind to imagine what does not currently exist. Drawing is a visual language that unlocks students' power to bring their ideas into the physical world. The beauty is that the ideas do not have to be practical, functional, or realistic. Like Leonardo DaVinci and his inventions, many of which were precursors to modern designs, students can stretch their imaginations outside of the boundaries of the physical world and imagine what could be possible tomorrow.

THE ONLY RULE IS WORK

To what end is all of this hard mental work of visualization and representing? STEM folks might say "It's essential to engineering." Art folks might say "It's essential to self-expression." Whether you are couching this question in the context of engineering or in art and design, the power of developing pathways for making enables students to work generatively. New ideas come to form while actively trying to solve the problems at hand. Work drives innovation.

Artist and educator Sister Corita Kent, well-known for her pop art graphics and advocacy, posted 10 Rules for learning and life at the Immaculate Heart College Art Department. Every single one of these rules offers an important nugget of wisdom. Rule 7 stands out: *The only rule is work. If you work, it will lead to something. It's the people who do all of the work all the time who eventually catch on to things.*

Our students get ideas as they work. The practice of linking the eye, hand, and mind in concert with materials and tools is the maker's way of "catching on to things" they discover, they make connections, and they imagine the possible.

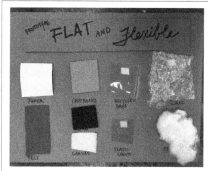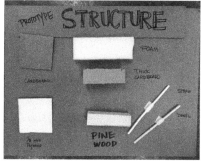

Material boards display prototyping materials side-by-side with final construction materials showing (left) flat and flexible materials; (middle) structural, rigid materials; and (right) attachment options.

The Power of Making What You Can Imagine

VECTOR AND RASTER GRAPHICS FOR DIGITAL FABRICATION

There are two types of 2D graphic images we use in digital fabrication: (1) vector and (2) raster (or bitmap) images. A vector graphic is composed of anchor points and the lines, or paths, between the points. Points and paths are mathematically defined and, therefore, independent of resolution. By contrast, a raster graphic is composed of individual dots called pixels. Raster graphics become pixelized and are less sharp as we zoom in while vector graphics are infinitely scalable. Here is a raster and vector graphic side-by-side for comparison.

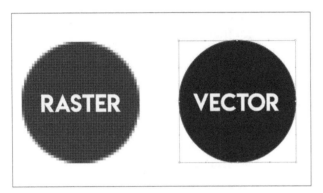

A raster and vector image side-by-side for comparison.

Raster graphics are editable in photo editing software like Adobe Photoshop, and vector graphics are editable in Adobe Illustrator. These programs are common in art departments as part of the Adobe Creative Suite. If Adobe software is not available, consider GIMP for raster images and Inkscape for vector images. Both are free, open-source programs available for download and use in digital fabrication. A guide titled, Illustrator to Inkscape, can be found at in the Resources section of the book which converts instructions for Illustrator tools used in this book to the Inkscape tool equivalent.

In digital fabrication, vector graphics are more common. As mathematically defined objects, vector graphics define perfect cut lines for the vinyl cutter, laser cutter, and CNC router. Raster graphics are useful in the more "painterly" processes such as engraving (etching) on the laser cutter or color separations on the digital embroidery machine.

ENGRAVING FOR THE LASER

One can etch on the surface of a variety of materials by creating an engravable image using 2D design software. Raster or vector graphics are both suitable for this process; each has their own characteristics and settings.

RASTER GRAPHICS FOR ENGRAVING

Artists prize raster graphics for the detail and subtlety they offer. Grayscale images with a full value range from black to white can translate very well as laser engravings. The laser cutter reads the image as a value map—even the lightest gray translates to visible engraving. To avoid a dulling raster field around an image, remove the space around an image in the photo editing software before rastering.

VECTOR GRAPHICS FOR ENGRAVING

Vector graphics can also be used for engraving. Choosing vector graphics for engraving projects adds an element of control over the final product. A person would choose a vector graphic over a raster graphic when clean, precise design work is desired. For instance, to etch the purple circles shown on the left on a piece of wood, the vector shape would be a better choice over the raster shape to avoid a fuzzy or pixelized edge.

The laser cutter software distinguishes cutting and engraving processes based on line weight and RGB color; when line weights are set to thicker than a hairline, the edge loses its definition and the machine defaults to engraving. As long as you are not setting hairline edges to designs, vector graphics are suitable for engraving. See the Laser-Cutting Process and the Plan Your Laser Cutting worksheets in the Resources section on pages 158-159 for details on specific laser settings.

CUTTING AND SCORING FOR THE LASER

Along with engraving, cutting and scoring are two important processes for the laser. Both require a vector line set to hairline for the laser

to read the object edge. Cutting and scoring are the same process but are powered differently. Scoring is sent to the machine at very low power and high speed. By contrast, the same file can be sent to the laser for cutting with high power and low speed. The second file cuts because the laser dwells longer on the path line. The high power and low speed allows the laser to penetrate the material. Each material has different settings specific to the laser. Consult the laser manual for more information.

CUTTING AND MILLING FOR THE CNC

Toolpaths for CNC machines—machine directions for milling and cutting—can also be generated from 2D vector design files. In CAM (computer-aided machining) software, the designer chooses different paths and designates which process to execute. VCarve Pro, the CAM software used in this book for the ShopBot CNC, creates toolpaths for pockets through the carving of negative space and cut profiles from closed vector shapes. The software can also generate toolpaths from 3D models and remove material from surfaces.

2D → 3D

2D designs can be transformed into 3D designs. By importing 2D design profiles into 3D design programs, a 2D design is extruded (given height), built upon, and modified like any other 3D model that can be fabricated as a 3D print or carved on the CNC. Similarly, using the laser cutter, flat materials can be designed with the intent of creating 3D objects and constructed into forms through joinery and connections.

FROM DESIGN IDEA TO VECTOR

While raster graphics are very popular and easy to find in print and on the internet, learning about vector graphics will open up many more options for digital fabrication design. Ways that students generate vector graphics in our lab include:

- Turn a Sharpie drawing into a **vector outline**
- Use the **Pen Tool** and **Shapes** to directly draw vector lines
- Convert **raster shapes** into **vector outlines**
- Turn **font into outlines**

For students who are just getting started with digital design, there are self-guided handouts included in the Resources section at the back of the book.

Additionally, several projects in this book go into detail about these approaches and can help students get started with the process of turning a design idea into a vector graphic. Refer to the Project Cross-Reference, page vi, for more information.

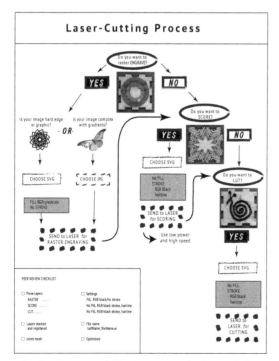

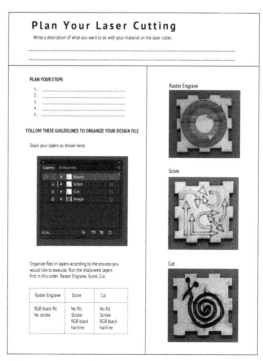

Laser-Cutting Process and Plan Your Laser Cutting worksheets with machine setting guidelines can be found in the Resources section at the back of this book.

PROJECTS

DRAW

MACHINE DRAWING

Drawing is a universal visual language, and a makerspace is full of machines that draw. One way to draw is to substitute a pen for the cutting tool on a CNC machine or vinyl cutter. Another way to use machines to draw is to explore variance and imprecision in a process. A loose pen or varying the power in laser injects an element of surprise into a work.

There are infinite combinations of materials, machines, and software awaiting the curious artist interested in machine drawing. Here are a few examples of machines you might find in a makerspace that can be used as tools for drawing.

DRAW WITH TOOLPATHS

Fill areas and stroke lines in drawings can be directly output by the CNC machine based on the settings of the toolpaths generated in the software. The nets of polyhedra shown here are created by putting a fill within shapes using a pocket toolpath and drawing a stroke with a profile toolpath. Afterwards the shape was cut out, folded, and formed. A more detailed description of this CNC drawing process can be found on page 40 in the *Design with Rules* project.

DRAW WITH VECTOR PATHS

Drawing on the vinyl cutter is a great alternative to cutting on the laser cutter. It teaches students the same principles and technical understandings of fabrication at a much lower price point.

Unlike the CNC, the vinyl cutter cuts stroke lines only. Designs that can be sent to the vinyl cutter include paths and trace outlines. Designs can be created directly in vector graphic software or programmed using code. Adobe Illustrator, Beetle Blocks, and Processing are excellent programs for generating vector paths for the vinyl cutter.

Craft cutting machines can also be outfitted with a pen. The design software has a tracing function, which enables the artist to turn

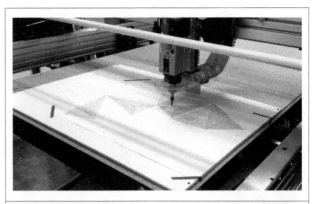

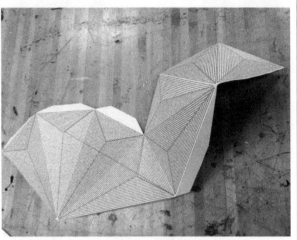

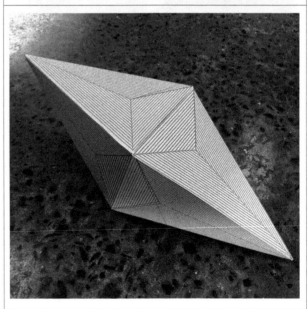

Draw with toolpaths
When sending a file to the CNC you must first generate a CAM (computer-aided manufacturing) file which sends instructions to the machine. In this example, a Sharpie marker stands in for the cutting tool. Instead of removing material, processes like carving and cutting are recorded with a mark, mapping the path and drawing it on the surface. Pens can be changed between toolpaths for multicolor pieces.

a high-contrast raster graphic into a vector graphic. This process works well for shape outlines. Additionally, if you are using a craft cutter, you can also cut material, which makes this tool a great choice for combining drawing and cutting. The material is left in place on the mat and stays registered between switching pen with blade.

DRAW WITH EXTRUSION

Any 3D design program can output flat designs if the z-thickness is small. This results in a flat 3D print that reads more like a drawing than a sculpture. Extruding these designs makes for an interesting drawing option for the 3D printer.

In the example below, students used Beetle Blocks, a programming language that outputs to a 3D printer to create Random Art Generators, coding different shapes with random number inputs, determining the size and placement of the shapes. Each time the program is run, all new shapes are randomly created.

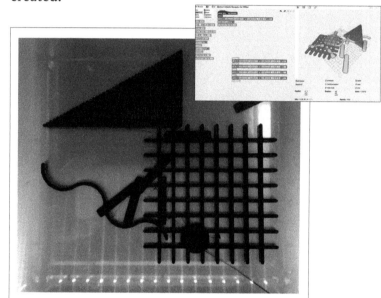

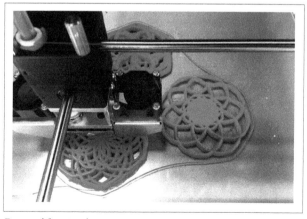

Draw with vector paths
Vinyl cutters can be set up as drawing machines (plotters) when outfitted with a pen. The machine shown here (Roland GX-24) can only record stroke lines. Fills can be created in your vector design software as hatch lines or small patterns, and cropped into shapes. A more detailed description of this process can be found in the Draw Text with Vinyl Cutter *project on page 30.*

Draw with extrusion
Random Art Generator in Beetle Blocks for 3D printer, "drawing" radial designs with the 3D printer by limiting designs to the xy plane.

MAKE MARKS WITH A LASER

The settings on the laser cutter can be used to change the quality of line on the material through the process of scoring and engraving. Think of the power itself like a drawing tool, the line quality can vary in density and value contrast.

DRAW WITH CODE

The computer has the capacity to do things differently than the human hand. Variables can include measurement, precision, and patterning. Sometimes what we want to achieve with our work requires algorithms. Similar to how a drafting machine can be a tool to aid precision, a computer program can do the same. We write code and the computer executes our intention.

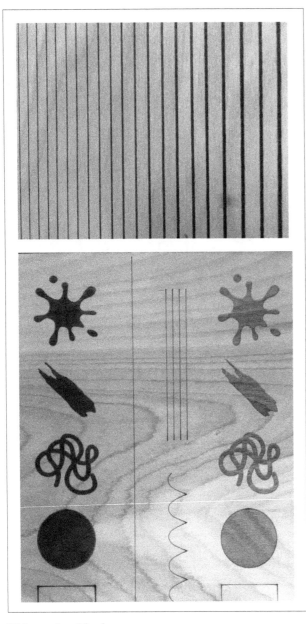

Make marks with a laser
(top) Graduated line thickness expressed through settings on the laser. The line shown here gets progressively thicker with changes in settings; (bottom) differences in etching effects through variations in power.

Draw with code
Examples of drawing with code: (left) drawing with TurtleArt; (right) drawing with Beetle Blocks (exported as lines).

Examples of work drawn with code: (top) grade nine artists' artwork designed in Processing and drawn with an AxiDraw drawing machine; (middle) artist's design drawn using the vinyl cutter with a loose pen and crumpled paper, (bottom) design drawn with a secure pen using the vinyl cutter.

DRAW WITH LIGHT

Lighting the edge of a piece of acrylic can make an etched or scored design glow as the light is drawn up through the material like the boxes shown below. These were made by geometry students—the designs were etched onto acrylic and mounted on a laser-cut box with an LED light strip. Etching produces a subtle effect on acrylic while scoring is more dramatic. The mark created from a score rests deeper within the material.

Attaching a light to a robot can be another way to express line and shape with a machine. The robots are programmed to make a shape, and using a long exposure setting on a camera and capturing the photo in a low-light environment or dark room, vibrant light drawings can be created. Building a delay at the start of the program allows the artist time to set up the robot and the camera timer.

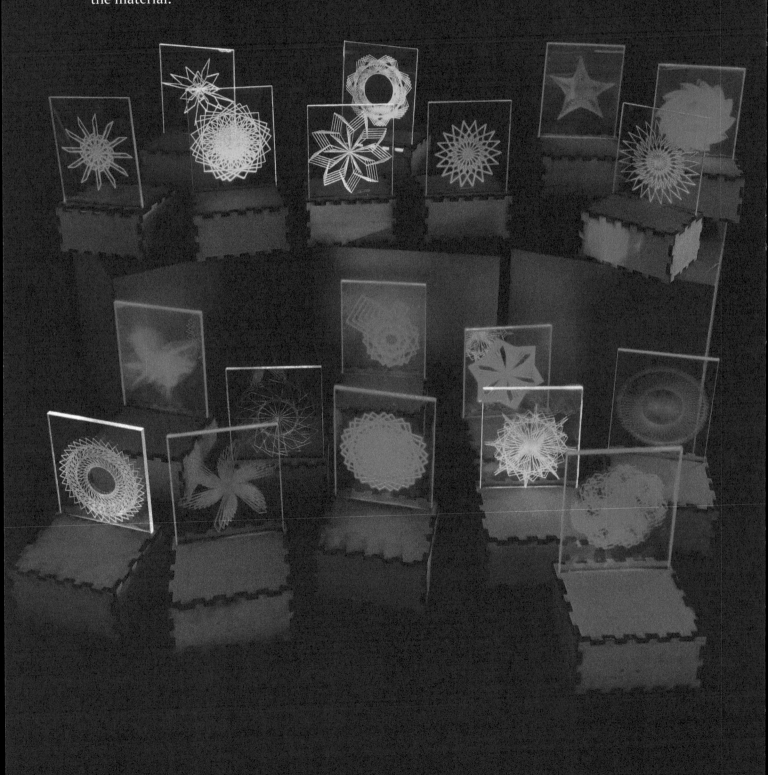

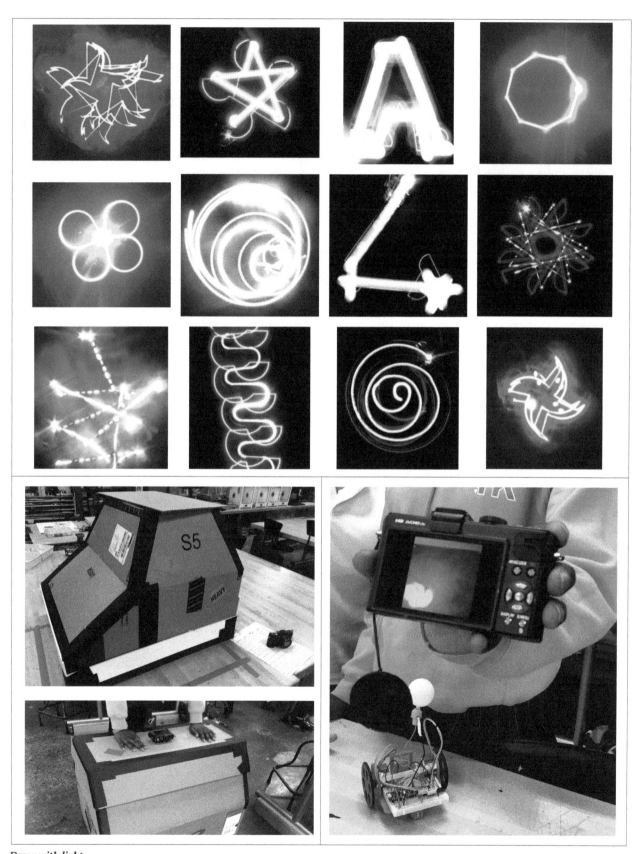

Draw with light

(facing page) Edge-lit acrylic etched with Beetle Block designs. Box design by Casey Shea; (top) grade nine drawings with light using Logo Turtle developed by Josh Burker, Brian Silverman, and Erik Nauman; (bottom left) dark rooms fashioned out of a large cardboard boxes for students to capture long-exposure photos; (bottom right) students evaluate each photo after the robot executes its program.

DRAW TEXT WITH VINYL CUTTER

OVERVIEW

1. Print a pen holder
2. Prepare machine for plotting
3. Set up font design for plotting
4. Turn font into outlines
5. Add a fill to the shapes
6. Draw with the vinyl cutter

MATERIALS AND TOOLS

- Vinyl cutter (directions refer to a Roland-brand cutter, but other vinyl cutters use a similar process)
- 3D-printed pen holder
- Stabilo pens

PRINT A PEN HOLDER

Some vinyl cutters come with pen attachments, or you can 3D print your own for the Roland GX-24 vinyl cutter using the file *Stabilo_Roland.stl*, adjusting the scale to fit the diameter of a Stabilo fine tip marker. The no-fuss method is simply to wrap a bit of duct tape around a marker to keep it secured in the cartridge during drawing.

PREPARE MACHINE FOR PLOTTING

1. Turn on the machine. The blue light will indicate that the machine is on. Choose a pen. Put it in the pen holder and set aside. Open the roller arm lock.
2. Slide paper in the vinyl cutter, making sure the rollers are spaced on opposite sides of the paper and within the gray bar sections for gripping the paper.
3. Secure roller arm lock.
4. Measure the paper with the vinyl cutter by choosing **PIECE.**
5. When the carriage returns to the bottom-left corner of the paper after measuring, set the **ORIGIN** point. You do this by pushing the origin button until it flashes.
6. Put the pen in the tool holder. Pen tip should hover right over the surface. Tighten the screw to secure the pen.
7. Run a test to confirm pen is properly spaced above the paper. Test should show a consistent pen line.

SET UP FONT DESIGN FOR PLOTTING

8. Text is a great element to introduce into a design for plotting. While fonts installed on the computer are editable, scaleable graphics, they are local to the computer and are not in the vector format needed for the vinyl cutter. To convert text to shape, type the characters and select the font of choice. An underline will be visible beneath the characters. This is an indication of font format.

TURN FONT INTO OUTLINES

9. Select font and **Type → Create Outlines.**
10. The text is now a series of shapes. While in vector format, the characters are outlined in paths and anchor points. They are in the form of closed, joined shapes in the vector software. Swap **FILL** and **STROKE** before moving onto next step.

ADD A FILL TO THE SHAPES

11. While vinyl cutters do not normally do fills, you can create your own. Open a vector line fill pattern, and add it to a layer underneath the text shapes. The pattern shown in the example is generated in Beetle Blocks and downloaded as 2D lines.
12. Open **Pathfinder** window. **Select All** so fill layer and text are both selected. Click on the **Divide** button. To remove the pattern lines around the perimeter of the shapes, zoom in and select a vector line inside the text. **Select → Same → Stroke Color** then, **Select → Inverse. DELETE.** The letters are now filled, and the design is ready for plotting. Save your work.

DRAW WITH THE VINYL CUTTER

13. Locate the Roland Cut Studio extension within Illustrator. Click on the large gray button. The design will open within Roland Cut Studio.
14. In order to match the design window with the size of the material in the vinyl cutter select **Cutting Setup → Properties→ Get from Machine.** Make adjustments in scale, orientation, and formatting before sending plotter file to the machine.
15. Send design to vinyl plotter by selecting **Cutting → OK.**
16. Machine will start plotting the design.

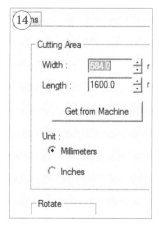

DRAW WITH EXTRUSION

Any 3D model can be set to small z-thickness which results in a flat 3D print that reads more like a drawing than a sculpture. Beetle Blocks, an online, block-based programming language is ideal for creating 3D-printed extruded drawings. Limit the design to only the xy plane, and the 3D print will be a flat, thin form.

The example shown here creates a random nest of lines that cross for extra support within a boundary.

1. Go to beetleblocks.com/signup to create an account. Run Beetle Blocks.
2. In the **CONTROL** section, grab an **EVENTS block** to indicate how to trigger the program. In this example, the **space key** and a **reset block** are stacked so each time the program runs, it clears the previous design information.
3. Set **extrusion diameter** to 1 mm, which puts out enough material to create a solid print while thin enough to be a drawing
4. Choose to **extrude lines or curves**.
5. Add a block to **ROTATE** the z-axis.
6. **ROTATE** a **random angle**, 0-360 degrees, from origin point.
7. Pick a **random number** for x and y within a boundary of 40 units from the (0, 0) origin.

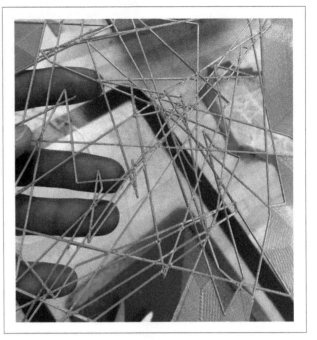

8. Put this within a **REPEAT block**. The number will determine the density of the design.
9. The **MOVE HOME** block will close the shape by bringing it back to the center.
10. Now you can download the design as an STL.
11. For very thin prints, you may want to print with a brim. A brim minimizes warping and adhesion problems at the edges.

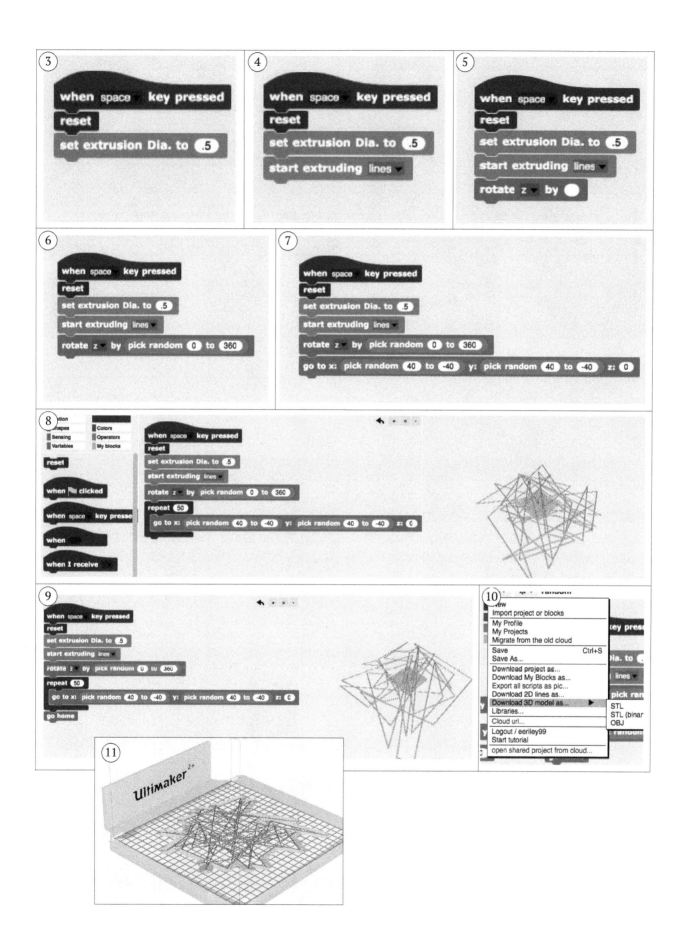

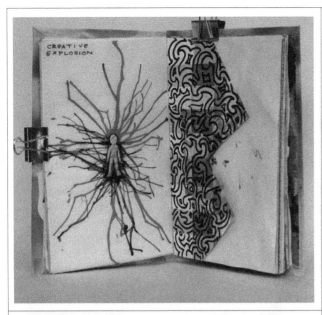

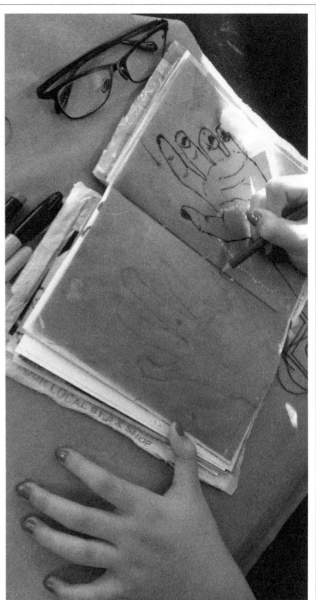

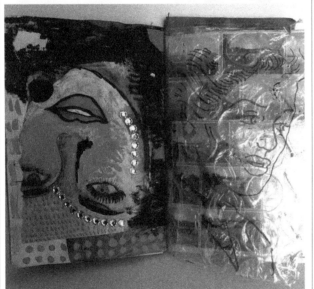

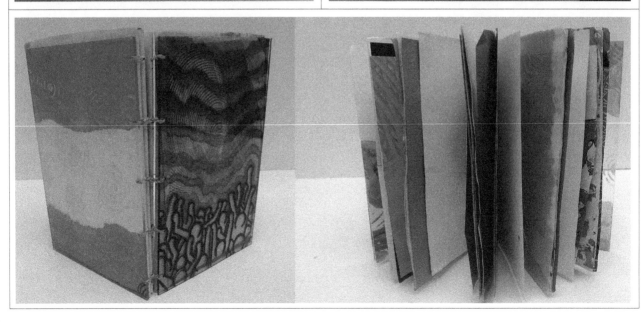

UPCYCLED LASER-ENGRAVED BOOK

Making sketchbooks is an inherently personal art activity. Books that are handmade and hand-bound can both capture the past in its pages while presenting possibilities for something new. They can be used to collect our paper memories, tell a story based on how an artist arranges a stack of ephemera, bring new life to something old, or represent possibilities between fresh blank pages.

Art is not the only subject that uses journals and sketchbooks. Science and lab notebooks can be personalized and made from scratch. Specialized graph papers and subject-specific page inserts can be included, making handmade books a fantastic STEAM project for the art room, lab, or makerspace.

Additionally, sketchbooks and journals are a rich area for exploration at the intersection of new technologies and storytelling. MIT's High-Low Tech group developed several materials for making with electronics that have made their way into the material vocabulary of artists. These materials, ranging from conductive

paint and circuit stickers to programmable circuit boards, can make a sketchbook into an interactive art piece.

The following project example brings the technology of digital fabrication into the mix, expanding the possibilities of a notebook as a classic maker project.

OVERVIEW

1. Laser engrave the cover
2. Prepare an image for the cover
3. Select and arrange papers
4. Sew a Coptic binding

MATERIALS AND TOOLS

- Laser cutter
- 8 ½ x 11 inch acrylic
- Spray paint
- Recycled papers
- Awl
- Wax thread
- Binder clips
- #18 embroidery needle
- Curved needle
- Bone folder (or scissor backs)

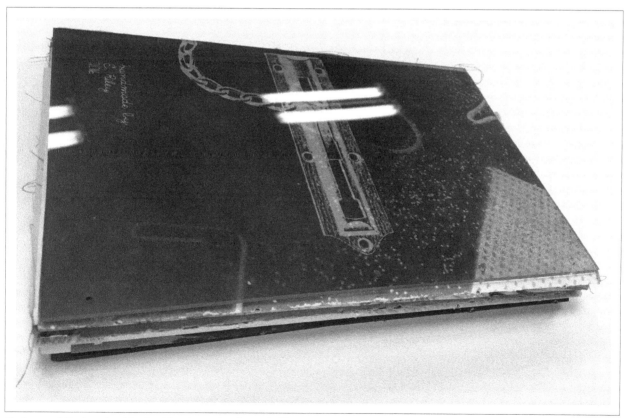

(facing page) Student sketchbooks; (above) completed upcycled laser-engraved book.

LASER ENGRAVE THE COVER

1. While engraving on acrylic alone can create a noticeable image and embossment, the transparent quality of the material offers interesting options for layering. To heighten contrast, spray paint one side of the acrylic and let the paint dry overnight before laser engraving.
2. Leaving the protective layer on one side of the material will protect the acrylic from scratches when engraving (acrylic shown with protective film facing the laser grid).

PREPARE AN IMAGE FOR THE COVER

In this next step you will prepare an image in Photoshop for etching on the laser.

3. Find an image from a copyright-free image source. Clip art and pattern books can be found at bookstores or online from Amazon. Some online sources for images include the New York Public Library Digital Collection and Creative Commons. Look for high-contrast images. They tend to give the best result for laser engraving.
4. Scan the image.
5. Open image in Photoshop. Isolate the image by cropping.
6. With the background layer unlocked, use magic wand to select white space around the image and delete. The result will be high contrast without a background for the most effective engraving. Note: Even a very light gray will show up in engraving, and removing the background avoids this. Save image as a JPG.
7. Open *Acrylic Cover Laser file* in Adobe Illustrator. You will notice two layers in the file: an engrave layer and a cut layer with holes for binding. Note the orientation of holes in relation to cover image. Next step is to place and embed the engraving image. **File → Place → Embed** (button on tool bar).
8. Position the design within the boundaries of the artboard. The design pictured here is intended as a wraparound. At this point in the design process, you will also decide if the image needs to be reflected. This is an important step if there is a direction to the image, like with text, as you will be

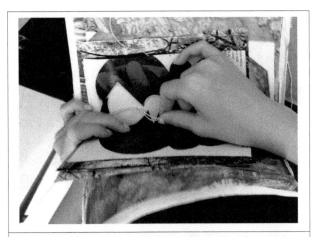

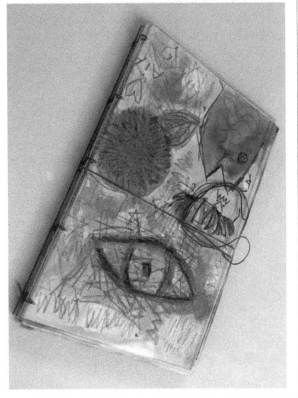

(top) Student using Coptic stitch to bind a laser-engraved sketchbook; (bottom) grade eight student's completed sketchbook. Photo credit: Zoe Hedstrom.

viewing the design from the reverse side through the acrylic.

9. Send the file to the laser cutter according to the settings for the machine.

SELECT AND ARRANGE PAGES

Fold twenty-five sheets of paper in half. Run a bone folder on the edge to create a sharp crease. Nest five sheets to make a signature. Each book contains five signatures for a total of twenty five sheets.

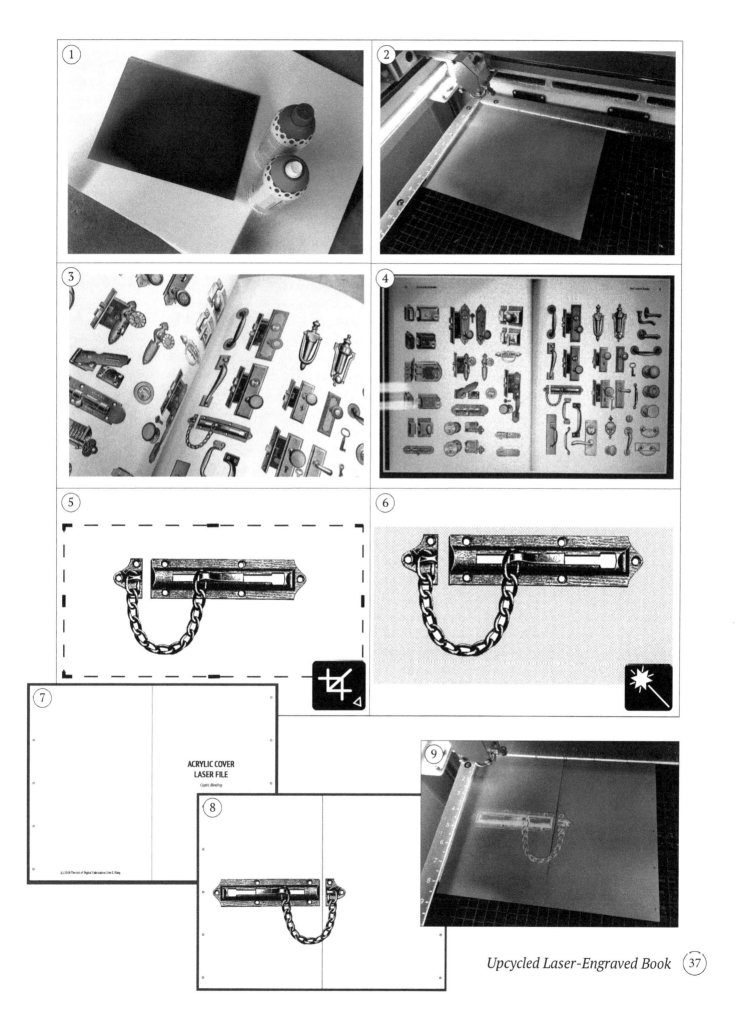

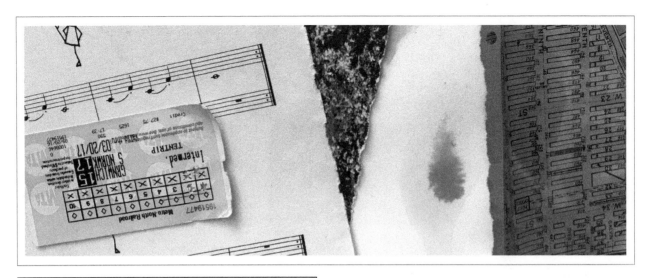

SEW A COPTIC BINDING

The binding for this book is a traditional Coptic binding style.

1. Fold and position *Acrylic Cover Hole Punch template* within the fold of each signature. Use a needle tool or awl to punch holes that will be used for sewing. Measure a long length of wax thread. A book this size requires about one-and-a-half "wingspans," or the length of your arms outspread. Thread a single strand through the embroidery needle, leaving a long tail. Do not tie a knot.
2. You will be sewing the bottom cover to the bottom signature as shown here.
3. Bring needle from inside through signature spine, around cover edge, and back through cover hole, and back into signature. Tie a knot.
4. Move on to next hole at signature spine and repeat until the fifth hole is reached.

5. Complete sewing the fifth hole to the cover and "close" the stitch by stitching "around" the stitch below it. Please note you remain on the outside of the book. Stack another signature on top of the last signature. Visually line up the holes. Bring needle through the first hole in signature #4 and back out the second hole. At this point you may want to change to a curved needle. Do a kettle stitch. A kettle stitch links individual signatures together by stitching "around" a stitch. Bring needle back through the second hole. Repeat the stitching and kettle stitching until the fifth hole is reached.
6. Sew the remainder of the signatures. Follow the pattern of stacking a new signature on top of the stack at the completion of sewing each signature. Likewise, follow the pattern of kettle stitching each signature to the signature below it.
7. Once the top signature is sewn to the book block, the next step is to sew the top cover onto the book. This is done by sewing the top cover to the top signature. Bring needle through cover hole, kettle stitch below signature, and bring needle back into top signature. Move onto the next hole at the signature spine, stitch cover, kettle stitch below top signature, and bring needle back into the top signature. Repeat.
8. Once sewing is complete, tie a knot on the inside of top signature, completing the book.

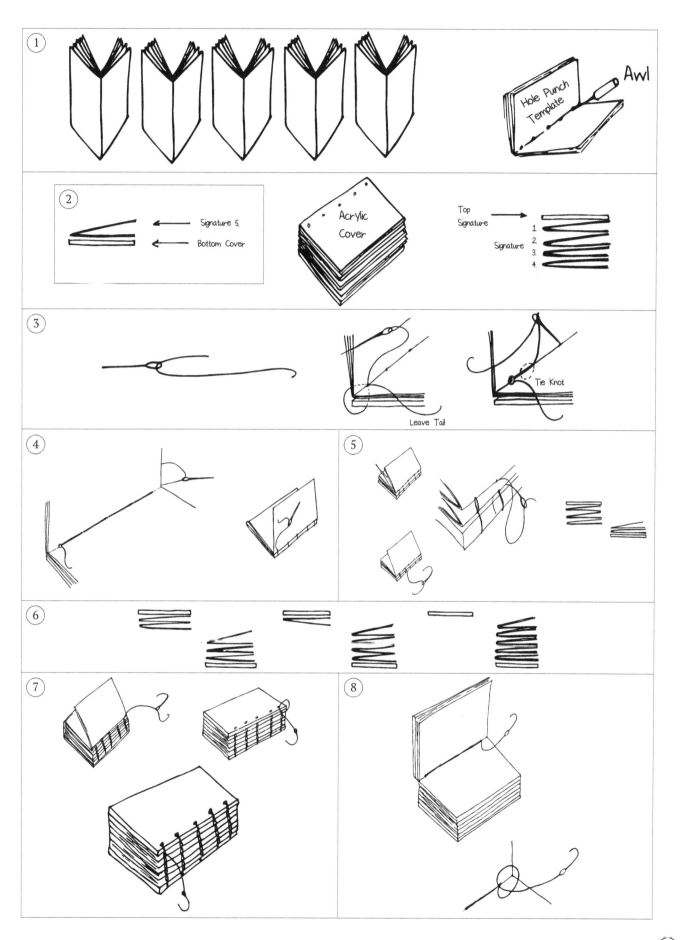

DESIGN WITH RULES

Student, grade nine, conditional design CNC drawing.

CONDITIONAL DESIGN

The three tenents of the Conditional Design Manifesto state that:

- Process is the product
- Logic is our tool
- The input is our material

OVERVIEW

1. Create instruction-based drawings
2. Use pen tool to draw vectors
3. Set up the CNC
4. Make a CAM file and draw with CNC

MATERIALS AND TOOLS

- CNC machine (directions refer to using the ShopBot CNC to draw, but other CNC machines with pen attachments use a similar process)
- Marker attachment for CNC
- 18 x 24 inch paper and markers

Inspired by the Conditional Design Manifesto, and the work of artists who make instruction-based artwork like Sol Lewitt and Yoko Ono, this project challenges students to create a design based on a set of rules. The rules act as a creative constraint dictating the input parameters of the drawing students produced. Programmed variance within the parameters means that each time the drawing is executed the result is slightly different. The activity was designed as an introductory project for *Art and Code* class.

The project starts with students writing down simple instructions in everyday language for drawing a shape. Pairs of students trade, test, and refine their rules. These sets of rules, or algorithms, create unique shapes when followed. What emerges is an individual interpretation of the rules and a one-of-a-kind record of thought and intention.

Students turn their shapes into a vector design using the pen tool in Adobe Illustrator. Each pair of students merge their designs revealing both the connection between the designs as well as their individual interpretations of the rules.

The final step is to fabricate the computer-drawn shapes. The design is interpreted on the CNC as a toolpath drawing.

CREATE INSTRUCTION-BASED DRAWINGS

Steps 1-2 familiarize students with instruction-based art, giving them practice executing a rule set. In step 3 students create their own rules.

1. Pair up and gather supplies for drawing.
2. Follow a set of rules to make a drawing. Pictured here: (1) Draw a line starting at the edge of the paper. (2) As one line approaches another, make a tunnel. (3) When you can no longer make a tunnel, start a new line. (4) When you can no longer make a line, STOP.
3. Sort into pairs once again. Generate a set of rules for drawing a single shape. Each person in the pair will be drawing a shape based on this algorithm. These shapes will become a combined digital design. The rule set pictured in this example is as follows: (1) Create a large enclosed shape. (2) Fill most of the paper. (3) Do not touch the edge. (4) Do not cross a line. Each student takes a photo of their final shape and moves on to step 4.

USE PEN TOOL TO DRAW VECTORS

In the next part of the activity students draw an image directly in Adobe Illustrator for outputting as a toolpath on the CNC. The pen tool is one of the most powerful drawing tools for students to learn in vector design. Paths and anchor points provide the building blocks for angular and curvilinear shapes. With handles, one can pull elegant Bézier curves and select and edit anchor points directly, affecting the profile of a path. In order for the CNC to draw fills using the POCKET toolpath, a vector shape needs to be closed and joined.

4. Open a new Illustrator file. Set the Art Board to 18 x 24 inches. Place and embed a photo of drawing generated in step 3. **File → Place → Embed** (button on tool bar).

5. Lock layer and create two new layers: (1) for a white translucent fill and (2) for the pen profile. On the translucent layer draw a white rectangle edge to edge set to 75% opacity to mute design. Lock this layer.

6. Click on the pen layer. Select the pen tool (P). When starting a shape, you will see an asterisk (*) in the bottom corner. Place anchor points around the shape profile, clicking (and pulling) when you have curves. If you stop the pen and return to a path, a forward slash (/) in the corner will indicate you are continuing the path.

7. Complete the shape. When the shape is closed and joined, a circle (°) will appear.

8. The shape can be edited using the Direct Section (A). Click on an anchor point to move individual points or adjust handlebars for curves.

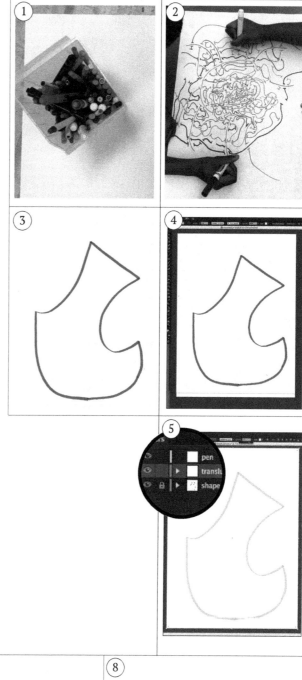

9. Combine student partner designs. Open both files in Illustrator and stack them on top of each other and save as a new file ready for the CNC.

SET UP THE CNC

10. If the table hasn't been resurfaced or isn't smooth, fasten a piece of foamcore to the top of the table.

11. Tape paper to the foam and mark an origin point that you will specify as (0, 0) for the CNC position.

12. Follow instructions for loading the plotter pen attachment and pen into the collet.

13. Bring the pen to the origin location.

14. Zero your machine (0, 0, 0)—X, Y, Z—through your software. Move the Z direction up. This will bring the pen back up to a safe height so as not to bleed on the paper.

MAKE A CAM FILE AND DRAW WITH CNC

15. In the CAM software create two toolpaths. These toolpaths will overlap, creating interesting stacking patterns. Each student

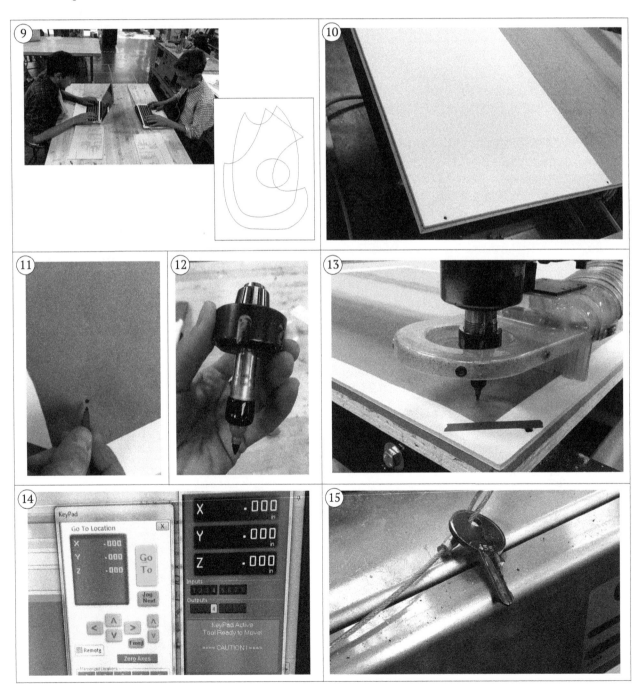

chooses their own toolpath and pen. When creating the toolpath, it is important to set the spindle to OFF. This is best achieved by creating a new tool in the database for a Sharpie attachment with spindle rpm set to zero. You can also ensure the spindle is not engaged by removing the key from the spindle power box.

16. Create one toolpath for the fill of the design. This will be a **POCKET** toolpath in the software. Variables that can be experimented with for the pocket fill include raster or offset. Raster produces a straight fill pattern at any angle. Offset produces a spiral pattern following the shape profile. Determine the size of the tool by varying the density of marks.

17. The second toolpath is the **PROFILE** toolpath. This will be anything in the design that you want drawn as a boundary line of the shape.

18. This picture shows alternating toolpath variations within shapes.

19. Save the CAM file. Open the G-code file to check the numbers. Look to make sure the z-axis is at minimum 0 and spindle RPM is set to zero. Draw the CNC design.

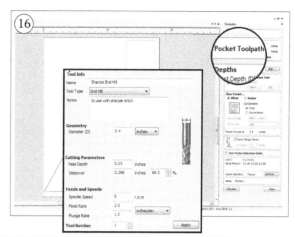

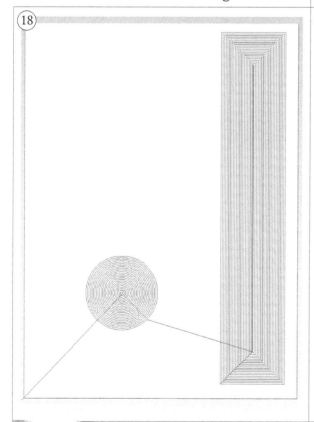

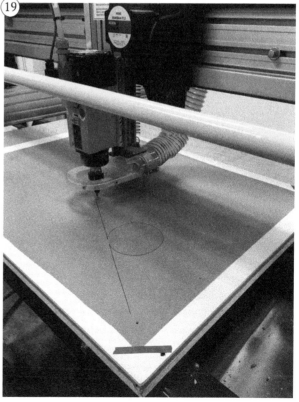

1. On a 6x6 inch square, draw a continuous mark with a highlighter pen, making sure not to overlap a line in the same spot more than once.

2. Stop when the paper is half-filled with overlapping lines.

3. Switch drawing tool to a Sharpie marker. At each junction, draw line edges either over or under.

4. Connect all the over or under junctions to create one, continuous, overlapping line.

Other examples of conditional design and rules-based art: (clockwise) students, grade nine, in Art + Code working together to create a mural based on a set of rules; installation view; graphics showing mirrored design before they are applied to fabric; finished T-shirt design; art history teacher Kristen Erickson working with grade twelve student on the heat press.

VINYL-CUT MURAL

Inspired by the Conditional Design group, students created a vinyl cut window mural based on a rule set. For this project, the challenge was to design shapes that could be configured in any direction to create continuous looping overlapping lines.

RULES-BASED ART T-SHIRTS

Students in an art history class worked on an integrated project with a computer science class. The set of rules and the resulting artwork were made into artistic T-shirts with heat-press vinyl. Students applied the graphic to the front of the shirt and rules on the back.

LIVING HINGE SKETCHBOOK

A living hinge, or laser cut pattern enabling material to bend, is an exciting way to integrate a flexible binding into a sketchbook.

The book in this project uses the same method for binding as the *Upcycled Laser-Engraved Book*, but as an alternative to sewing the book cover onto a series of signatures, the book is bound as a block and is glued onto the cover.

OVERVIEW

1. Draw a vector design
2. Laser score book cover
3. Measure, fold, arrange papers
4. Put it all together

MATERIALS AND TOOLS

- Laser cutter (directions refer to using the Epilog laser machine, but other laser cutters use a similar process)
- 3 mm plywood
- Arches Text Wove 19½ x 25½ inches, 120 GSM weight
- Awl, wax thread, binder clips
- #18 embroidery needle
- Curved needle
- Bone folder
- PVA glue
- Masking tape

DRAW A VECTOR DESIGN

In this initial design step you will be preparing an image in Adobe Illustrator for the laser.

1. Open the file titled *Living Hinge Laser File* in Adobe Illustrator. Select the layers panel to make three layers visible (score, cut, text). The score layer contains the example design for this tutorial. To create an original design, hide text layer, lock cut layer, and select vectors on score layer and delete.

2. Using the Illustrator tools, create a design of your choice. In this example, a series of concentric starburst shapes were created using the star tool, designating the number of sides and radius of the inside and outside points of the shape. With scoring you will be "drawing" the designs with the laser on low power. With this in mind, design the image with stroke lines only.

3. Position the design within the edges of the master laser file for the sketchbook. Make sure this design is on the score layer and the line weight is set to RGB black (0,0,0) and 0.001 pt. (hairline). Save the file.

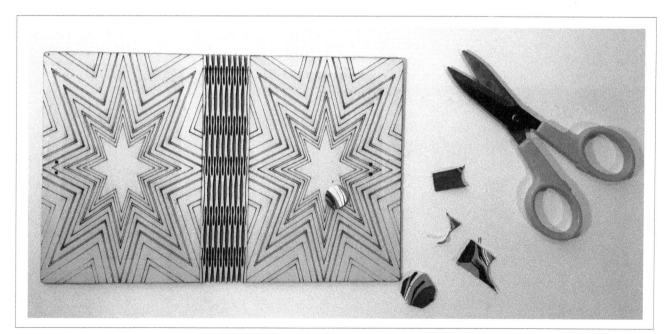

Laser-scored, living hinge plywood cover for a sketchbook.

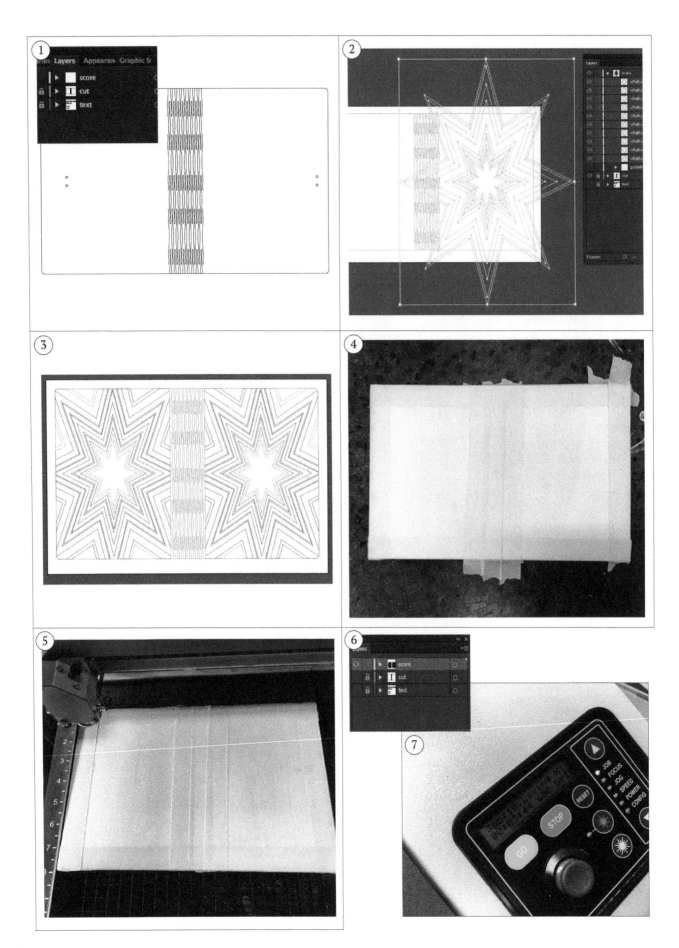

The Art of Digital Fabrication

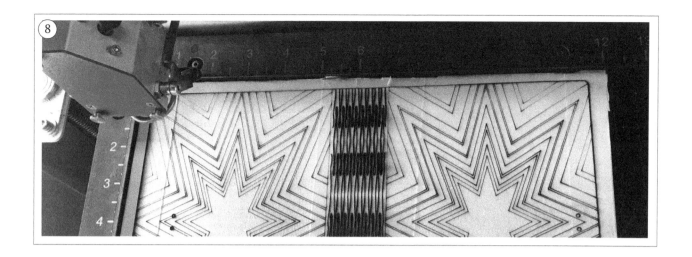

LASER SCORING BOOK COVER

4. Adhere some masking tape along the binding and the edges to prevent scorching the surface of the sketchbook.
5. Load the wood into the laser.
6. Organize the layers by process. Start with the score layer. Lock the layers you are not using.
7. Send the job to the laser with the appropriate power and speed settings. After scoring the book cover, select the cut layer. This is the layer with the living hinge and profile cuts. Send the job to the laser with appropriate power and speed settings.
8. After completing the job, remove the piece and remove masking tape.

MEASURE, FOLD, ARRANGE PAPERS

There are many types of paper that can be used for the sketchbook. I chose Arches Text Wove as a versatile weight for a variety of art media. Take a full sheet of Arches Text Wove at 19½ x 25½ inches and measure five and one-half inches from the long edge and crease the paper using a bone folder. Carefully tear across the score line to make a piece of 19½ x 20 paper. Fold paper in half again and tear at score line. You will now have two 19½ x 10 papers. Fold these papers in thirds to make a total of six 6½ x 10 inch papers for the book. You will need a total of 20 papers. Fold these papers in half and use *Living Hinge Hole Punch Template* to punch holes in the binding edge.

There are many resources for creating living hinges. Obrary is the source for the living hinge used in this project, with ten flexible patterns for free download that can be incorporated into designs. Epilog Laser's (epiloglaser.com) *Sample Club* also has a living hinge sketchbook design for download.

Obrary (obrary.com) living hinge samples (shown here) can be downloaded and incorporated into projects.

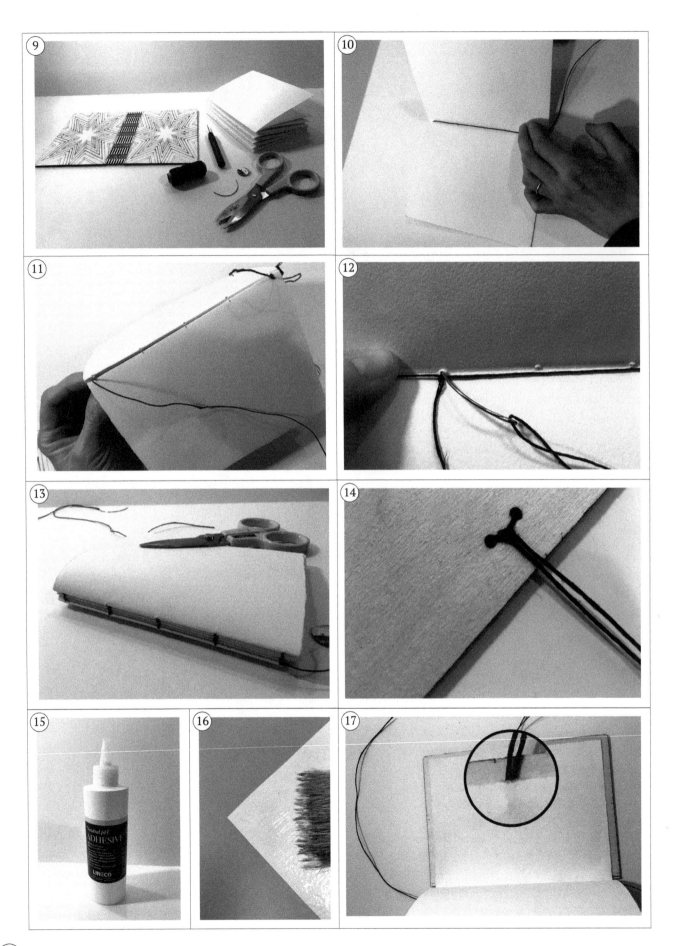

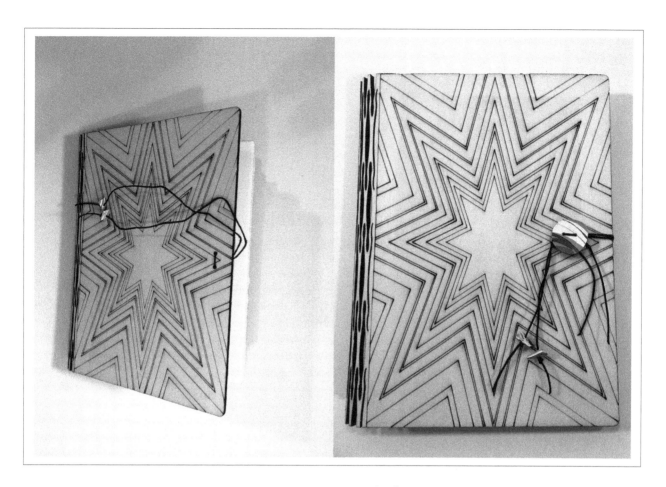

PUT IT ALL TOGETHER

9. Gather the signatures, laser cover, and book binding supplies. Refer to *Upcycled Laser-Engraved Book* for instructions on how to make a Coptic binding. This book also uses a Coptic binding but will not require sewing directly to the covers.

10. Thread a piece of wax thread onto a needle and do not make a knot. Bring thread through the bottom hole on one signature from the binding side. Leave a 4-inch tail. Bring the needle through the opposite hole in the signature. Note: This will result in a single thread running along the inside seam of the signature, across three signature holes. This thread will "capture" the internal binding stitch when sewing on the second signature.

11. Stack a second signature on top of the bottom signature. Come in from the binding side to bring the needle into the first hole of the second signature. Pull thread taut.

12. Move onto the next hole coming out of the binding side. Bring the thread into the bottom signature, looping around the long thread. The thread captures the stitch. Bring the thread back into the top signature and repeat the pattern until you reach the end of the row.

13. Follow the same pattern for Coptic binding as shown in the *Upcycled Laser-Engraved Book*. When you reach the last hole in the last signature, tie off the stitch at the binding.

14. Tie a long thread through the holes on one side of the cover. This will be used for a button closure. This thread can be braided and embellished with beads.

15. You will be using PVA for gluing the book block to the wood cover.

16. Using a soft brush, spread adhesive on one side of the book block, taking special care to reach the corners. Position the paper over the thread and rub paper until it is fully adhered.

17. Let glue dry completely before moving on to the next step. Laser cut a custom button or fashion one out of another material. Sew the button in place.

3D FILAMENT RELIEF DRAWINGS

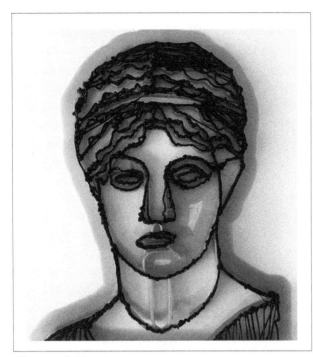

Filament relief drawing

A 3D pen is a handheld tool that melts 3D printer filament. It can be an exciting tool for introducing line quality into a piece of 3D-printed artwork. This project combines a traditional technique in drawing, finding the edge of planes within a form, with 3D-printed technology. The relief form can be built around an original drawing or originate from a photo source. In the end, the work becomes a unique expression, contrasting machine precision with an expressive line.

OVERVIEW

1. Find an image
2. Draw, scan, trace, and scan
3. Turn design into an SVG
4. Turn SVG into an STL
5. Prepare and print STL
6. Draw with 3D pen

MATERIALS AND TOOLS

- 3D printer with PLA filament
- Handheld 3D filament pen (we use the 3Doodler pen)
- ABS filament for 3D pen

FIND AN IMAGE

(1) Find an image that you would like to re-create as a relief drawing. It could be an original drawing or from a photo source. Look for an image that has strong contrast and would be suitable for a contour drawing.

DRAW, SCAN, TRACE, AND SCAN

(2) Print the image in color or grayscale; just make sure there is enough clarity to see the planes within the form so you know where the lines will be drawn. (3) Use a Sharpie marker to trace contour lines on the image. At this point, you can also decide if you want a continuous contour line. Without a continuous line you will need to print a brim or a raft to hold the artwork together on the 3D printer. (4) Turn over the trace, showing the back side of paper and ghost image. Retrace with Sharpie trace showing through. (5) Trace over the entire drawing. Scan the design.

Find an image.

Print.

Trace contour lines.

BRIM AND RAFT IN 3D PRINTING

Two options for 3D print adhesion built into the slicing software can be used with this project.

1. A BRIM (top) is a perimeter of material that prevents warping and can hold thin material in place.
2. A RAFT (bottom) is a platform that rests beneath the print that maximizes surface area for printing.

Each option has settings that can be previewed and adjusted to be incorporated into the design idea.

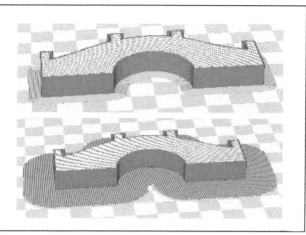

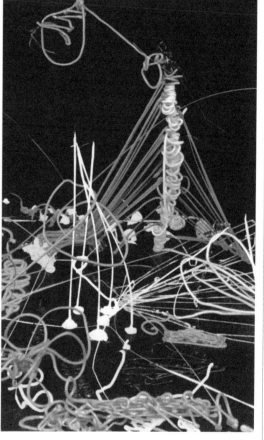

3D PEN TECHNIQUES

Students can experiment with line quality using the 3D pen before moving on to an art piece. Mark making for drawing extends to this medium beautifully. Like a leaky pen dwelling on an area, the 3D pen extrudes and leaves blobs, while quick marks can resemble fibers.

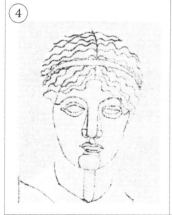

Turn paper over to reveal ghost image.

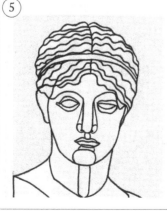

Retrace.

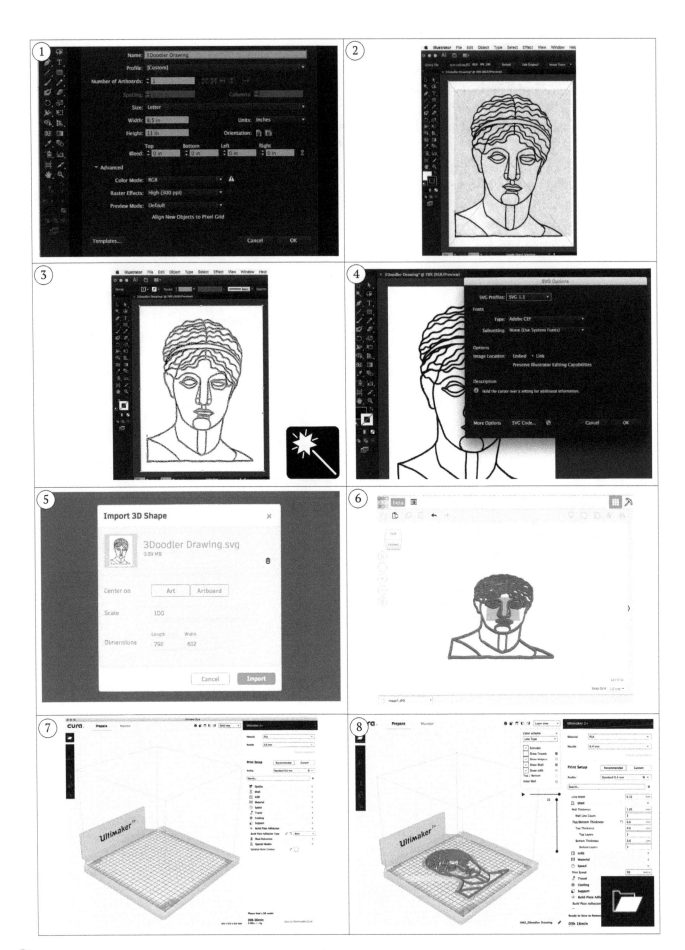

TURN DESIGN INTO AN SVG

1. Open a file in your favorite vector software. Adobe Illustrator is shown here.
2. **File → Place → Embed** (button on tool bar). After embedding the image, the blue diagonal lines will disappear.
3. **Image Trace → Black and White Logo Expand.** This will convert the trace line to paths. Use the magic wand tool to select negative space around the object. Delete. You will notice that the bounding box will disappear but the shape remains.
4. Save as an SVG file.

TURN SVG INTO AN STL

5. Open a new project in Tinkercad and rename the file in the Name field in the upper left corner. Import the SVG file. The image will be previewed in the window. Select Import.
6. An extruded version of flat shape will be imported into Tinkercad. Export the file as an STL.

PREPARE AND PRINT STL

7. Open the preferred slicing software. Ultimaker Cura is shown here.
8. Import the STL file by selecting the file icon in upper-left corner. Rescale as needed. Include a brim to help support the thin material. Depending on design it may not be needed.
9. Export the file as an STL.
10. Print the design in PLA.

DRAW WITH 3D PEN

Load 3D pen with ABS filament. Use the pen to add line work to the relief edge. Additional cross-contour lines can be worked into the surface. The 3D-printed walls can act like infill beneath a 3D-printed surface with the pen line anchoring on edges. Consider incorporating melted elements and a PLA base.

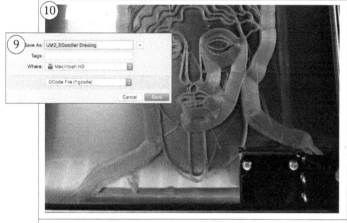

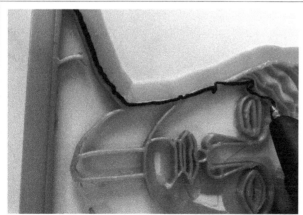

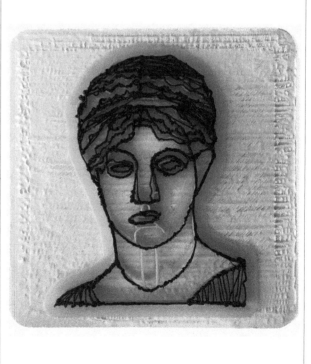

POSITIVE
AND
NEGATIVE SPACE

ETCHED TINS

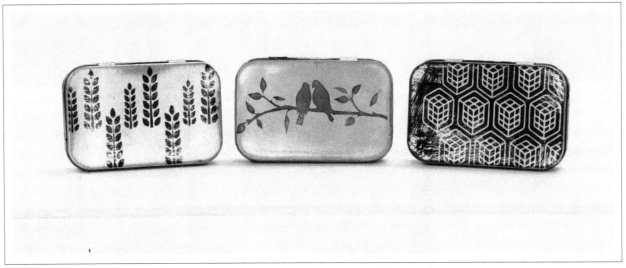

Etched tins created by grade twelve students.

Identifying positive and negative space, and making choices about how to organize the figure-ground relationship is an exercise that promotes the development of spatial skills. The following project utilizes the positive space of a vinyl sticker as a barrier for the chemical process of metal etching.

Small metal containers like mint tins are useful to explore etching. Designing a vinyl sticker stencil offers an opportunity to explore how digital design can be used in the real world. I first learned about the technique of applying current to a salt-water- soaked sponge to speed up oxidation on a metal surface from Casey Shea at the ReMake Education Summit.

Emily Dixon and I built upon this idea for our class. Students etched tins and made 3D puzzles which were custom-designed to fit within the enclosure. See *3D Puzzles* on page 61.

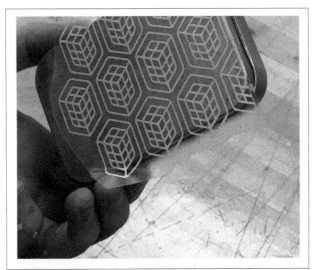

OVERVIEW

1. Design vinyl sticker
2. Etch metal
3. Attach a copper plate
4. Exploring differences in metals

MATERIALS AND TOOLS

- Vinyl cutter, vinyl, and transfer tape
- Mint tin, aluminum, or copper
- 6 V lantern battery
- Salt, sponge bits, alligator clips
- Beeswax block

Students working on drilling holes in the tin.

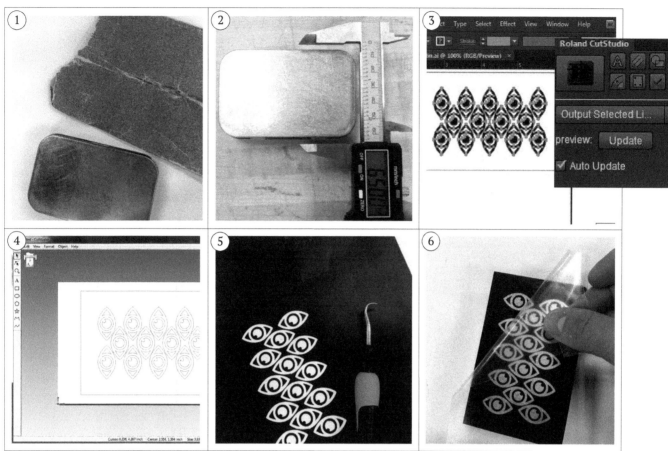

DESIGN VINYL STICKER

1. If you want to etch directly on the tin you will need to lightly sand the surface to remove the coating.
2. Measure the tin with calipers to determine the size of the graphic you will create.
3. Choose a positive and negative space design. This example is from The Noun Project, by artist Amy Schwartz. If the image is in vector form, move on to step 4. If it is a raster image (JPEG, PNG), a detailed description about how to turn a raster design into a vector can be found on page 53.
4. Export the design from Illustrator to your vinyl cutter's software. This shows the process using Roland software and the Roland Cut Pro Extension.
5. Remove the negative space with a weeding tool. Apply contact paper and burnish.
6. Transfer the vinyl to tin and burnish onto the surface leaving the vinyl as a stencil.

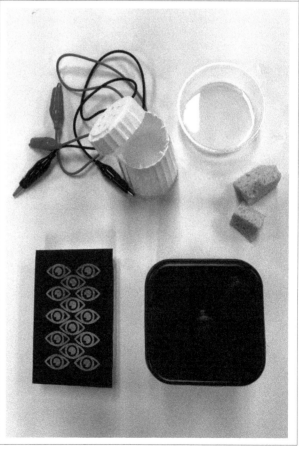

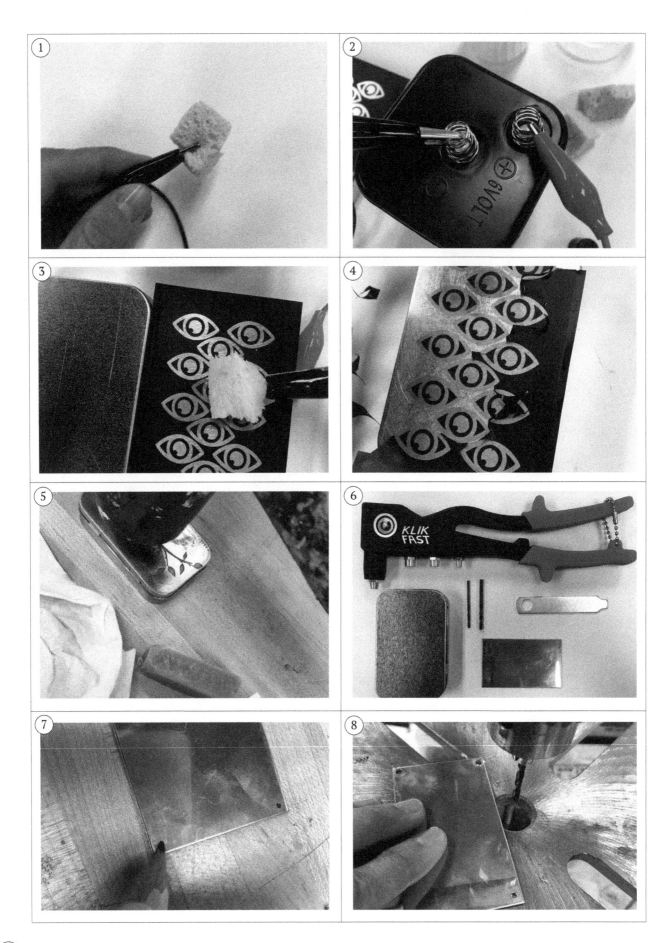

The Art of Digital Fabrication

ETCH METAL

Materials needed for etching include salt, water, alligator clips, sponges, and a 6V lantern battery. ***Review circuit safety with students. Remind students to avoid touching battery terminals and alligator clip ends. Avoid short circuits by not allowing the alligator clip ends to touch during use.***

1. Clip a sponge to the end of an alligator clip. This example uses a black wire, which will hook up to the negative terminal on the battery in the next step. Dip sponge tip in salt-water. Clip a separate wire to the metal you will etch.
2. Hook up the opposite ends of the alligator clips to the positive and negative terminal on the battery to complete the circuit.
3. Dab the sponge to etch the surface of the metal. The vinyl acts as a stencil. Dab surface dry with a towel.
4. Remove vinyl to reveal etched surface.
5. Warm the surface of the tin with a hair dryer and coat with beeswax. This will slow rust.

ATTACH A COPPER PLATE

For a different look, try attaching a copper plate to the tin before the salt-water etching. ***The following steps use a drill press. Review power tool safety with students. Remind students to pull back hair, tuck in loose clothing, and wear eye protection before proceeding.***

6. Materials needed for riveting include rivets, rivet gun, copper plate, tin, one drill bit to match the rivet, and a smaller drill bit to match the pilot hole.
7. Mark the plate where you want to create a rivet hole.
8. Using a drill press pre-drill some pilot holes. Drill a slightly larger hole the size of the rivets.
9. Center plate on tin and mark location of holes with a Sharpie.
10. Repeat step 8 with tin.
11. Load rivet gun with a rivet.
12. Pop a rivet into one corner and work your way around the plate.

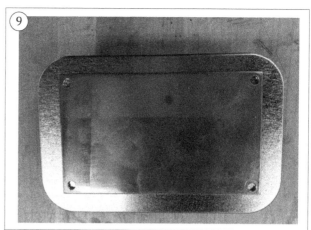

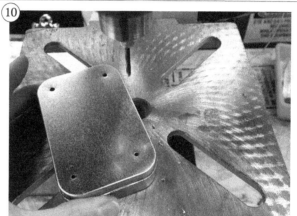

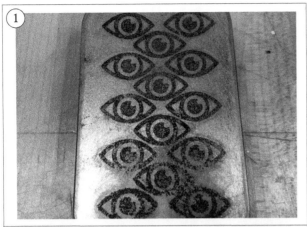

EXPLORING DIFFERENCES IN METALS

1. Corrosion is the result of directly etching on the tin. The rust shows up later, within a day. The longer the sponge is applied to the surface, the more corrosion occurs and as a result, more rust appears. A light layer of beeswax was applied to this tin to seal it and slow down the rusting process.
2. The same process of etching can be used with copper. The etching process dulls the surface of the copper and with enough corrosion, the surface will develop a blue/green patina.
3. Etching contrasts with the shiny copper surface.
4. The unsanded mint tin will not take an etch at all.

3D PUZZLES

3D puzzles are an interesting way to explore shapes in design. In this project, students are challenged to make a two-color puzzle within a mint tin. Because the exact positive and negative space shapes will not fit together if directly printed on the 3D printer—due to printer tolerances—the process involves measuring and offsetting shapes before modeling, slicing, and printing.

For a puzzle to fit properly, the tolerance zones of each part should not intersect. As pieces are added to the puzzle, more play is introduced into the interlocking parts. The tin has a lip, so depth becomes an additional consideration for fit. Each student discovers which offset is most appropriate for their individual design.

Most students make more than one prototype in order to achieve the proper clearance of parts. To test for fit, very thin (1 mm) prototypes are printed before printing the final pieces. This project delves into technical and design learning, while not overworking the 3D printers. The flat format requires no support or plate adhesion and is less likely to cause a bottleneck in the print queue.

Tolerances are affected by many variables: the materials, the environmental conditions, and the machine itself. Mathematics meets the real world as designers contend with shrinkage, warping, surface finish, and room temperature on a given day.

OVERVIEW

1. Prepare the profile shape
2. Prepare puzzle design
3. Create multiple SVGS
4. Create multiple STLS
5. Slice STL files for prototype
6. Make prototype and print final

MATERIALS AND TOOLS

- 3D printer
- Filament
- Calipers

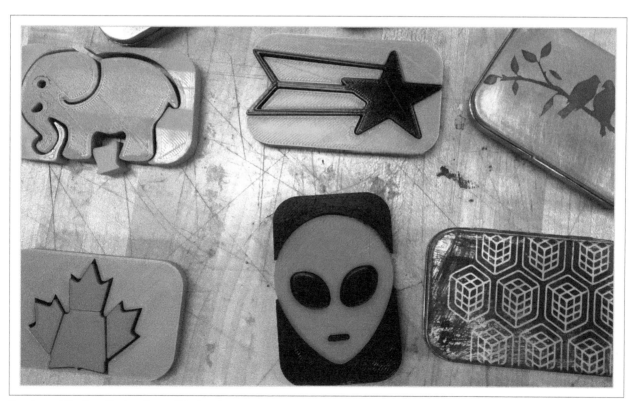

Puzzles and tins from Engineering and Design class.

PREPARE PROFILE SHAPE

In this first step you will be preparing an image in Adobe Illustrator.

1. Trace the bottom profile of tin with a thin marker. Scan as a PDF. Open PDF in Illustrator.
2. Create two layers, and lock the one with the image. You will use this as reference.
3. **Show → Rulers**. Grab guidelines from the ruler and place them along the edges of the tin bottom to trace. If the shape is not square, unlock image layer (with scan) and adjust with the rotate tool.
4. Draw a rounded rectangle just within the boundary of the guidelines. You can adjust the radius of the corners in the rectangle dialog box. If units are not in millimeters, go to **Preferences → Units → General → Millimeters**.

PREPARE PUZZLE DESIGN

5. Find a vector graphic for creating puzzle. The source for this can be a Sharpie drawing or found image that has been image traced, or text that has been converted to outlines. Another possibility is to draw the entire puzzle with the pen

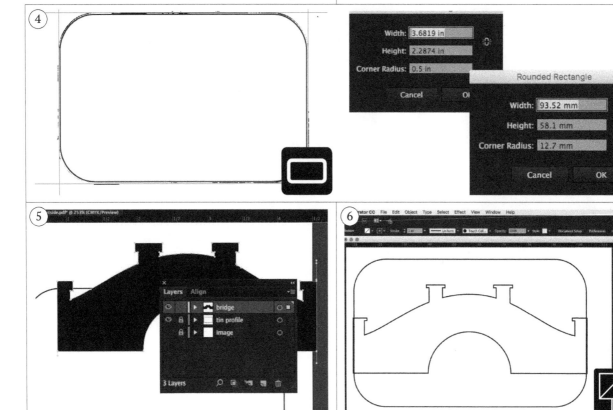

tool. Look for something simple like a black and white image. Open the design shape as a vector graphic in a separate window. Copy and paste. The image pictured here is from The Noun Project by artist Joel Wisneski.

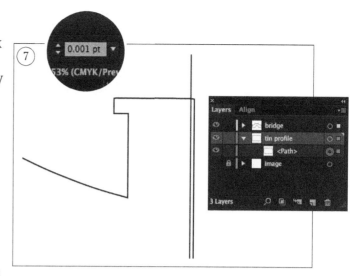

6. Position shape(s) in the frame of the puzzle tin. Set shape to **NO FILL** and black **STROKE** lines. If shape is filled, this can be achieved with the **swap FILL and STROKE** arrow toggle.

7. A slight overlap of border assures pieces will separate at edges. It's easier to identify overlaps with a hairline stroke line (0.001 pt).

8. Select all of the puzzle piece shapes. Locate the **Pathfinders** window. **Pathfinders →
Divide.**

9. The division has produced individual puzzle shapes. Locate these shapes in the **Layers** panel. A colored **FILL** will make shapes stand out.

10. Delete unneeded shapes.

The next step is to determine a width of offset for the first prototype. 3D Hubs (3dhubs.com/knowledge-base) publishes a set of design guidelines for 3D printing, recommending a 0.5 mm spacing between parts. Students use this as a starting point for their first prototype. For each piece, the offset was set to -0.25 mm (on radius). Offsetting the sides by 0.25 mm results in 0.5 mm of clearance where any two pieces touch. This is enough to account for variations like printer tolerances, shrinkage, and distortion. Students can increase or decrease this number for further refinement as they move through prototyping.

11. Select all of the puzzle parts. Set to **NO FILL** and 0.001 point (hairline) stroke.

12. **Object → Path → Offset Path.**

13. Select **Inverse → DELETE.**

14. **Window → Info**. Note width and height of puzzle shapes. This measurement should be exactly 0.5 mm smaller than the one noted in step 4, due to the offset in step twelve.

CREATE MULTIPLE SVGS

15. Separate and color code shapes to help differentiate layers. Make sure shapes have **NO STROKE.** Confirm that there is no width to this outline for accurate measurement.

16. Temporarily delete all layers except your first color shape. Using artboard tool, click shape to create an artboard flush with the edges of the shape. Delete first artboard. Export first color shape as an SVG. Undo deletions. Follow the same procedure for your second color shape.

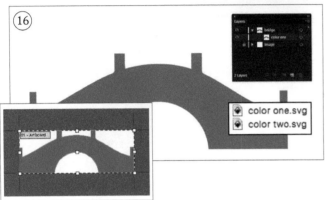

CREATE MULTIPLE STLS

17. Open a new workspace in Tinkercad and import the first SVG file. Return to step 14, noting the dimensions of the puzzle. In this example, the horizontal measurement matches the width measurement. Key in the width measurement, and press the import button. Repeat these steps for the other shapes in the puzzle.

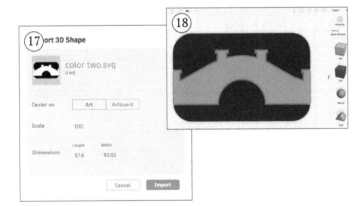

18. The shapes should now be to scale and nested in Tinkercad. Select the first color set to export as an STL for 3D printing. Repeat the process for other color sets in the puzzle.

SLICE STL FILES FOR PROTOTYPE

19. Open your slicing software. Ultimaker Cura is shown here. Since the prototype is a flat, extruded shape, it will not need supports or build plate adhesion.

20. Click on the scale button on the left tool bar. Unselect **Uniform Scaling**. Key in Z height. For prototyping use 1 mm.

21. Export as a G-code file onto an SD card. (Note: Second color shape shown here. You will have to do this process with both positive and negative shapes as separate files.)

MAKE PROTOTYPE AND PRINT FINAL

22. Load SD card into 3D printer. Select Print from file menu and print. Print both colors.

23. Print each set of colors as thins and test the fit. If more space is needed between shapes, revisit step 11 and create a larger offset line.

24. Determine the height of the final print using calipers to measure tin depth.

25. Input that measurement into Cura.

26. Print final.

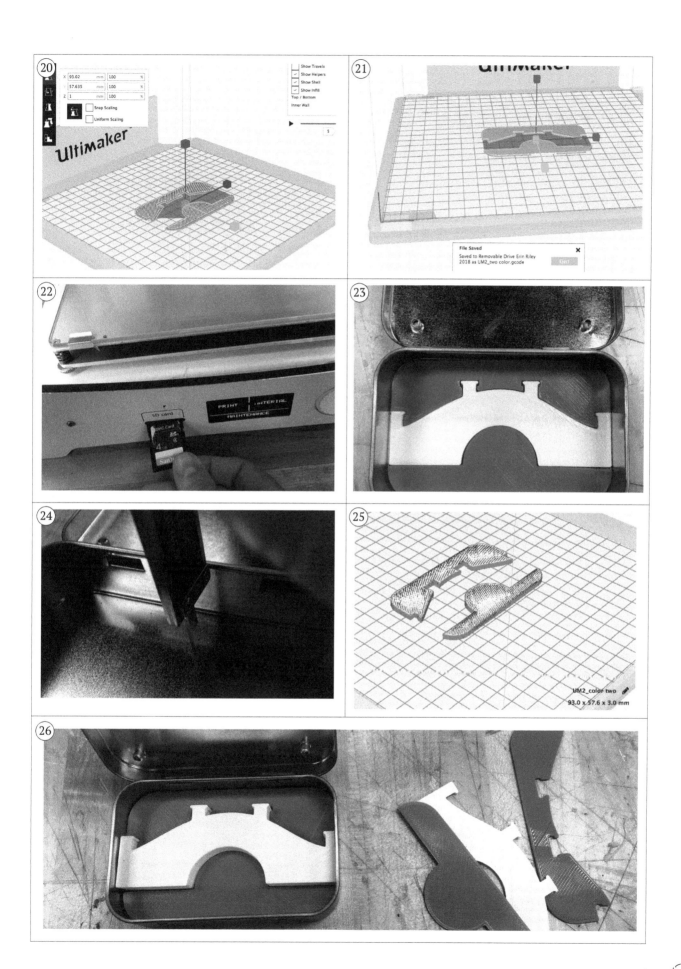

PATTERNING

Pattern enables us to perceive the underlying structure in a composition. Pattern surrounds us in our natural and built environment and is aesthetically pleasing.

Patterns can be built inside of graphics software or designed using code that generates graphics. A shape or design, as a singular unit, can be reproduced through translation or rotation. Geometric shapes lend themselves well to this approach. The process of starting with a simple shape—and repeating it—builds complexity into a design. Patterning a shape in the horizontal and vertical directions fills the page and patterning a shape around a pole creates a radial design. The visual repetition creates a unified pattern as shapes echo adjoining shapes.

TurtleArt is a graphical Logo coding environment and our go-to program for building geometric shapes. TurtleArt uses a relative cursor on a Cartsian grid canvas that traces a line to create a design. Like mapping, students can imagine themselves in the space which makes it an excellent beginner coding environment. Turtle designs are converted to vector graphics and 3D printed, cut on the laser cutter, or cut on the vinyl cutter.

I highly recommend Josh Burker's work with TurtleArt in his book *The Invent to Learn Guide to Fun* with resources for getting students started with creating designs. The *TurtleArt Tiles* project in the book has a tutorial on patterning using nesting loops to fill the screen with repeating shapes.

MAKE A RADIAL DESIGN WITH TURTLEART

Contact TurtleArt (turtleart.org) to inquire about receiving a copy of the free TurtleArt application. Download and install the program on your computer. Build designs by pulling blocks of code onto the blue work canvas and snapping them in place. Run code by clicking the Turtle with the magic wand tool. Reset by clicking the eraser tool. To practice making a basic radial design try the following example.

1. Make the turtle move **[forward 100]** units and turn **[right 90]** degrees.
2. Repeat this procedure four times.
3. You will notice in the stack of blocks that there are four repeating pairs.
4. In the **FLOW** tab look for the repeat block. Simplify the code by putting the unit **[forward 100, right 90]** into a loop that **[repeats 4]** times.
5. In the **MY BLOCKS** tab look for the diamond shaped custom block and place it at the top of your stack of blocks. Name this block **[square]** and you now have created a new element that you can use in the program.
6. Make another shape (circle shown here). Connect this shape to the block.
7. Turn the turtle by some degree. This example **[left 60]** reorients the turtle to face left.
8. Determine how many rotations you will need for a full circle to make a radial design. This design used 60 degrees and will need six rotations to complete a 360 degree circle. Put this number into a **REPEAT** loop.

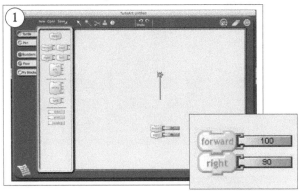

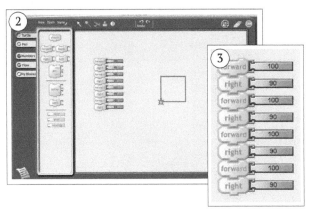

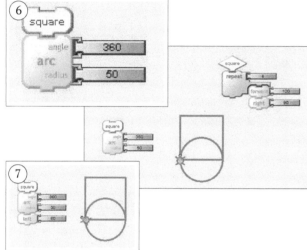

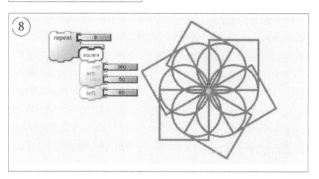

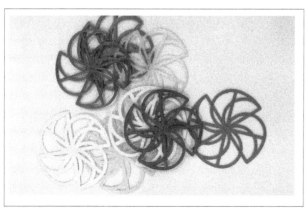

3D-printed TurtleArt pinwheel designs.

MAKE A PARAMETRIC PATTERN FROM A TURTLEART DESIGN

Patternodes 2 is a downloadable app (lostminds.com/patternodes2) that creates programmable, repeating patterns of any graphic. A parametric design, meaning a design based on variables (also called parameters) is adjustable and can be redesigned just by changing the variables. The graphical interface includes sliders for making small adjustments to the parameters the user sets for the design. The multiple iterations of the design can be previewed before exporting.

In this example, a TurtleArt pinwheel was used as the basis for a parametric pattern, and the final designs were exported as an SVG, imported into 3D modeling software, and 3D printed as pattern sheets.

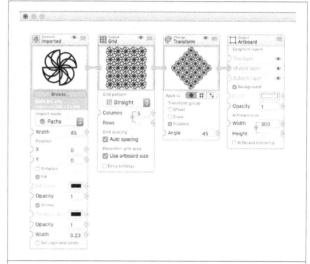

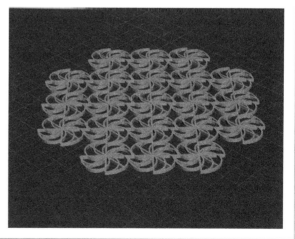

(top) Patternnodes 2 software transforming a radial design into a repeat-pattern vector graphic; (bottom) repeat-pattern image as a 3D extruded form.

Patterning (67)

CONVERT A TURTLEART DESIGN INTO A FABRICATION-READY FILE

The online TurtleArt converter (playfulinvention.com/taconverter/v2) turns a PNG image from TurtleArt into an image, hairline, or outline SVG vector graphic. These vectors can be directly output to a laser cutter. Note: Start your TurtleArt stack with a "Clean" block when using TurtleArt Converter.

Files generated from the TurtleArt converter were fabricated on the laser cutter: (top) an image example shows the outcome of a raster engraving; (bottom left) the hairline example shows the outcome of a score line; (bottom right) the outline example shows the outcome of a cut line.

SILKSCREEN CLAY

Vinyl cut stencils provide a non-toxic method for making silkscreen masks. In this project, students create a shape that forms into a radial design through the use of repeated patterns in TurtleArt. A detailed description about how to make a radial design is described in the *Patterning* project on page 67. After cutting the stencil of the design with the vinyl cutter and preparing a screen, the pattern is silk screened directly onto moist, leather-hard clay slabs. Having "open time" while the clay is still wet is a painterly process. Images can be built up, wiped away with a sponge, and layered.

OVERVIEW

1. Make a vinyl sticker
2. Prepare screen and stencil
3. Prepare clay
4. Silk screen

MATERIALS AND TOOLS

- Vinyl cutter (directions refer to a Roland brand cutter, but other vinyl cutters use a similar process)
- Vinyl and transfer tape
- Silk screen silk
- Weeding tool
- Clay, clay tools, roller, and canvas
- Glaze and foam brush
- Kiln (if using kiln-fired clay)

MAKE A VINYL STICKER

1. Prepare a black and white vector graphic.
2. If you are using a Roland-brand vinyl cutter, load the machine with material. Load from the back with vinyl side up. Clip far left and right corners under rollers and under gray bars. Calibrate with piece, roll, or edge, depending on the vinyl you are using. After the machine takes a measurement, hold down the origin button to set the origin point.
3. Open the vector graphic in Illustrator. Set up file by making a bounding box for easy weeding. Copy/paste if you want multiples. Locate Roland Cut Studio Extension. Click on large gray button to export the design to Roland Cut Studio. In the software, go

Grade nine student's radial design created with TurtleArt on clay.

to **File → Cutting Setup → Properties → Get from Machine → OK**. This will get the vinyl measurement from the machine.
4. **File → Cutting → OK** cuts the material. Release the lock to remove the material. Leave a little room around the design as you cut it out.

PREPARE SCREEN AND STENCIL

5. Gather sticker, transfer film, weeding tool, and scissors.
6. Weed sticker. Apply transfer tape and burnish the surface to assure good contact. Gather supplies for the screen: silk, vinyl scraps, and the vinyl sticker.

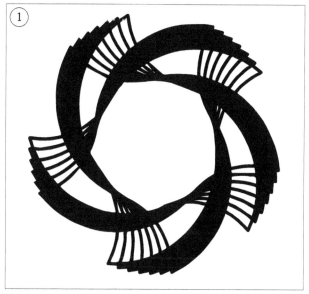

Grade nine student's radial design created with TurtleArt.

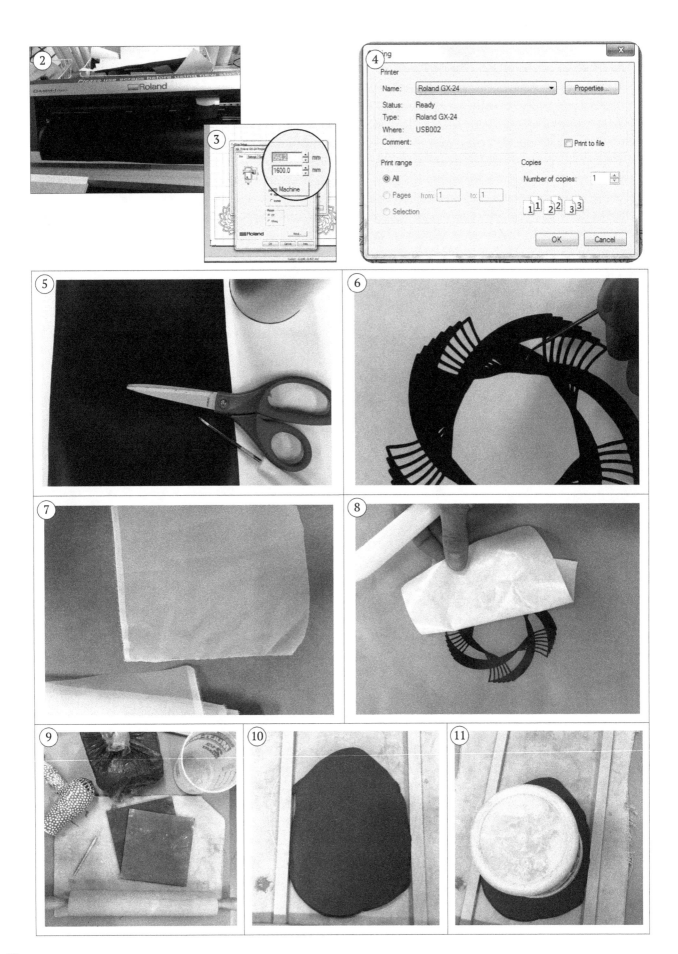

7. Cut a square of silk that is larger than the clay you will be using. With flat side of silk facing the table, center and adhere the vinyl sticker to the silk.
8. Burnish the surface with a bone folder or the back of scissors. Remove transfer tape.

PREPARE CLAY

9. Gather supplies: raw canvas, MDF, rolling rails, rolling pin, and clay. Drape raw canvas onto MDF. Get a grapefruit-sized ball of clay.
10. Press the clay into the canvas, flattening it, and roll it out until the roller comes into contact with the rails.
11. Cut desired shape out of the clay with a stencil. Flip clay on new piece of canvas. Run roller over clay one final time and trim with stencil. Drape with plastic and set aside for one day while clay becomes leather hard. You can also speed up drying with a hairdryer.

SILK SCREEN

12. You will need leather-hard clay, screens, cardboard, and glaze.
13. Drape the screen design gently on the face of the clay. Look to confirm the placement through the translucent silk. Pull glaze across the stencil with a piece of cardboard or a foam brush. Dry with the hairdryer between layers. Wash silk for multiple silk screen sessions.
14. Glaze on leather-hard clay.
15. Fire clay. If using underglaze and you want a glossy finish, cover fired underglaze with a clear glaze and refire.

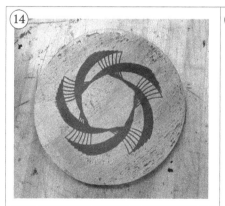

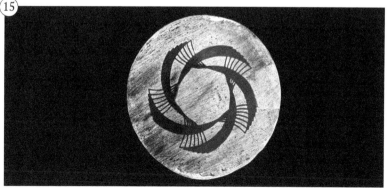

Grade nine student's process from design to fired clay disk.

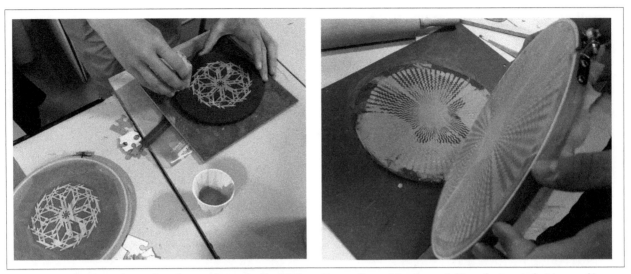

The two examples pictured are using a hoop with stretch silk with the pattern as the positive shape: (left) grade nine student is reworking clay; (right) grade nine student printing over "marbled" clay. Marbled clay can be made by wedging white and red clay scraps together.

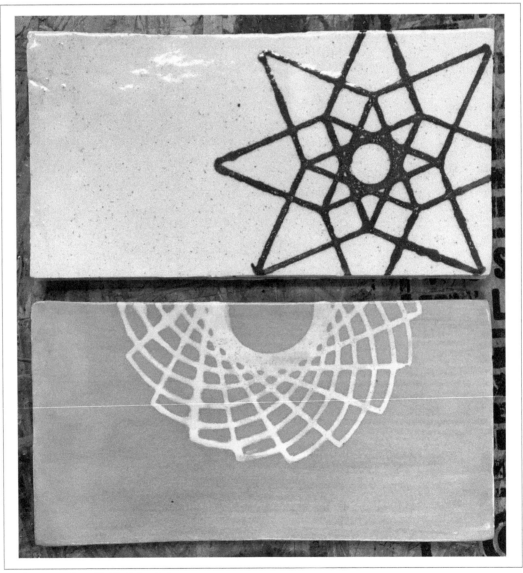

Grade nine students' finished clay designs.

POP-UP DRAWINGS

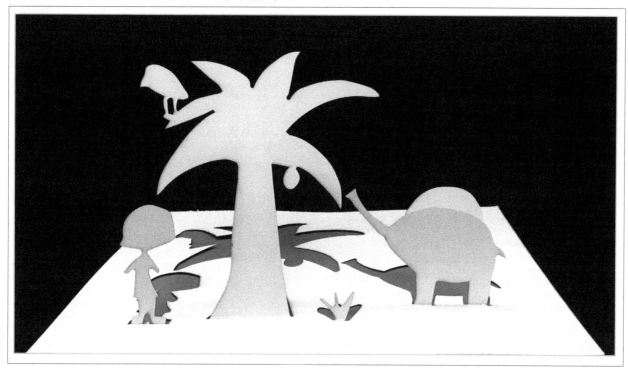

Grade one student's pop-up.

Foundational concepts like moving from 2D to 3D can be introduced to students in early grades, preparing them for increasing challenges as their skills and interests grow. This project was designed by Zoe Hedstrom, lower and middle school art teacher. Simple line drawings are brought to life through digital fabrication.

The outline of a two-dimensional drawing is made three dimensional, using the laser cutter to make a simple profile of a shape. Students are asked to build a composition with continuous lines and shapes off the "ground" plane. The edges of each shape create terminating points that after laser cutting fold into a pop-up, and the resulting negative space creates a shadow shape.

OVERVIEW

1. Turn a drawing into a vector
2. Turn a 2D idea into a 3D form

MATERIALS AND TOOLS

- Laser cutter
- Railroad board or thick paper, one for positive shape, one contrasting paper for negative shape.
- Sharpie marker
- Glue dots

TURN DRAWING INTO A VECTOR

1. Make a Sharpie drawing. All lines start and stop at the edges of the "ground." Scan drawing as a high-resolution photo. Turn drawing into a vector graphic using Image Trace. **Image Trace → Black and White Logo → Expand** will convert trace line to paths. Use the magic wand to select negative space around object. **DELETE.** You will notice that the bounding box will disappear while the shape remains.
2. Take the following steps to make sure graphic is laser cutter ready: (1) size the artboard to the size of the material, (2) set **FILL** to **NO FILL**, and (3) set line to RGB (0,0,0) black. Set line weight to 0.001 pt. (hairline).

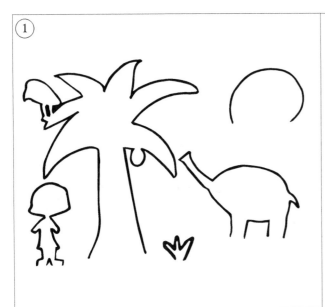

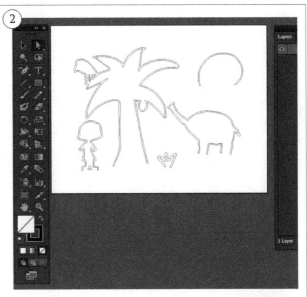

TURN 2D IDEA INTO A 3D FORM

3. Send your design to the laser cutter. The Sharpie line outline is cut and a very thin shape can be removed from your railroad board.
4. Score edge lines with butter knife or bone folder along a straight edge. Fold along the score line to create a pop-up.
5. Displaying against a dark ground creates contrast and implies a shadow shape on the ground plane. The railroad board can be secured in place with glue dots.

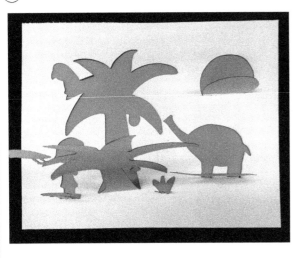

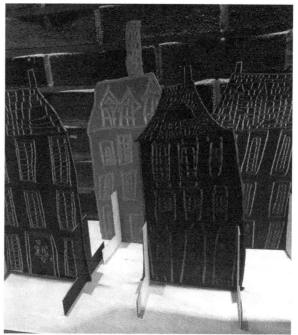

Zoe Hedstrom's second-grade students made townhouse sculptures on the laser cutter; (bottom right) a second-grade drawing for rastering on the laser cutter.

TOWNHOUSES

Zoe Hedstrom built upon the 2D-to-3D idea introduced in first grade with her second-grade artists. They made townhouses as part of a unit on buildings. Students were able to see their drawings as raster etchings. Once students are in middle school they will start to use digital media to design for digital fabrication, moving from hand-drawn designs to digitally composed designs. These early visits to the lab help introduce them to the possibilities these tools offer.

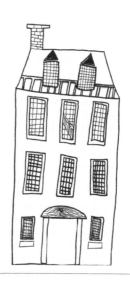

PET STICKER

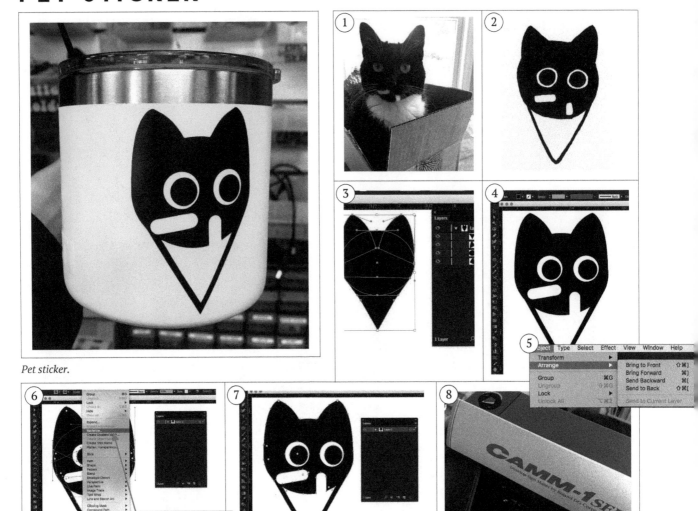

Pet sticker.

Use Adobe Illustrator, or your favorite vector software, to design a pet sticker. Start the design by building up shapes as vectors. Once the design is complete, consolidate all the vector shapes by converting the design into a raster graphic as a solid black and white shape. The final steps are to retrace the graphic and cut the vinyl.

STEPS

1. Find a picture of your pet that can be turned into a simple graphic.
2. Sketch the idea using a black pen. Limit the design to black and white shapes and outlines.
3. Identify the basic shapes in the sketch. Start drawing the main shapes in Illustrator using black FILL.
4. Add detail shapes over the top of design using white FILL. Another way to build shapes is by (1) using contrasting FILL and STROKE lines and (2) adjusting the stroke line to create a wide outline that will read as a shape and cut well on the vinyl cutter.
5. Shapes can be brought to the front or pushed to the back by selecting Object → Arrange.
6. When you are finished with the design, rasterize your image by selecting Object → Rasterize.
7. Do an IMAGE TRACE. Delete negative space.
8. Save file. Cut sticker.

3D FORMS

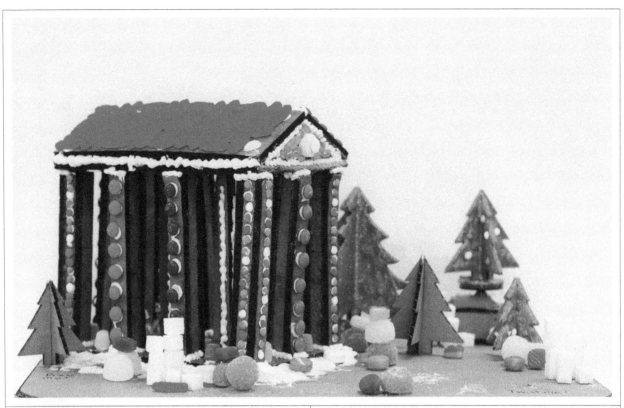

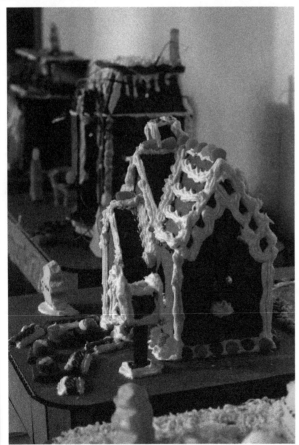

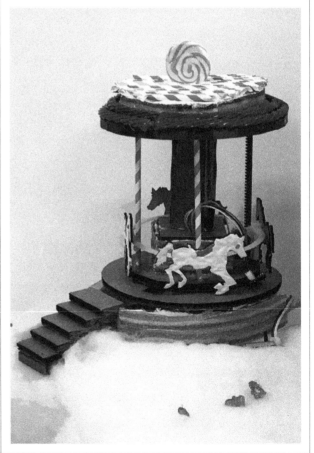

(top) Interactive holiday Parthenon; (bottom) row of gingerbread houses with Arduino-driven components; gingerbread carousel with micro:bit, bit:booster and linear servo actuator.

INTERACTIVE GINGERBREAD

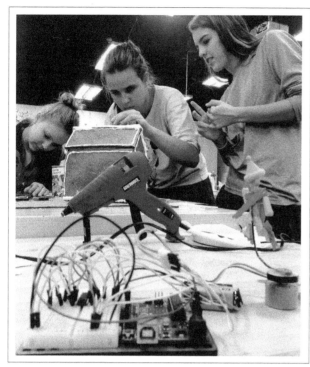

Students working on integrating electronics into gingerbread house

This project was designed for a high school engineering and design class. They were sorted into teams and asked to create a festive, interactive project built out of gingerbread and controlled with a microcontroller. The inspiration originated from two sources: (1) a description of an interactive gingerbread house project by Gary Stager and (2) learning about gingerbread cutting on the laser cutter at AS220 in Rhode Island. The aim of this project was to bring together a team of students to design, build, and program microcontrollers while creating an artistic, interactive, holiday-themed construction.

This is an ideal beginning design project moving from a 2D to a 3D design. Gingerbread is forgiving. Many mistakes can be masked with icing, and the shapes do not require joinery. The following is an outline for the project.

GUIDELINES FOR PROJECT

* Design team: three to four members
* Members of each team will take on different/multiple roles in the process.
* Each team is required to (1) design circuits around sensor triggers, (2) program circuits with a microcontroller, (3) prototype physical structure out of cardboard, (4) laser cut gingerbread, and (5) bring the entire piece together in an integrated way.

ROLES

Coordinator – Oversees the project and makes sure all of the parts come together. Leads the documentation effort.

Designer – The designer is responsible for realizing the 3D idea in gingerbread:
* *Research designs*
* *Draw an architectural plan with dimensions*
* *Make an optimized 2D file in Illustrator*
* *Create a cardboard prototype*
* *Cut entire file on one sheet of gingerbread*

Programmer – The programmer is responsible for working on coding the microcontrollers to make the interactive elements in the installation.

Builder – The builder works with the programmers and designers to:
* *Build circuits*
* *Integrate electronics into physical structure*

MATERIALS AND TOOLS

* Laser cutter
* Cardboard
* Craft materials
* Gingerbread
* Royal icing and candy
* Microcontrollers (Arduino, micro:bit with bit:booster, MakerBit)
* Small motors, including LEGO motors
* Sensors (temperature, light, sound, motion, etc.; Grove sensors work well with the bit:booster add-on board)
* Electronic components (LEDs, buzzers, switches, etc.)
* Breadboards, batteries, wires
* Linear servo actuators. These can be 3D printed for an inexpensive mechanism that introduces linear motion into creations. Links to Potent Printables files on Thingiverse can be found in Notes.

ARCHITECTURAL DRAWING PLAN

Teams get together to brainstorm ideas for structure. The designers create an architectural drawing plan with three points of view—two side elevations and top view. These plans are detailed including dimensions and notes.

OPTIMIZE 2D DESIGN FILE

Students create an optimized file that is sized for a 16 x 24 inch pan of gingerbread. Since each team only gets one piece of material, they will want to maximize what they can make. An optimized file not only saves on material but it acts as a creative design constraint.

CARDBOARD PROTOTYPE

Students prototype their design in cardboard, making any adjustments to their file.

CUT GINGERBREAD

Once the file is been finalized, students move on to the gingerbread. They can design in layers, introducing score and raster elements into the design. Scoring is very effective on the gingerbread surface and provides more

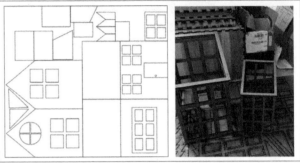

(top) Architectural drawing plan for gingerbread build; (bottom left) optimized file ready for the laser cutter; (bottom right) cardboard prototypes.

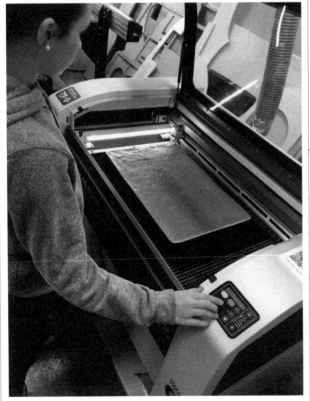

(bottom left) Grade twelve student cutting gingerbread on laser cutter; (top right) circuits labeled and mapped out for Rockefeller Center ice rink; (bottom right) high school student preparing to solder LEDs for gingerbread house lighting effects.

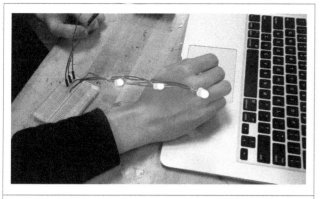

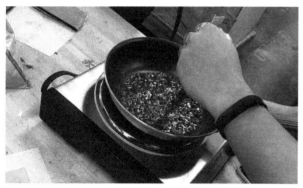

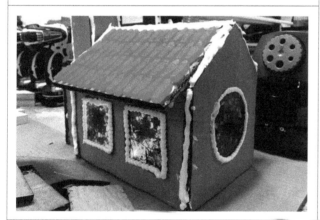

contrast. The best gingerbread is fresh, making it easy to separate pieces that haven't been cut through with an X-ACTO knife.

INTERACTIVITY

Each creation has multiple outputs that can be triggered by the viewer. Students build circuits with lights, piezo speakers, motors, or even LCD screens. Interactive elements can be triggered with switches, buttons, or sensors such as motion detector sensors.

FINAL BUILDING

All the pieces come together in a final build. The microcontroller is hidden under a cardboard base and the electronics are powered with a battery. Students embellish the houses with royal icing, candy, and craft materials. Snowy landscapes can be fashioned with the creative use of materials like branches and directional spray paint.

Students display their interactive gingerbread houses in the final two days before school breaks for the winter.

TRADITIONS

Several projects have become traditions in our engineering and design lab. *Interactive Gingerbread* is one of them. While we primarily create new project prompts and challenges in our lab, some projects have become yearly events. Each year, students raise the bar, driven by excitement around seasonal materials, candy construction, and competition with peers.

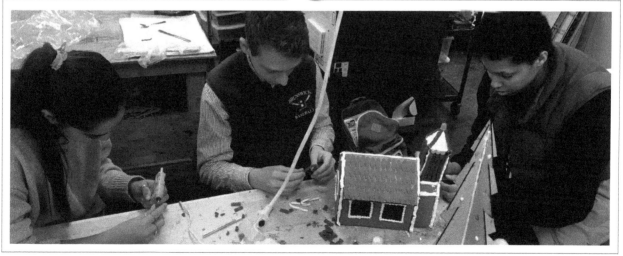

(top to bottom) Programming LED gumdrops using a micro:bit and bit:booster; melting rock candy for windows; candy windows illuminated with a NeoPixel ring, students building and programming, preparing final display in lunchroom.

3D-PRINTED STACKS

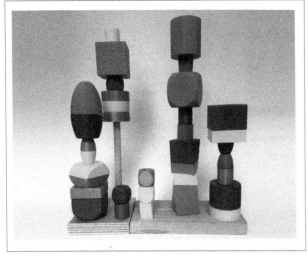

Additive technology gives sculptors the power to explore form with precision and imagine 3D forms that in some cases would be challenging to create with subtractive approaches.

This project offers the immediacy of 3D modeling and fabrication, with the addition of a post-print design step to play with and envision more complex forms. The design process is in stages: makers design a group of 3D shapes as modular units, related but individual, then the same 3D shapes are rescaled, providing a collection of forms in two sizes to explore repetition and unity. Through different stacking configurations, a variety of shape and color combinations emerge.

OVERVIEW

1. Model 3D shapes
2. Build a base
3. 3D print
4. Put it all together

MODEL 3D SHAPES

The 3D shapes for this project could be created with a variety of software. Tinkercad is a great choice for students starting out with 3D modeling. Students can create complex forms by combining and subtracting simple forms. The same can be achieved in OpenSCAD, a code-based 3D modeling program that can be set up to make parametric designs. Parametric design allows students to create even more elegant and complex shapes using control variables.

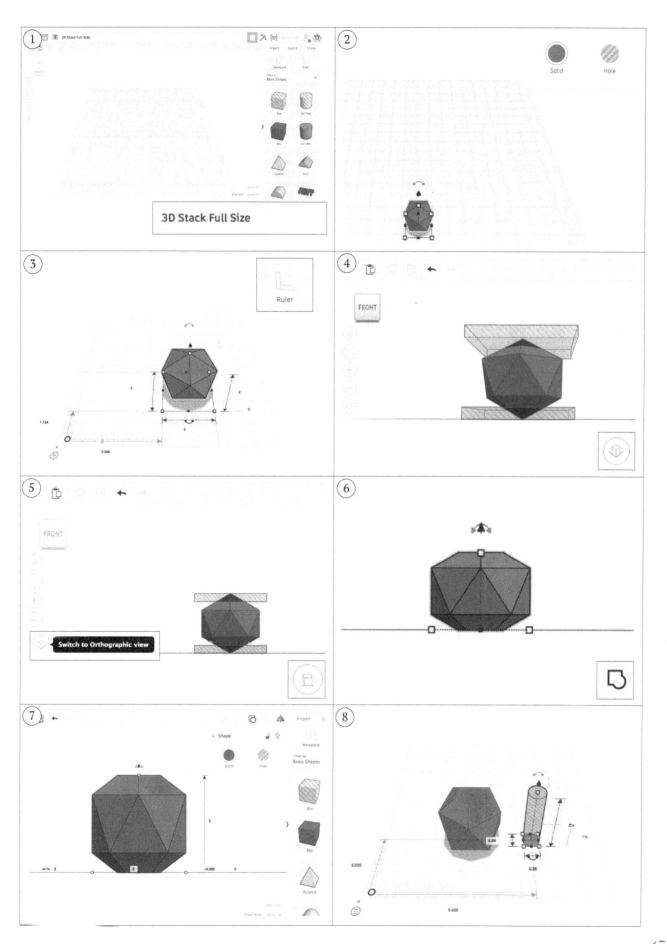

DESIGN 3D SHAPES IN TINKERCAD

1. Open a new project in Tinkercad. Rename the file in the name field in the upper-left corner.
2. Start the design by introducing a 3D shape onto the workplane. As you design, consider the "YHT rule" (See Notes) for support-free printing. Printing at an angle reduces the need for supports.
3. Drag a ruler onto the workplane and rescale the shape to full size. Shapes roughly 2 inches W x L x H work well for this project.
4. Add and subtract shapes using solid and hole forms and grouping. In this example, two rectangular prism holes are positioned at the top and bottom of the shape.
5. An orthographic view from the side gives an accurate view of the shape profile.
6. Select and group objects. Reposition the shape so it lays flat on workplane.
7. Continue modeling through the process of adding, subtracting, and resizing the shape.
8. After designing the final shape, drag a cylinder hole onto the workplane. Size it to the dowel. The dowels used in this example are 0.5 inches. Allow extra room to account for the thickness of the 3D print filament.
9. Align and group the shape and hole.
10. Continue making shapes. You can make as many shapes as fit on the printer platform. Printing multiple objects at once saves time.

PROGRAM 3D SHAPES IN OPENSCAD

1. Go to OpenSCAD (openscad.org) to download software. **File → New →** the user interface window will open. To start out, create a basic shape by typing code in the editor window. Shown here is a 50.8 x 50.8 x 50.8 mm or 2 x 2 x 2 inch cube. With **center = true**, the cube is located in the center of the X, Y, Z axes. **PREVIEW** (F5) compiles the design. It should now appear in the viewer window.
2. We want to create a cylindrical hole with plenty of clearance for the dowel. The dowels we are using are 0.5 inches. To account for tolerances and any post-print surface treatments, the hole is sized to 0.55 inches or 13.97 mm. The hole is created by using the boolean operation, **DIFFERENCE ()**. Difference allows us to subtract the cylinder from the cube.
3. You can use this simple cube to make a more complex shape by adding another cube rotated 45 degrees on the z-axis. The two cubes are merged using the Boolean operation **UNION ()**.
4. **PREVIEW, RENDER** the 3D model (F6). Click the **STL** button, the far-right icon in the editor window, to export design for 3D printing. Print the 3D design.

The power of OpenSCAD and other parametric design programs is that a multitude of shapes can be designed by making simple changes in control variables and code elements. The following steps set up your code for parametric design.

5. **Variables l, w, h** (length, width, height) are assigned the value 50.8 mm. The diameter of the dowel hole is assigned a value of 13.97 mm. Create a **vector** "dimension" with a list of the variables in square brackets **[l, w , h]**. Now you can use the name, **dimension,** as a shortcut in your code. When scaling, you want to keep the size of center hole constant to fit the dowel. The variable **diam** is used to do this. 10 mm has been added to the **height** parameter of the cylinder to ensure the hole is cleared during scaling.
6. In step 3, the shape was rotated 45 degrees once. In this example, a **for loop**—which

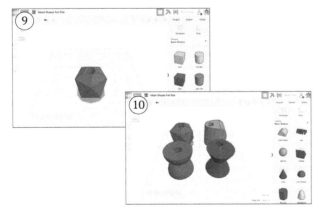

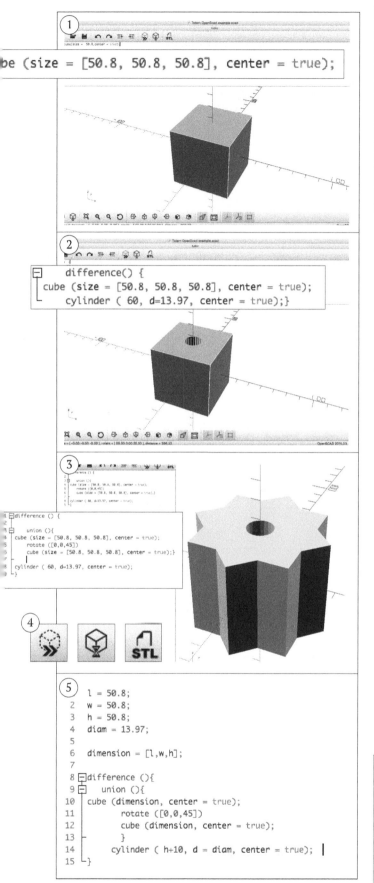

OPENSCAD NOTES

The user interface has three parts:

1. The viewer window – this is where you view rendered parts as you build
2. The console – view warnings
3. The editor – where you write the code

An OpenSCAD user manual is found online with a handy "cheat sheet" for the OpenSCAD language.

runs the code in the loop a specified number of times—**rotates** the shape nine times (the range, [0:8]) at 10 degrees. The four sides at 90 degrees complete the 360-degree rotation. The values that define the **dimension vector** were changed as well, creating a different shape that can be easily scaled.

7. To make the design parametric so the proportions stay constant while scaling, redefine width (w) and height (h) as dependent variables of length (l). Now every time the length is scaled, height and width rescale proportionally.

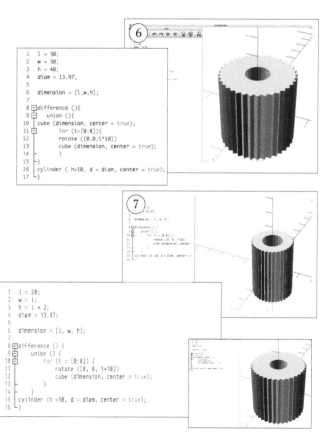

BUILD A BASE

OVERVIEW

1. Collect materials and tools
2. Sand edges smooth
3. Load smallest drill bit in press for pilot hole
4. Match drill bit with marks on wood
5. Continue to drill working up in drill bit size
6. The final hole is ½ inch to fit the dowel rods
7. Stack pieces on dowel

MATERIALS AND TOOLS

- Drill or drill press
- Several drill bits in increments, smallest for the pilot hole and the largest ½ inch
- Sandpaper and wood block
- ½ inch dowel

PUT IT ALL TOGETHER

With a mixture of 3D-shape blocks and colors to choose from, the post-print design step allows the artist to compose complex shapes and color combinations before settling on a final design.

The final step in this process is to gather 3D-printed shape blocks, base, and support dowel, or dowels, depending on how many sculptures will be constructed. Try different configurations. When the final design is stacked, if there is a dowel sticking out of the top, use a pencil to mark the dowel and saw off the extra wood with a dovetail saw.

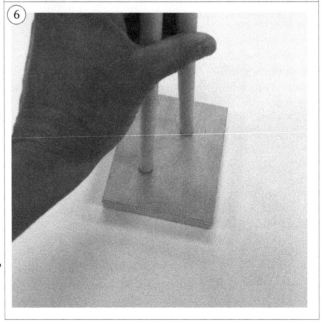

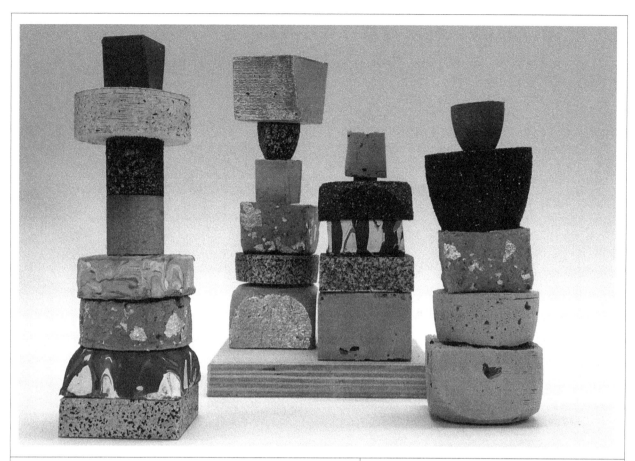

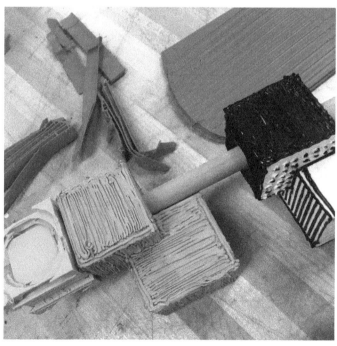

Variations on 3D-Printed Stacks *projects*

Students in the art elective 3D Design for Fabrication used 3D-printed shapes as base forms for sculpture. They created molds, cast forms with a variety of materials, and finished them with a variety of surface treatments. For more ideas on casting materials for 3D printing check out the Casting and Forming, on page 132. (from top, clockwise) 3D-printed stacks as a variety of cast objects; "failed" prints spray-painted to be integrated back into the art piece; student used a 3D pen to add surface texture to stacked pieces.

3D MODELING AND MATH

Math is everywhere in art. It is foundational to image and space building. Artists use math to build compositions, patterns, or structurally solid 3D constructions. When considering how to unlock the power of making what you can imagine, design and digital fabrication provide a pathway for bringing ideas into the physical world. It also connects our visualizations to the powerful math built into our design software. We are able to see and work in a 3D design space where we can measure, align, mirror, and program forms. Digital design integrates all the letters of STEAM that school tends to artificially separate.

We have the added benefit of revision when working with digital design tools. Files and programs, modifiable as digital designs, bring our ideas back to a mental space where we are reimagining form and possibilities. Control/Command C, V, Z, as well as Versions 1, 2, 3, are stamps, erasures, and digital sketches expressed through our keyboards and mouse and built on a screen. The principles of iterative design are cross-disciplinary and cross-curricular, providing a powerful model for students to apply to all learning.

The three projects that follow showcase the different ways that 3D modeling connects to math, and how variations in the project guidelines and constraints can transform these projects to serve different educational objectives and audiences.

PROJECT: THREE-PROFILE MODEL

In this project, high school students were challenged to create a 3D model using only the profiles from three points of view. The profiles—two side elevations and top view, corresponding to the xy, yz, and zx planes—were extruded and used to carve positive and negative space from a rectangular prism defining the boundaries of the form.

Grade eleven student's three-profile model.

BIG IDEAS

- **Cartesian geometry** – mental rotation and the XYZ coordinate planes
- **Extrusion** – Defining outside boundaries of form in 3D from three 2D shapes
- **Boolean operations** (AND, OR, NOT or AND NOT) – building shapes and forms with positive and negative space

MATH CONNECTIONS

Gridding systems are an important math understanding and can be introduced in lower grades through 2D design. The *TurtleArt Patterning* section explores these ideas. The Cartesian grid is especially useful for patterning and the polar grid for radial designs. The resulting file a student generates in this project is output as a 2D design and imported into Tinkercad where it can be extruded into a 3D shape.

In 2D design software like Adobe Illustrator we use shape modes to teach students how to build compound shapes. The Shape Builder and Pathfinder tools are Boolean operations for 2D design, meaning that the shapes can be added, subtracted, and intersected with precision. Another approach to building compound shapes using positive and negative space— but without Boolean operations—is through ordering layers. Shapes are brought to the front or pushed to the back by arranging how they are stacked. (See *Pet Sticker* project on page 76 for an example of this process.) When the desired design is achieved, the design is rasterized, traced, and converted to a vector graphic.

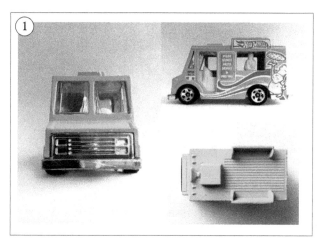

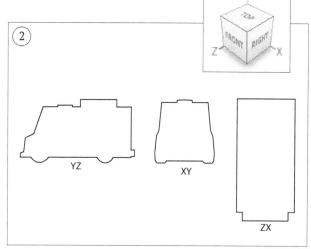

Cartesian geometry

In this project, (1) an object was photographed from three points of view. (2) The image was traced with the pen tool in Adobe Illustrator—each view corresponds to an XYZ coordinate plane.

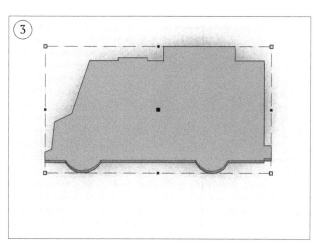

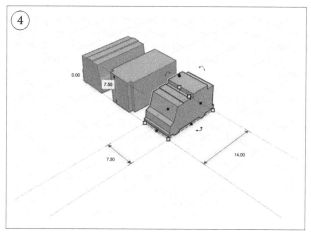

Extrusion

(3) The 2D profiles were brought into Tinkercad; outside boundary measurements were defined by the appropriate coordinate measurement after gathering these numbers. (4) Each extrusion measurement was set to the same XYZ; each extrusion was set to the same orientation on the XYZ coordinate plane; each shape is then turned into a "hole".

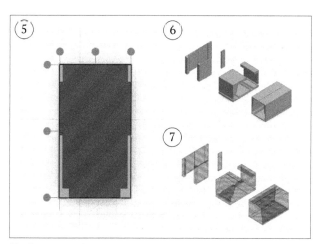

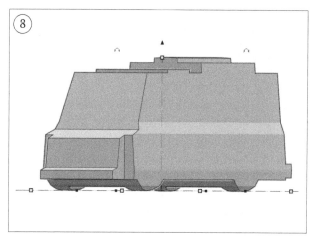

Boolean operations

A rectangular prism is set to the XYZ measurement from above and copied three times. (5-6) Each prism is aligned with an extrusion "hole" and "grouped" to hollow out negative space. (7) Each hollowed-out extrusion is turned into a "hole." (7) These three "holes" are aligned together. (8) A new rectangular prism is set to the XYZ measurement and grouped with the holes to create a three-profile model.

PROJECT: GENERATIVE ART

Sean Justice, in his work in education exploring the materiality of digital materials, describes computational art making as "an approach to new media that connects studio materials with digital form through a serendipity mindset."

In this project, students apply the idea of serendipity to their work by programming variability into their code that generates 3D forms. Using the software application Beetle Blocks, they create custom code blocks containing a set of instructions for drawing a particular 3D shape. They replace specific numbers with variables, thus changing the geometry of the form. As students pass different numbers to the code block, new, unique artwork is generated.

BIG IDEAS

- **Functions** – a unit of code that performs a task
- **Parameter** – holds data that gets passed into the program and can be changed for a different result
- **Serendipity** – finding value in interesting but unexpected outcomes

MATH CONNECTIONS

Students can start thinking about functions, or reusable blocks of code, outside of coding environments. Grouping objects in 2D design is a form of digital stamping or a way to keep objects together to use as a unit when creating something with multiple, repeating parts that make a unique whole. This can be a good on-ramp for the introduction of a 2D-graphic application like TurtleArt, which has the ability to make custom blocks within the coding environment.

The *Design with Rules* project on page 40 is an example of a project that uses variation in the interpretation of a rule set. The variance—specifically the unique interpretation by the individuals participating in the activity—becomes a set of flexible parameters that affects the outcome of the design. For students grappling with the idea of variables in algebra, this can be a real-world application of this abstract concept. As students gain more experience with programming, they can explore systems and algorithms that include random elements. The serendipity of seeing these unpredictable variations often leads to new ideas.

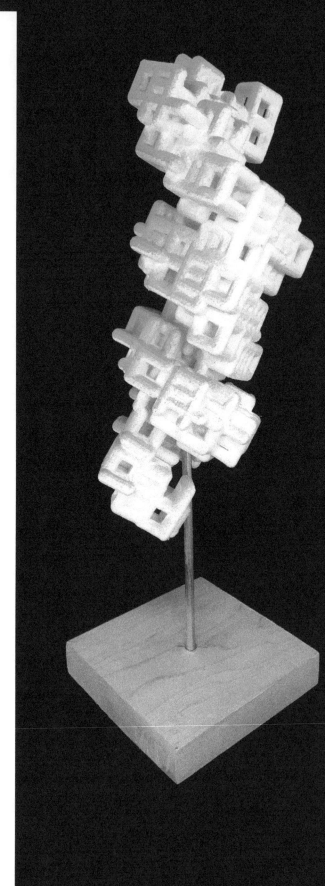

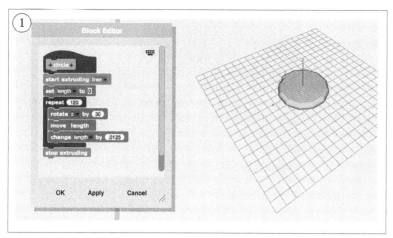

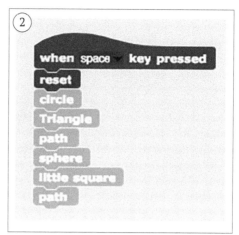

Functions

In this project, (1) students created blocks of code, or functions, that create specific forms that could be reused in the program; printing viability was taken into consideration (see YHT rule) for each shape that was created. (2) Several functions stacked in a sequence.

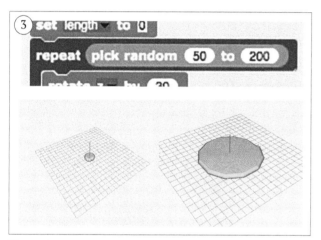

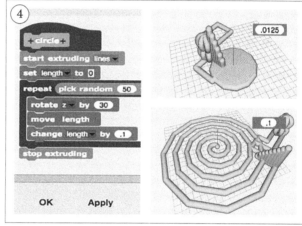

Parameters

(3) Places were identified within the code block where random number ranges could be defined or variables could be substituted for numbers. (4) Variables nested within loops enabled the incrementation of values, thus changing scale, shape, and form.

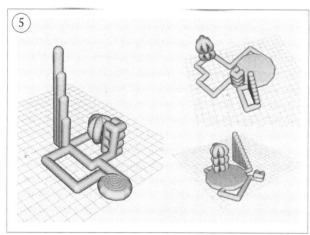

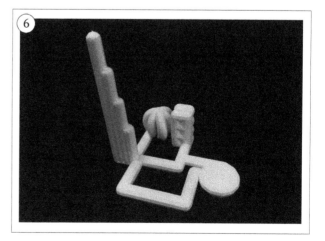

Serendipity

(5) Multiple shapes were generated with different numbers assigned to the variables. This produced unique pieces with each run of the program. With each test, students evaluated the work and determined which pieces to print based on aesthetics and printability. (6) Final piece was printed on the 3D printer.

PROJECT: CAPSULE CHALLENGE

This challenge was designed for a high school engineering and design class as an introductory 3D modeling exercise. Students are tasked with creating an object that fits neatly inside a capsule. This is an extremely flexible project and a good example of how different challenge levels can be crafted by adjusting the project constraints and guidelines. The guidelines for this project were designed to introduce students to several engineering, mathematical, design, and 3D printing concepts with minimal lecture. This project also serves to move students from the accessible, but simple, Tinkercad design software to Fusion 360, which is required for precise engineering design.

GUIDELINES/CONSTRAINTS FOR PROJECT

Design an object that fits inside a capsule: While the inside object can be anything the student wants, it must fit into their capsule. The object can be designed with the easy-to-use Tinkercad design software, yet this guideline requires that the students do more than just drag shapes with the mouse. It requires planning, math, and probably several iterations of the design. It rarely works the first time, and that's a good thing.

Design a capsule that can be closed with screws: The precision needed for the screw fittings and hardware joinery requires the use of Fusion 360 and shows students the necessity for using more professional design software and mathematics.

Design a capsule that prints efficiently, requires minimal support structures, and requires minimal cleanup: 3D printing has standardized rules for efficient printing, like the YHT rule (see Notes). Learning these rules helps students design objects that are more likely to realize their design visions and print without errors.

Note: Some of these constraints and guidelines are more ambiguous than others. These can be tuned as you introduce the project to different groups of students over time. Ambiguous, or "ill-structured" problems serve several

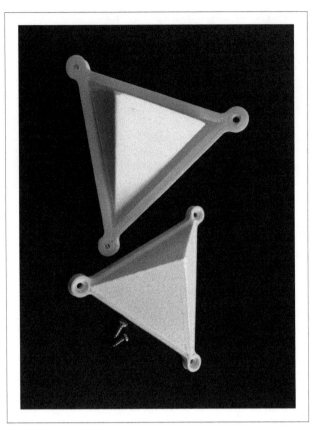

Pyramid-shaped capsule form with smaller pyramid nested within.

functions for student learning. Students ask more questions, like "What does efficient mean?" and engage in more conversation about the project, resulting in ownership and the development of higher-order thinking skills. Resist the temptation to answer all their questions or tell them exactly what to do.

BIG IDEAS

- **Positive and negative 3D space** – defining positive and negative space boundaries of form and designing within those boundaries
- **Fits and tolerances** – understanding how variations in machines, materials, and environmental conditions affect how parts fit together, and adjusting for these variables to get the desired result
- **Printability** – taking into account the limitations of the fabrication machine and designing for optimal results

Printability

In this project a form was cut in half and hollowed to create two sides for a capsule. (1) The orientation of the cube on the left would not be suitable as a hollow form for 3D printing without supports; the unsupported, horizontal plane would result in a messy print. (2) The cube pictured here would be suitable without support because the slope angle is 45 degrees and provides support from the filament it builds upon, with each layer. (3) The form pictured here adheres to the "YHT rule" but does not have much surface area on the workplane; this print would need a raft for 3D printing to help with adhesion.

Positive and negative 3D space

(4) Shape is created in Tinkercad, cut in half, and sent to Fusion 360. (5) Negative space is removed by creating a shell; the measurement of shell thickness is noted as it will be important to calculate the negative space for the design object, which will fit inside the capsule.

Fits and tolerances

(6) The next steps create the 2D shapes for the seam profile, bosses, screw holes, and counter bore holes. This design uses McMaster-Carr screws, part number 90065A047. The bosses are 6 mm in diameter, counter sink 4 mm, and pilot holes are 2 mm. These measurements take into account the clearance for the screw head and channel for tapping the screw. (7) Work your way around your design, and select all of the shapes that will make up the profile that will be extruded; extrude profile to make seam. (8) Select countersink area and extrude negative space.

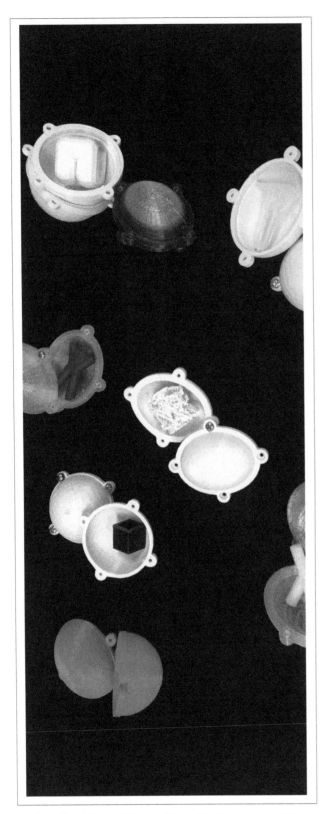

Student ellipsoid-capsule forms with smaller forms nested within.

USING CONSTRAINTS: CAPSULE CHALLENGE VARIATIONS BY LEVEL

Bringing ideas into the physical world brings with it the constraints from the real world. Digital fabrication tests that with machine instructions and viable tool paths. In art, design, and engineering there are times when the intention or function of the design imposes an additional layer of real-world constraints.

Changing project constraints can make the *Capsule Challenge* project simple enough for students as young as third grade, or complex enough for high school engineering classes. At the simplest level, you can ask students to design a 3D object that fits into an existing box or capsule. The real-world constraint of the enclosure asks students to think hard about measurement and scaling, which may be something of an abstraction in math class.

Josh Ajima (designmaketeach.com) created a "3D Gumball Gallery," filling capsules with small-scale 3D prints highlighting several prominent 3D printing artists and designers. These store-bought capsules and the gumball machines that dispense them are available for purchase in online stores. Josh's students have used these machines to fundraise, and future galleries will feature student work. This is an example of a design constraint for students to consider when scaling a piece to fit within a confined space.

As students advance in 3D design and fabrication, they can explore the math in the design process, the actual machine output, and variables that affect printing tolerances. Students could calculate and test filament diameter to create nesting shapes. Nesting close-fitting shapes requires offsetting instead of scaling as offset changes geometry, while scale creates the exact same shape at a different size. This level of detail requires knowledge of your unique machine and testing of the three kinds of engineering fits (clearance, location/transition, and interference).

Fits and tolerances

(9) View of countersinks. (10) Export your design as an STL file. (11) Slice and print.

Positive and negative 3D space

To fit the design object within the capsule, use the original capsule form from Tinkercad. (12) The object was roughly sized to the size of the capsule along with a rectangular prism "hole." (13) Design object, capsule, and rectangular prism "hole" are aligned and centered to determine the sizing. If the object extends beyond the outer boundary of the capsule, it can be either resized or trimmed.

Positive and negative 3D space

To trim, turn the capsule into a "hole" and the rectangular prism into a solid. Group the shapes; this creates the negative space of the capsule. (14) Turn negative space into a hole and center the design object; "group" to create a trimmed design object. (15) For clearance fit between the object and capsule body, you will need 0.5 mm space between the forms (a total of 1 mm when you account for both sides); reduce the size of your design object by 1 mm in each dimension.

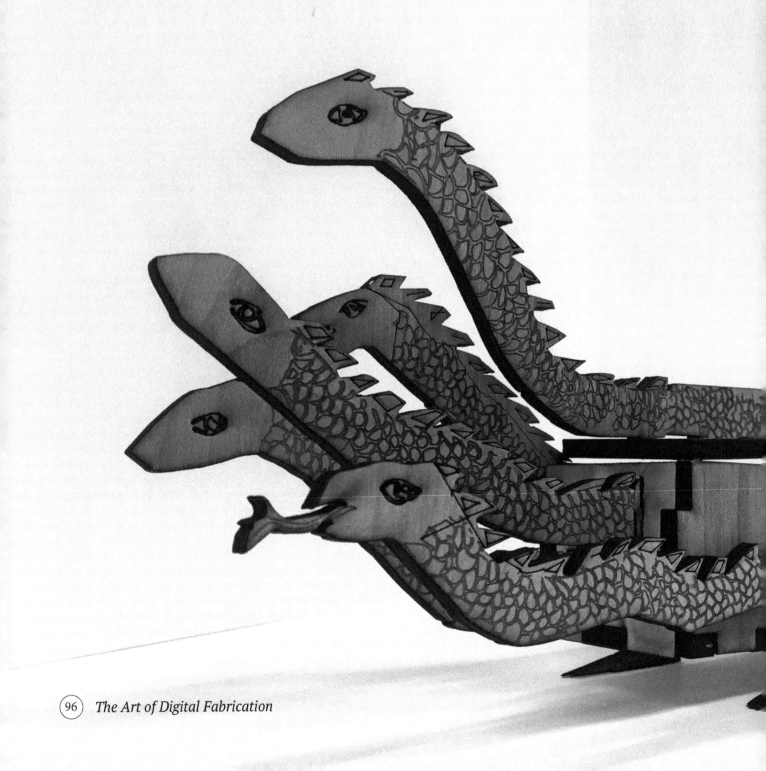

ANIMAL BOX

One of my favorite fablab projects is Brogan Miller's *Omni-Animals* from the Transformative Learning Technologies Lab at Stanford University. It beautifully integrates a range of learning with vector graphics and laser-cutting techniques. These animal boxes, inspired by the *Omni-Animals* project, explore 2D-to-3D learning in the creation of a functional object.

Students are challenged to explore the relationship between the box and the animal, and consider ways they would like to merge the two ideas. They use the following set of guidelines.

- Design a 3D animal or object
- Include box in design
- Must contain three kinds of joints or hinges
- Must include three laser processes (cut, score, raster)
- File must be optimized

Students go through a prototyping process using cardboard, a flexible, inexpensive, and easy-to-manipulate material before moving onto wood. They start with a cardboard version of their box created with the BoxMaker application. They work through their design ideas as drawings, figuring out the raster, score, and cut elements. Then they turn their designs into vector graphics and add the joints. The final step is to cut their files on the laser cutter and assemble.

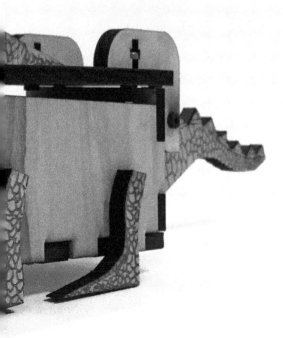

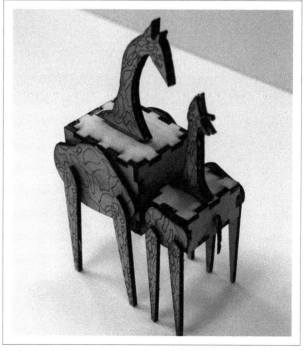

High school students' wooden animal boxes.

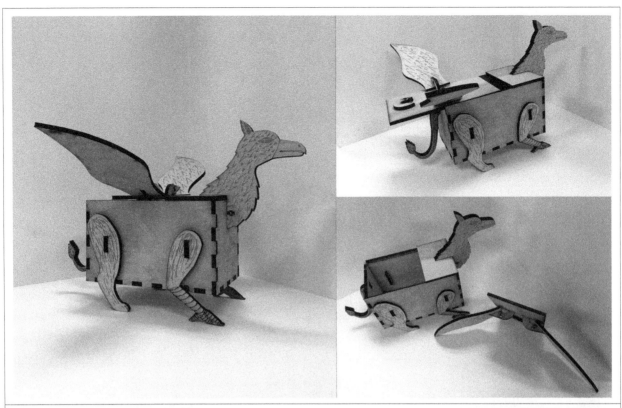

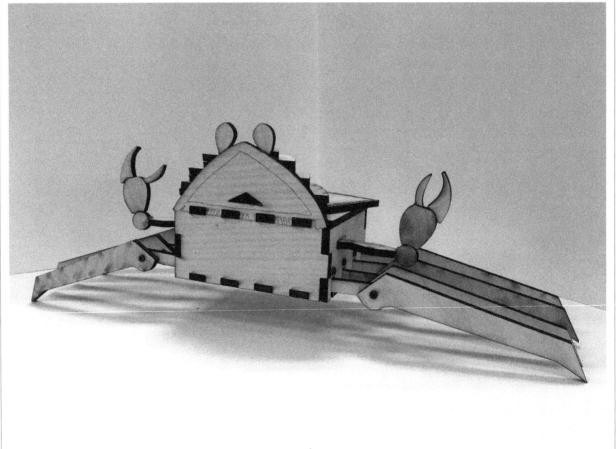

High school students' wooden animal boxes.

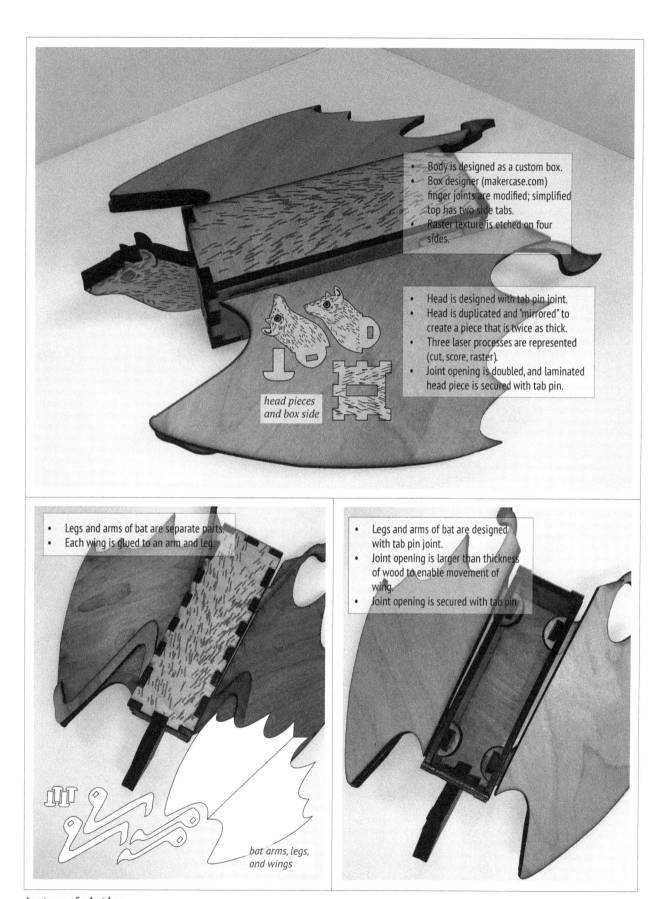

- Body is designed as a custom box.
- Box designer (makercase.com) finger joints are modified; simplified top has two side tabs.
- Raster texture is etched on four sides.

- Head is designed with tab pin joint.
- Head is duplicated and "mirrored" to create a piece that is twice as thick.
- Three laser processes are represented (cut, score, raster).
- Joint opening is doubled, and laminated head piece is secured with tab pin.

head pieces and box side

- Legs and arms of bat are separate parts.
- Each wing is glued to an arm and leg.

bat arms, legs, and wings

- Legs and arms of bat are designed with tab pin joint.
- Joint opening is larger than thickness of wood to enable movement of wing.
- Joint opening is secured with tab pin.

Anatomy of a bat box

An example of an animal box with a description of the parts and construction according to guidelines for the project. Joinery examples on page 157 were used to get students started with designs.

BREAK OUT OF THE BOX

The laser cutter and CNC are great tools for making boxes. Boxes can be made in all shapes and sizes, serving a variety of purposes. Beyond its usefulness as a container, the possibilities with a simple box are endless. A box can be used as a form in sculpture, a housing for electronics, or as a surface for display.

For a simple laser-cut box, there are several websites like MakerCase (makercase.com) that can generate files and allow you to customize box size, material thickness, and joint type.

This section highlights a variety of ways students can use a basic box form in their projects.

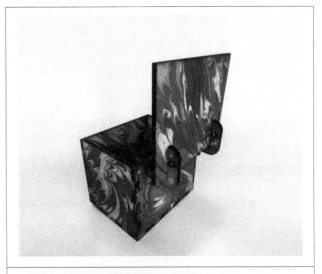

OVERVIEW

Box as container
Marble box
Mixed materials box
Game and puzzle box

Box for housing electronics
Synthesizer

Box for sculpture
Modern Middle East integrated project
Kinetic box

Box for display
Possibility box

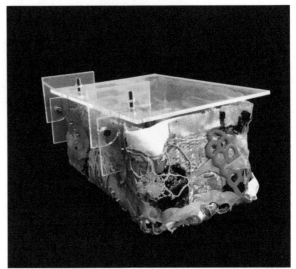

MARBLE BOX

With its absorbent surface, plywood is a great material for marbling, mixing a traditional art process with digital fabrication and softening the look of machine-made parts. Marbled wood also works well with the engraving process on the laser cutter. We use ¼ inch plywood, as it is less likely to warp, and both sides can absorb the wet media.

Marbling is a process that everyone loves. We made marble boxes in the eighth-grade art elective Imagine, Design, Build. We fill enamel trays with carrageenan solution and float Higgins drawing ink on the surface. DIY rakes are made with cardboard and bamboo skewers hot-glued into the corrugated edge.

We started the first marbling session with laser-cut blanks, and the students took several classes to complete the surface treatment.

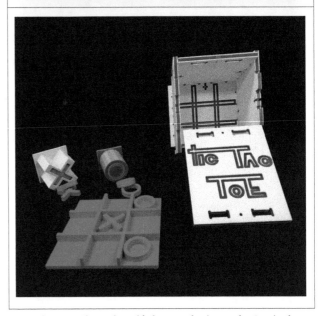

(top to bottom) Plywood marble box; grade nine student's mixed materials box—melted PLA with laser-cut hinges and top; grade twelve student's tic-tac-toe game—3D-printed pieces and board, ColorCore HDPE box.

Allowing the surface to dry between classes, or drying with a hair dryer, allows for double-sided marbling, remarbling, and additional stacking of texture and color effects. The behavior of the ink is somewhat unpredictable, and wonderful results emerge from this process at the intersection of science and art.

MIXED MATERIALS BOX

Students are encouraged to experiment and explore material mash-ups. It is an opportunity to find creative solutions for attachments and requires making adjustments to joinery to account for differences in thickness of material.

GAMES AND PUZZLE BOX

Creating boxes for holding loose parts for puzzles, game boards, and game pieces is a personal and practical way to explore design. The challenge can extend beyond the "holding of things." Students can explore how parts nest and stack within an enclosure.

SYNTHESIZER

Students who are using electronics and microcontrollers in the digital fabrication lab often make boxes as enclosures. The Engineering and Design class makes Atari Punk Synthesizers as one of their electronics projects. As an introduction to vector graphics and designing for the laser cutter, students customize six sides of a box that snap into corners with dowels. They are given the following set of guidelines for their synthesizer enclosure:

- Must have holes cut for the potentiometer and switch within the boundaries of the hardware
- Must have holes cut for a speaker
- Must include a raster graphic
- File must be optimized

After fabricating and assembling the enclosure, the final step is creating 3D-printed press fit knobs for the potentiometers.

INTEGRATED ART PROJECTS

We often use boxes as a form in sculpture. This was the case with the final project for a Modern Middle East humanities elective. Charged with expressing themes in visual form, they were

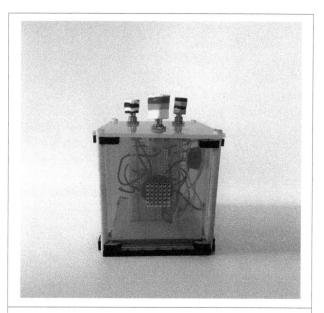
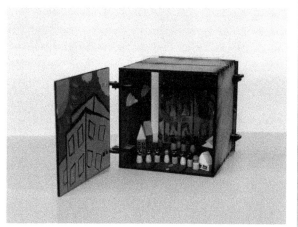
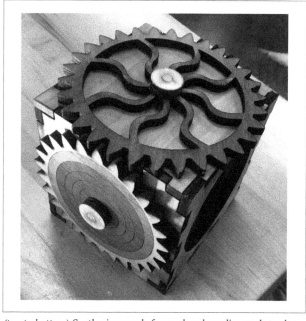

(top to bottom) Synthesizer made from colored acrylic; grade twelve student's 3D English project; grade eleven student's kinetic box.

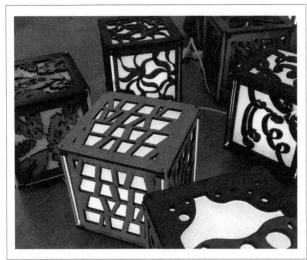

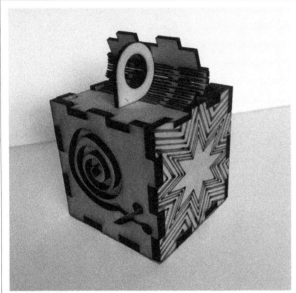

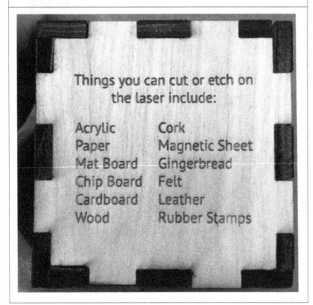

Things you can cut or etch on
the laser include:

Acrylic Cork
Paper Magnetic Sheet
Mat Board Gingerbread
Chip Board Felt
Cardboard Leather
Wood Rubber Stamps

*(top to bottom) Laser-cut lamps from grade nine art class;
possibility box; bottom of possibility box.*

free to use the materials and machines in the lab over the course of two weeks. Some of the processes they explored to create their box-based work included (1) laser engraving and cutting, (2) making vinyl sitckers as decals and/or stencils, and (3) integrating arts-and-craft materials.

KINETIC BOX

Another favorite making project is automata and kinetic sculpture inspired by the collection of automata resources and artwork from the The Caberet Mechanical Theatre and The Tinkering Studio. Using a box-making application, students create cardboard prototypes using the laser cutter before designing in other materials for the laser cutter. Cardboard is close to the thickness of the plywood we use in the lab, making the testing process directly transferable through recycled material to final construction. Students experiment with cardboard as a material using the *Cardboard Technique Inventory* on page 145. We use a gear template generator (woodgears.ca) and have a collection of sample cams for students to test and hold in place with binder clips.

LIGHT CHAMBERS

Illuminating boxes opens up exciting possibilities for art students. Taking advantage of the laser cutter's precision detail cutting, designs using positive and negative space patterning make stunning lamp shades and light chambers. Treating the surface of the wood like a canvas, students paint and enhance the surface with art materials like watercolor and art markers.

We use chandelier-style LED bulbs because they maintain a low temperature.

POSSIBILITY BOX

This project showcases all possible digital fabrication techniques in one box. Leaving these samples around the workspace can inspire newcomers. The possibility box includes raster, score, living hinge, and cut elements. The bottom piece has a list of materials that can be cut on the laser cutter.

CATCH-ALL DISHES

In the Digital to Form art elective, students use the CNC to make catch-alls. This simple project teaches them about two basic toolpaths, a pocket and a profile. A simple dish is a great starting point for learning about the CNC router.

OVERVIEW

- Set up CNC
- Create toolpaths
- Run file
- Finish work

MATERIALS AND TOOLS

- CNC router (directions refer to using the ShopBot CNC, but other CNC machines use a similar process)
- Compression bit for milling
- ¾ inch plywood

SET UP CNC

1. Fasten the material to the CNC spoilboard.
2. Choose tool and secure it in the collet.
3. Mark origin point and move the bit tip to just above the mark. **ZERO** (X, Y). Reposition the tool along the X and Y to allow room for zeroing using the Z plate.
4. Position the Z plate underneath the bit. Connect alligator clip to rail and check the circuit by touching bit tip to plate.

CNC dish.

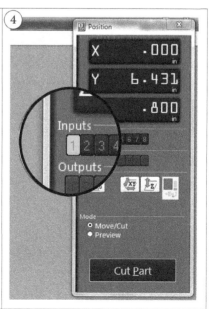

5. The input indicator on the Position box will light up, confirming a connection.

6. **ZERO** Z with the Z-plate. **Cuts → Zero.** The bit will slowly approach the Z-plate and when the bit makes contact, Z location is set. The machine will repeat this process a second time to confirm location. After process is complete, return the plate and clip to their storage on the gantry.

CREATE TOOLPATHS

7. You will need a vector file with the profile shapes you will be cutting and milling. When designing for the CNC, take special care with closing shapes. Cutting shapes and pockets require closed paths.

8. Take a measurement of the material thickness using calibers. Make a note of this measurement.

9. Open a new file. In job setup, input the material thickness as well as the size of the sheet. The origin in this example is set to the lower left corner.

10. Import the design: **File → Import Vectors.** Check for duplicate and open vectors: **Edit → Select All Duplicate Vectors**. Delete any duplicate vectors. **Edit → Select All Open Vectors → Edit → Join Vectors.**

11. Select the **POCKET** shape you will be milling. It will show up as a pink line.

12. From the **Toolpath** tab select **POCKET.** Determine the cut depth of the cut. It should be less than the thickness of the material. Choose the tool. I chose a compression bit that I can use for both the pocket and the profile. See the chip load calculator in the ShopBot software to calculate the feeds that match the material. Offset and raster will give you different pocket patterns. Name the toolpath and calculate. Once calculated, pocket toolpath appears as a series of pink, removal lines.

13. Select the **PROFILE** vector you will be cutting. It will show up as a pink dashed line.

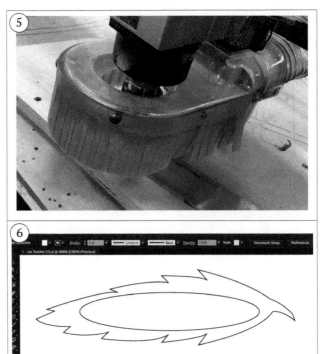

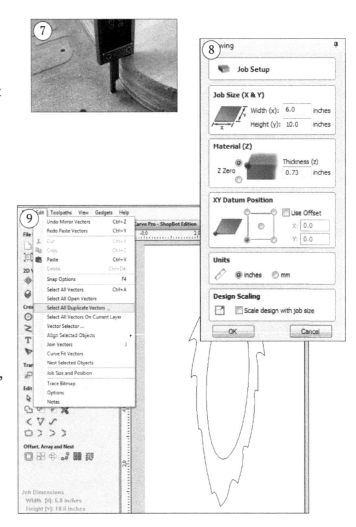

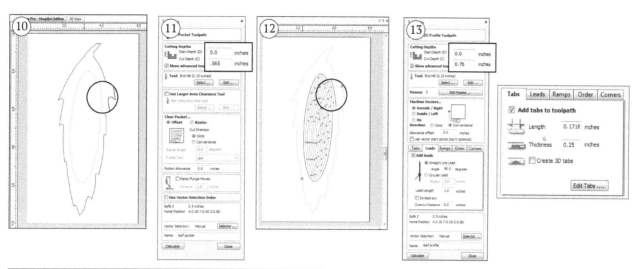

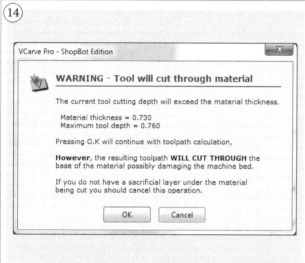

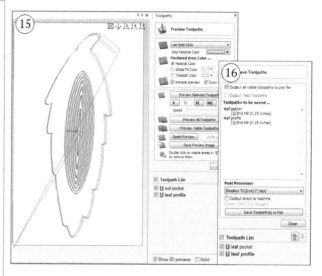

VCarve Pro - ShopBot Edition

WARNING - Tool will cut through material

The current tool cutting depth will exceed the material thickness.

Material thickness = 0.730
Maximum tool depth = 0.760

Pressing O.K will continue with toolpath calculation,

However, the resulting toolpath **WILL CUT THROUGH** the base of the material possibly damaging the machine bed.

If you do not have a sacrificial layer under the material being cut you should cancel this operation.

OK Cancel

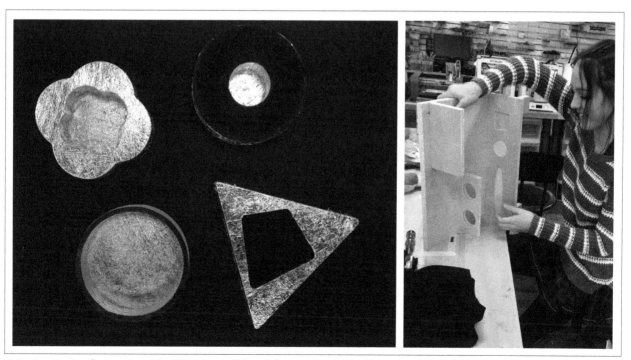

(left) Metal leaf surface treatment for CNC dishes; (right) student, grade nine, working on a catch-all design.

14. From the **Toolpath** tab select **2D PROFILE**. Set the cut depth slightly deeper than the material you are cutting. The tool will cut through to the spoil board slightly, ensuring the material will release. Set Machine Vectors to **Outside / Right** and add ramps and tabs. Name the toolpath and calculate.
15. Material warning will appear. Check that you have set the depth properly.
16. Simulate the toolpaths to confirm that you have set up the file correctly.
17. Save the CAM file.

RUN FILES

18. **Part File → Edit** to look at G-code before running the file. Check for the X, Y, Z positions, spindle RPM, machine speed, and cutting depth. **Part File → Load.**
19. Engage spindle power by turning key.
20. Press the green **START** button on the ShopBot position window.
21. Press green button on the wired controller remote. This will start the spindle. **Press OK** to run file.
22. **Press OK** to the prompt about the spindle starting.
23. CNC milling and cutting the piece.
24. After cut is finished, the machine returns to (0, 0) and Safe Z. Remove key to disengage spindle.
25. Remove the material.

FINISH WORK

26. Saw or chisel material from tabs. File and sand tabs for a smooth edge finish.

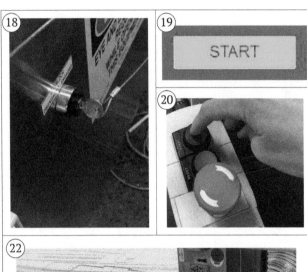

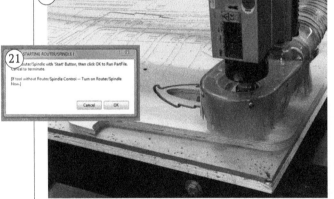

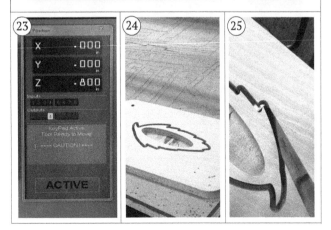

CUTTING PLYWOOD

When working with plywood, it is desirable to have nice edge quality on both the top and the bottom surfaces. To help with this, use a compression bit. The geometry of compression bits contain cutting edges for both an upcut and downcut.

For this project I used a ¼ inch compression bit from Onsrud, item number 60-111MW.

3D PROTOTYPING AND SCALING

Prototyping is not only changing the materials used as the project progresses but often changing the size of the project. It is often easier to work with a smaller version as the design improves. However, once the design needs to go full size, scaling is an important concept to understand. Working small with inexpensive or recycled materials like cardboard allows students to work through ideas and make adjustments quickly. It's easy to move from prototype to final form with simple calculations. Once designs are finalized, scale can be calculated directly in Illustrator. Using calipers, measure both the thickness of the prototyping material and the material you will use for the final. Note both measurements.

To scale, divide measurements and multiply by 100. This creates the inputs for Adobe Illustrator in percentage. When *scaling up,* divide thicker material by thinner material. When *scaling down,* divide thinner material by thicker material.

To illustrate scaling up and scaling down we will use the shelf bracket and prototype pictured below. The thinner prototyping material is 0.21-inch plywood. The thicker final material is 0.701-inch plywood.

TO SCALE UP

(0.701/0.21)*100 = 333.81 %

Select the entire design, double click the scale button, and key in 333.81 to scale up for the thicker material.

TO SCALE DOWN

(0.21/0.701)*100 = 29.96 %

Select the entire design, double click the scale button, and key in 29.96 to scale down for the thinner material.

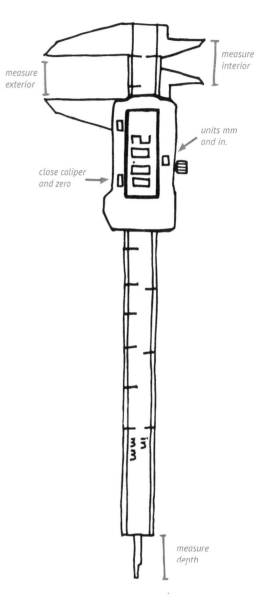

measure interior

measure exterior

units mm and in.

close caliper and zero

measure depth

HARDWARE FOR SCALING UP AND DOWN

For 5 mm plywood try

M3 x 20 mm low-profile screw, M3 square nuts.

For 18 mm plywood try

Recessed Hex Head Joint Clamps for Wood, McMaster Carr # 91560A120.

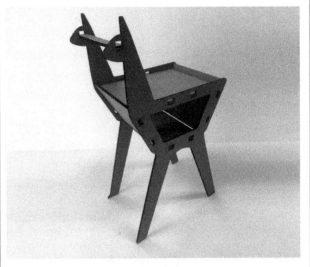
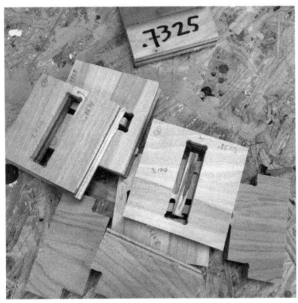
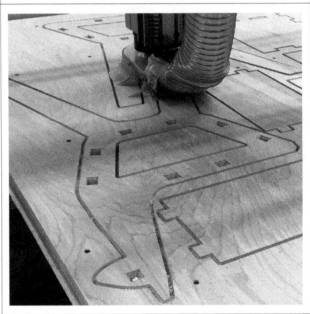

(clockwise from top left) Grade nine student's drawing and plans for a table design; cardboard prototype; cutting final design; testing joinery.

PROTOTYPING AND RESCALING

Students begin the process of moving from design idea to final creation through a series of prototypes. This process typically starts with a drawing. The design is roughed out three-dimensionally with inexpensive building materials like cardboard or chipboard. At this stage the measurements and proportions are taken into consideration before drawing digitally.

The next step in prototyping is often the first digital draft. The laser cutter is an invaluable tool for this stage of prototyping, especially for large CNC pieces and furniture. Students start with a full-scale design, in this case,

48 x 96 inches, scaling down each prototype for the laser cutter, and making adjustments. For each version, they are adjusting joinery, refining proportions, and nesting parts.

Once the design is finalized, the next step is to make test joints. Students take several thickness measurements of the stock they will be using and average it. This measurement is used to cut several test joints to determine the degree of clearance they need for their parts.

The final file is scaled to this final joint measurement. Two interlocking pieces on the full sheet should be cut first and tested for fit before running the full file.

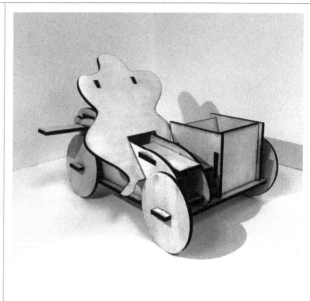
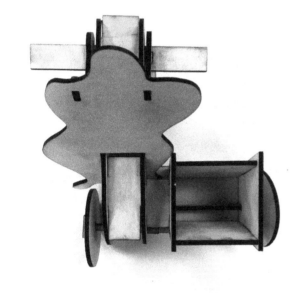

(clockwise from top left) Peter's chipboard prototype; Installation Guide for the construction of the puzzle; assembled puzzle.

PROTOTYPING FOR FIT

Peter Huang created a 3D press-fit puzzle out of plywood using the laser cutter for the Studio in Creative Technology class at Teachers College. His process included creating a chipboard prototype, designing the parts in Adobe Illustrator, and testing clearances for joints. In addition to the design considerations and constraints with the materials, the artist put a great deal of thought into how to transfer expressive quality of his concept drawing into flat, rigid material. Details like the forward tilt of the rider and grip on the handlebars were captured by working with angles and curves and substituting pegs for joinery for some of the connecting parts. To create a 3D puzzle that can be assembled and stay in place while also being taken apart without damage, fit became critical in the prototyping process.

Economy of parts also played a role in the design. Wanting to create an accessible puzzle with the right degree of challenge, Peter's prototyping process involved simplifying. Puzzle pieces were limited to the essential pieces.

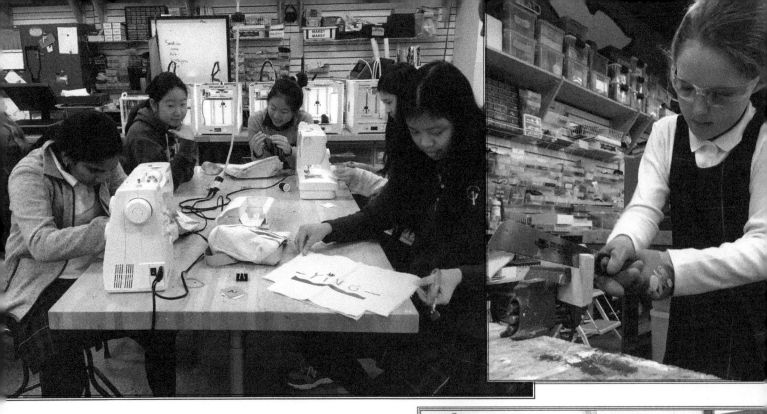

THE ONLY RULE IS WORK. IF YOU WORK, IT WILL LEAD TO SOMETHING.

—Sister Corita Kent

PIXEL-ART PAINTINGS

Grade eight student's pixel-art painting in progress.

Pixels, or tiny elements of graphic information, have been a part of the art and design vocabulary since early computer graphics. Low-resolution video cards limited images to blocky representations. This vocabulary is familiar in retro gaming and 8-bit graphics. In 3D we see it in Minecraft and voxel 3D design programs.

In this project, students use pixels as building blocks to create a large painted image. This is a creative method that teaches digital image and fabrication skills, reinforces the usefulness of the Cartesian grid, and helps students understand that "pixelation" can be used as an artistic element.

Pixels are the elemental unit of a raster image. In digital art and design, as well as in digital fabrication, knowing the difference and the applications of raster and vector graphics is a foundational understanding.

Using a pixel-by-numbers Processing application created by Erik Nauman, students are able to convert images into "color by number" pixel maps. Students choose the density of pixels and range of color, and the program generates a numbered grid with a color key. The grid is in vector form and can be printed or exported for digital fabrication. We used a large-format printer to make large poster-sized grids. Students mounted and sealed the printed grids on wood with Mod Podge and painted the pixel-art grid with acrylic paint.

Not only do students enjoy selecting images to convert to pixel art, they are excited by the process as their pixelized image emerges from the blank grid.

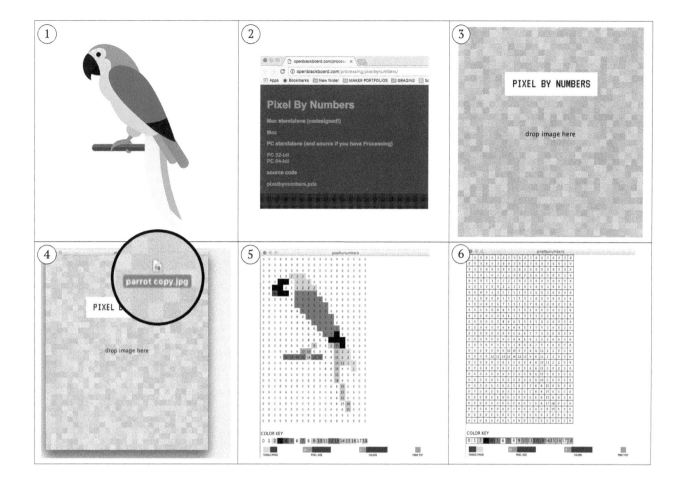

OVERVIEW

1. Find an image
2. Use pixel-by-numbers app
3. Scale in Illustrator
4. Transfer to wood and paint

MATERIALS AND TOOLS

- Printer
- Plywood
- Mod Podge
- Large brushes for sealing printout
- Small brushes and cotton swabs for pixel painting
- Acrylic or craft paint

FIND AN IMAGE

1. Find an image that you would like to recreate as pixel art. Look for simple images without too much detail. Shown here is a clip art image created by Katemangostar (Freepik.com). Download the image as a JPG or PNG. Make a copy of original file. This will be used to compare degrees of pixelation.

USE PIXEL-BY-NUMBERS APP

2. Go to: openblackboard.com/processing/pixelbynumbers. Download the software. Locate the app and unzip.
3. Double click to open the app. Locate the file that you want to pixelize.
4. Drop and drag file into the PIXEL BY NUMBERS window.
5. Image will pixelize. Locate the sliders at the bottom of the window. You can adjust these to change the following:
 - Toggle from image to frame
 - Pixel size
 - Colors
6. When you are happy with the look of the image, press the **PRINT PDF** button.
7. The grid will be downloaded to the Downloads folder.
8. Print an 8½ x 11 inch version and use the color key to test the design.

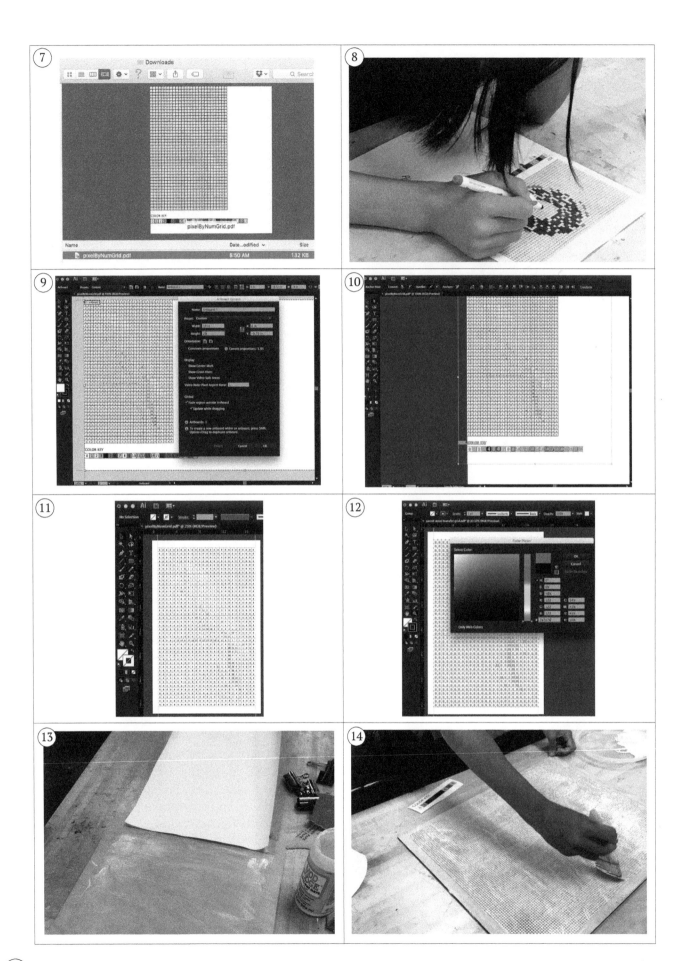

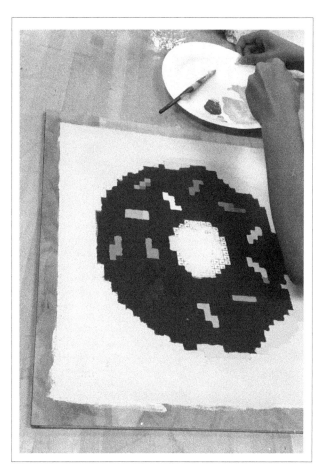

SCALE IN ILLUSTRATOR

9. Resize the art board to the size of the wood.
10. Select the color key and delete it, leaving just the grid.
11. Resize grid to fit the wood.
12. If you would prefer a lighter grid that doesn't visually compete with the paint, set to No Fill and RGB gray stroke.

TRANSFER TO WOOD AND PAINT

Print grid and corresponding color key. Set the color key aside. You will need it as a reference. Gather supplies and tools: plywood cut to size, Mod Podge, large brush and acrylic paints, small brushes, and cotton swabs.

13. Paint a thin layer of Mod Podge on plywood making sure to have even, flat coverage. Float paper on the surface of the prepared wood and cover the surface of the paper with more Mod Podge, making sure to smooth out bubbles. Let dry for 24 hours.
14. Use the color key to paint the pixel image.

EMBROIDERY PATCH

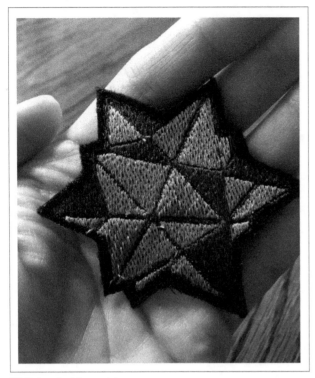

Digital embroidery patch.

Embroidery is another area for exploring pixels and digital fabrication. Embroidery threads, like tiny brush strokes, can add up to an image in a painterly way.

In this project, a multicolored image is digitized using SewArt (sandscomputing.com), which turns a raster image into a digital toolpath for thread. The image is built up in color sections and when completed, the edge is finished off to make a patch.

OVERVIEW

1. Make a color graphic from black-and-white graphic
2. Digitize the raster graphic
3. Prepare the embroidery machine
4. Run the embroidery machine

MATERIALS AND TOOLS

- Brother PE770 Digital Embroidery machine (This example uses the Brother PE770, but any embroidery machine that can read digital embroidery files can be used.)
- Felt
- Interfacing
- Embroidery thread
- Fray Check

MAKE A COLOR GRAPHIC FROM BLACK-AND-WHITE GRAPHIC

1. Find an image that you would like to embroider, one that is graphic and simple in color. For this tutorial we will be using a graphic from The Noun Project (created by Dima Lagunov) and introduce color in Photoshop. Go to thenounproject.com. Create an account. Find a simple graphic that you would like to turn into a colorful design for embroidery. Download the graphic as a PNG.
2. Open the design in Photoshop.
3. Use the magic wand tool to select sections of the design. Use the eyedropper tool to set the color for filling either using the paint bucket tool or edit fill to "colorize" the image.
4. Save the file as a PNG.

DIGITIZE A RASTER GRAPHIC

5. Open SewArt. File Open (to get file).
6. Units. Change the units under **Options →
 Units → Imperial**. Resize the image. The
 Brother PE-770 has a 5 x 7 in. embroidery
 field. Make sure to size the design within
 that boundary. This image has been
 resized to 3.5 x 3.5 inches to make a patch.
 Resize under **Tools Resize** to make it the
 desired size of the embroidery.
7. **Tools → Wizard**. This tool guides the
 user through a set of prompts to optimize
 the image for the stitch toolpaths.
8. The next step will be turning the image
 into stitches in **Stitch Mode**. Notice how
 the color map is reduced compared to the
 Photoshop version (to the right).
9. **Tools → Convert to Stitches**
10. **Auto-sew Image** will convert the entire
 image into a color map of stitches. Use
 the needle tool to hand select the colors
 so they can be bunched together in the
 toolpath and run sequentially by color.
11. Save stitches as a PES embroidery file. PES
 is a common embroidery file format, used

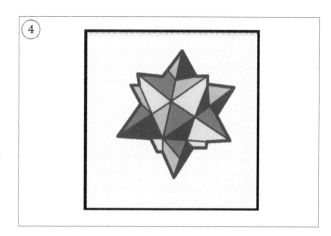

by the Brother PE770. Check your machine
to see what file format it uses.

12. SewArt will generate both a toolpath
 PES file and an informational text file.
 Save the PES file to a thumb drive for the
 embroidery machine.
13. The text file gives you important
 information about the file including
 size, number of colors, and thread types.
 The file is now ready for the embroidery
 machine.

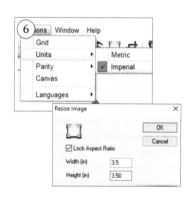

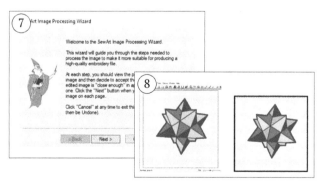

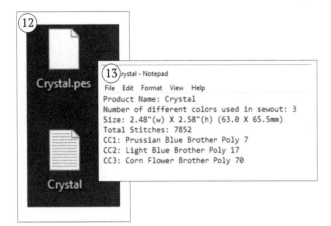

Crystal.pes

Crystal

Crystal - Notepad
File Edit Format View Help
Product Name: Crystal
Number of different colors used in sewout: 3
Size: 2.48"(w) X 2.58"(h) (63.0 X 65.5mm)
Total Stitches: 7852
CC1: Prussian Blue Brother Poly 7
CC2: Light Blue Brother Poly 17
CC3: Corn Flower Brother Poly 70

PREPARE THE EMBROIDERY MACHINE

14. Add an iron-on stabilizer to the back of the fabric to minimize buckling and to support the design. The shiny side faces the fabric.
15. Place the stabilizer and iron it onto the backside of the fabric.
16. Loosen the hoop and place the fabric within the boundary. Once tightened, it should be taut like the surface of a drum.
17. For the next step you will need an embroidery machine. Shown here is the Brother PE770. Check bobbin to make sure you have adequate thread. If not, spool a new bobbin. Use the digital instructions on the LCD screen to guide you.
18. Carefully place the hoop underneath the foot of the machine.
19. Snap hoop into place by matching up the clip and bolt heads.
20. Thread the machine with the thread of choice. If you are running a multicolor file, you will load up the first color of the design. Use the digital instructions on the LCD screen to guide you.
21. Lower the foot of the machine.

RUN THE EMBROIDERY MACHINE

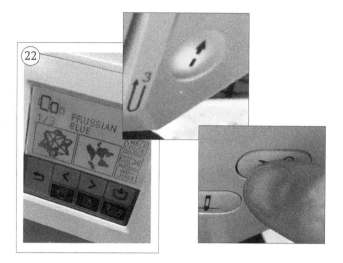

22. With the first spool of thread loaded in the machine for the design and the green light indicating the file is ready for embroidery, run the first color by pressing the green button. The stitching will start out slowly and pick up to a steady stitch pace. When the stitching is complete, press the scissor button to cut the thread between the needle and the fabric piece.

23. Cut the thread on the left side of the thread spool. Now the thread is ready to remove. Lift the foot. Pull the thread free from the front.

24. Add a new spool of thread for the next color in the sequence. Rethread the needle and lower the foot. The green light should be on. Run the second color.

25. When all stages of the stitching are complete, press the scissor button to cut the thread and press the **HELP** button on the LCD to unload the hoop. Carefully unclip and remove the hoop. Apply some Fray Check around the design and let it dry. This will stiffen the fabric.

26. Carefully cut around the edges of the design for finished edges.

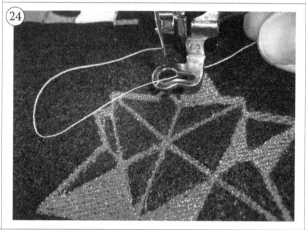

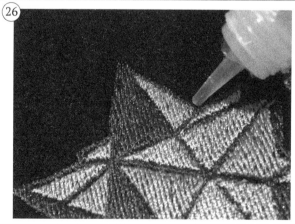

GLITCH ART

A glitch, or interrupted signal, can render technology dysfunctional or offer moments of beauty in the corrupted image. In this project, artists stitch together a glitch image they make through the manipulation of the underlying data of digital images.

There are two things happening in the process of glitching an image: (1) the artist experiments with additions and deletions in the text file (a representation of the bits in the image file) and (2) the raster image linked to the text file progressively degrades. The final image and text, printed on a regular or large-format printer, become the material for manual composition—the artist's hand making final additions and deletions.

There are apps and online sites that allow different kinds of glitching, but I find that this "old fashioned" text-based method helps students understand that image files are made up of bits that can be rearranged and modified. This leads to understandings that are helpful in digital design and coding.

OVERVIEW

1. Alter text and image
2. Print multiple images
3. Make a "glitch" collage

MATERIALS AND TOOLS

- Color printer (large format for large-scale compositions)
- Scissors
- White glue and glue brush
- Three printouts: original image, glitch image, image text

ALTER TEXT AND IMAGE

Note: Instructions for altering a text file decribed in the following steps are for Mac users. If you have a PC, web tutorials are available with instructions for glitching images by altering text with Windows-specific apps.

1. Select an image. Save as a JPG and save an extra image as a backup.
2. Open image in a photo editor. Photoshop and Preview are two possibilities. Keep the file open while you do the next step. Go to Finder and change the file extension from JPG to TXT. Open the TXT file in a text editing program. Now you should see the image and text simultaneously.
3. Start altering the text file by adding and deleting information. Don't edit the first part of the file; this may corrupt the file so much it can't be understood by the graphics software. Make changes further down in the middle of the text file. Try **FIND and REPLACE**, type in random characters, **DELETE**, and move parts. Save file. Evaluate the changes to the image. Continue or undo to return to previous state.

PRINT MULTIPLE IMAGES

4. Save two files: the file as a TXT and JPG.
5. Open the TXT file again and look for a section of text you would like to incorporate into the art. Save this section as a screenshot. Print original image, corrupted image, and image text for the next step.

FINAL PAPER COMPOSITION

6. Gather the materials. In this step students will be moving into low-tech making with digital prints.
7. Just as the digital glitching happens through adding, deleting, and moving digital information, students can approach the low-tech step the same way. This project can take the form of a collage, paper weaving, or reconstructed deconstruction.

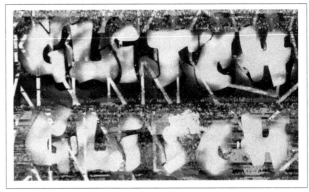

Grade nine student's design. She created a laser-cut stencil to spray-paint text over her image glitch.

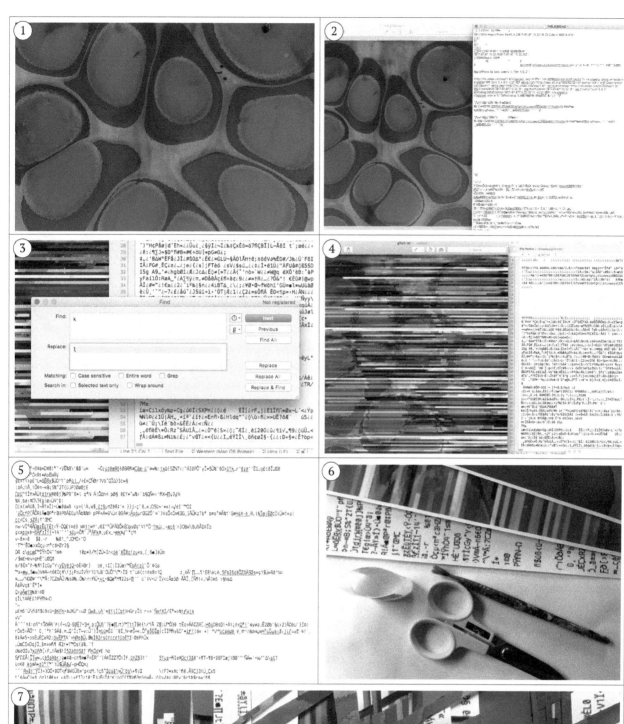

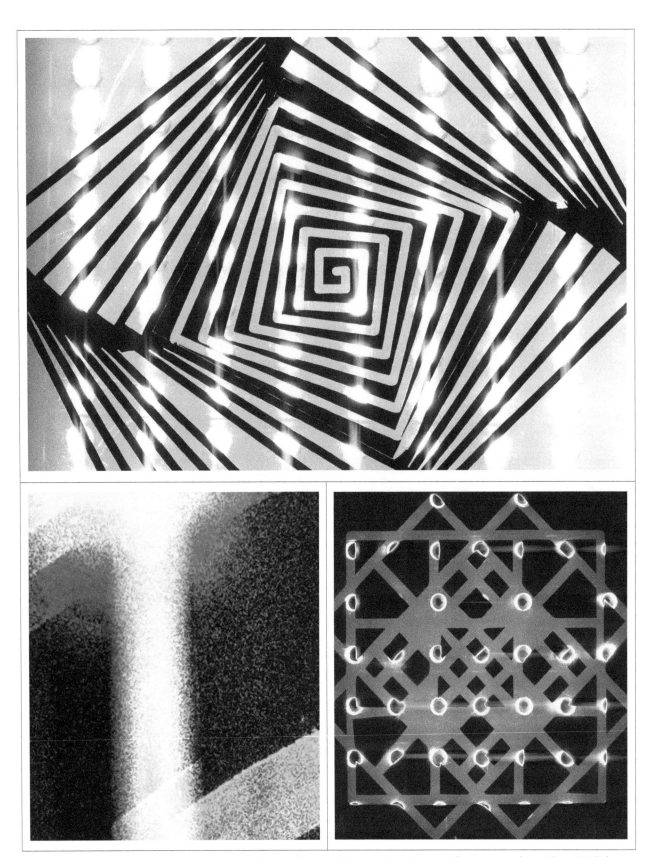

Student examples of material explorations with glitch images: (clockwise) Students placed cut stencil patterns on glass with an LED light panel* backlighting the image and scanned them on a flatbed scanner; the negative space image creates the effect of light-bending; close up of light effect. Based on the length of the scan, the light separates and "glitches" in varying degrees as it goes through the glass.

*An LED light panel was chosen over other lights which can heat up and pose a safety hazard.

GLITCH ANIMATIONS

As students create a progression of glitch images, testing how far they can push the file corruption without rendering the file unviewable, they are creating a progression of images that can be made into an animated GIF. The GIF file format stores multiple image layers into one file. Students decide the ordering and timing of their images to create a simple animation.

STEPS

Note: Instructions for creating an animated GIF as decribed in the following steps use Adobe Photoshop. If Photoshop is not available, web tutorials are available with instructions for using GIMP, a free image-editing application.

1. Create two or more glitches in a progression. You will need to take screenshots of the images before making a GIF into Photoshop because the files are corrupted from glitching.
2. After creating your screenshots, collect them into a folder on your desktop.
3. In Photoshop, go to **File → Scripts → Load Files into Stack.** Select **Use → Folder.**
4. The following window will appear. Note: If you are using a Mac and a ".DS_Store" file appears in the stack, remove before moving on. Click the OK button.
5. You now have all your images in separate layers in Photoshop.

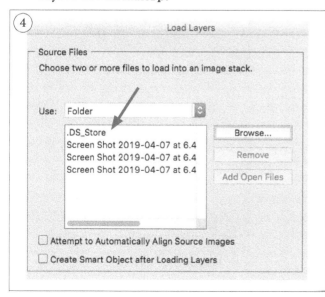

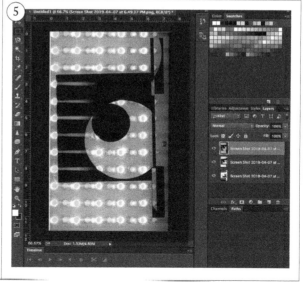

6. Go to **Window** → **Timeline** to open up the Timeline window. Click the Create Frame Animation button.

7. At the bottom of the Timeline locate the file icon. This button duplicates the selected frame. Create one frame for every layer in your GIF.

8. Select your first frame. Make visible which layer you want to show on this frame.

9. Select your second frame. Make visible which layer you want to show on this frame. Continue this procedure until each frame is showing the corresponding layer.

10. Under each frame select how long each frame should be delayed. At the bottom of the Timeline select "forever" for a loop.

11. Go to **File** → **Export** → **Save for Web** to export your GIF. A window will appear that will allow you to select size and quality of your GIF image. **Save.**

12. Your GIF can now be embedded into a website as an animation.

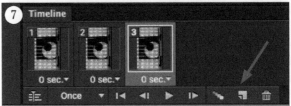

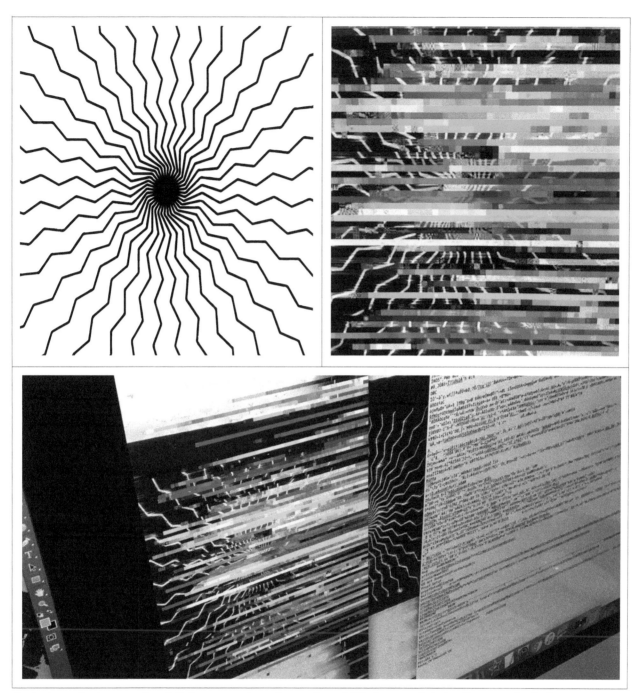

Grade nine student's progression of glitches were used to make an animated GIF. (from top, clockwise) The process involved creating a design with code; making an image glitch by altering text file; continuing to alter the code in stages and stacking each of the layers in Photoshop to create GIF. An example of the glitch GIFs can be found at artofdigitalfabrication.com.

WEBCAM MACROSCOPE

Changing scale is a powerful design element, one that can transport the viewer into a world that they do not recognize, or alternatively, one that invites a closer look. Science has inspired artists to consider scale and has given us the tools to see the world on the macro and micro levels. In their mesmerizing film, Powers of Ten, Charles and Ray Eames show us both, challenging us to consider the enormity of range of point of view.

The familiar microscope magnifies the viewed object. A macroscope does not. In this project, students build different macroscopes using a webcam that can take stills and videos of objects. The macroscope case has convenient racks for placing the viewed objects, camera, lights, and other useful accessories.

In the EDL we wanted to explore the idea of "close looking" and develop a project that would encourage tinkering.

Different learning objectives can be served using variations of this macroscope. High school art students built a laser-cut version of the macroscope with petri dishes to capture wet media stills and create beautiful abstracted videos of zoomed-in objects. In the fourth grade, students built a cardboard version and studied natural objects up close. An Engineering and Design class brainstormed new purposes for the tool, designed new features and then built their redesigned versions of the macroscope.

THE PARTS

- 12-megapixel webcam
- Enclosure (find directions and files at artofdigitalfabrication.com)

THE PROCESS

- Tear down the webcam
- Build the macroscope
- Tinker with the macroscopes
- Explore variations
 - Flip lens
 - Software
 - Video editing

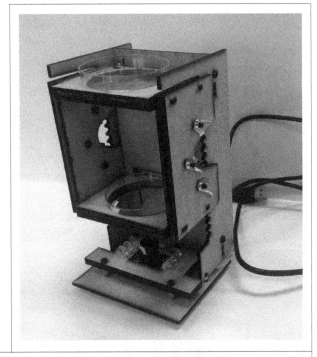

(top) Lasercut webcam macroscope with petri dishes; (bottom) close-up still images of paint by art students using the lasercut webcam macroscope.

TEAR DOWN THE WEBCAM

To get to the internal electronics of the webcam, students used small screwdrivers to remove any hardware and carefully separate the enclosure from the circuit board, lens, and wiring. Students also checked to make sure the camera was functional and tested capturing images in QuickTime on a Mac.

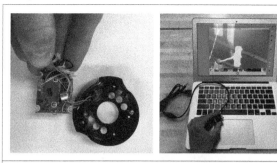

BUILD THE MACROSCOPE

Laser-cut macroscope – This version consists of a laser-cut stand designed to hold a webcam and racks, or stages, to place materials to be photographed. The macroscope has two stages and three regions for composition—one for a foreground and background and a place to mount a smartphone for backlighting or displaying digital images into the design composition.

Cardboard macroscope – This build, by Abraham Orozco, does not require digital fabrication tools.

Hybrids – Students are invited to create an enclosure of their own design, modifying the laser-cut or cardboard versions, or creating their own design from scratch.

No matter which version of the macroscope students build, this project is an excellent way to encourage tinkering as students work with the imperfections of the webcam and idiosyncrasies of the items they choose to photograph.

(top left) The internal electronics are removed from the enclosure; (top right) camera is tested using a camera app on the computer; (bottom) fourth-grade students testing webcam before building cardboard macroscope. Photo credit: Katherine Pushkar.

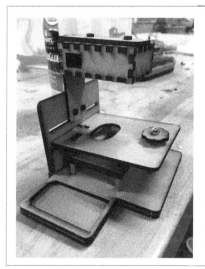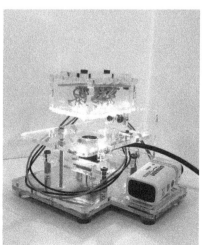

(bottom left) High school Engineering and Design student's microscope prototype (she modified the lens for higher magnification); (middle) final microscope design, incorporating a light panel with both white and UV LEDs that the user controls for different backlighting effects; (bottom right) high school film students constructing cardboard macroscopes us tools for shooting close-up videos.

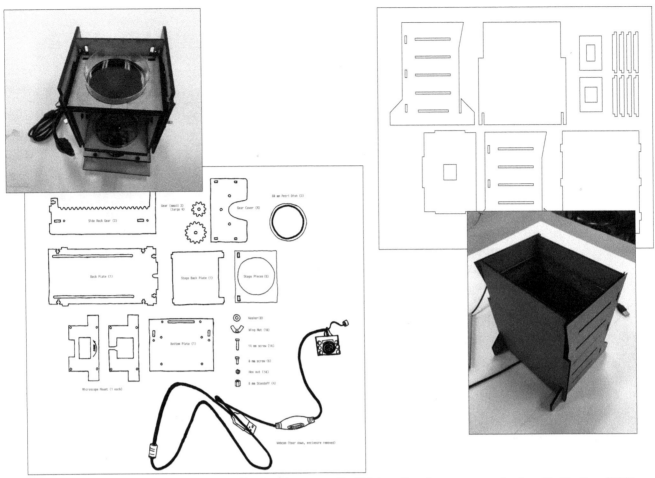

(left) Laser-cut macroscope and parts inventory file (Parts_inventory.pdf); (right) cardboard macroscope and pattern file (CardboardWCM. pdf). Files available at artofdigitalfabrication.com.

TINKER WITH THE MACROSCOPES

With many variations in material properties, students have a wide variety of ways to explore their ideas through this project.

Foreground, Middleground, Background

The webcam macroscope is set up to have three regions for composition. There are two stages for petri dishes and a set of rails on which to place a smartphone above the camera. The three regions can be treated as a foreground, middleground, and background.

Focus

The camera can be focused anywhere within the range of the machine.

Materials

A wide variety of dry materials can be used with the macroscope. Materials with different textures, colors, and density are a great choice.

Wet materials can be used with the macroscope. Watercolors and inks are a good choice for painting. A pipette can be used to remove liquid along with paper towels.

Digital images or animations mounted at the top of the macroscope can provide a light source and backdrop for compositions.

Lighting

The camera can be lit from below with the LEDs on the webcam or from the light source of a smartphone.

Petri dishes

The petri dishes can hold materials or liquids and help protect the electronics and the camera from getting damaged.

Taking photos and making video

Any of these materials listed above, along with lighting and focus can be put together in any combination to capture photos or make video.

EXPLORE VARIATIONS

Flip lens

Convert a macroscope into a true microscope for higher magnification. To flip the lens, unscrew it, turn it around, and reattach with electrical tape. This modification will reduce the viewing area and requires backlighting.

Software

Photo Booth and QuickTime are programs you can use to capture images on a Mac, and the camera app can be used on a PC. Webcam-capture apps like webcamera.io can be used with a Chromebook.

Video editing

The webcam takes photographs and video that students use in other projects or as the basis for artmaking. These graphics collected from the macroscope can also be digitally manipulated to any scale.

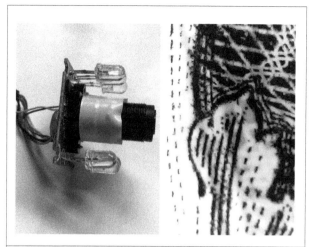

(top) Lens flipped for a true microscope; higher magnification image; (bottom) video captured through computer software.

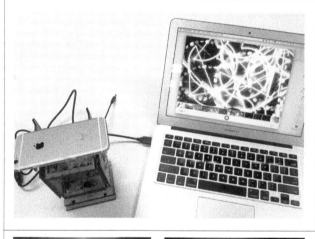

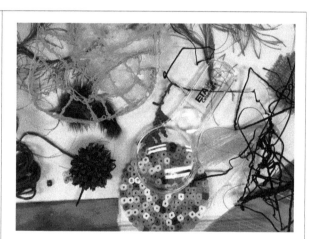

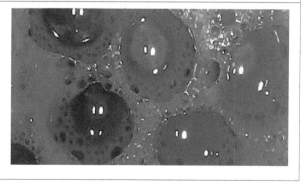

(from top, clockwise) Two stages and a smartphone stand enable design for a foreground, middleground, and background; dry and wet materials to look at under the camera; capturing wet media explorations; introducing LED lights to create light effects; (following page) student images captured with a macroscope designed to hold and reflect objects within a mirrored interior.

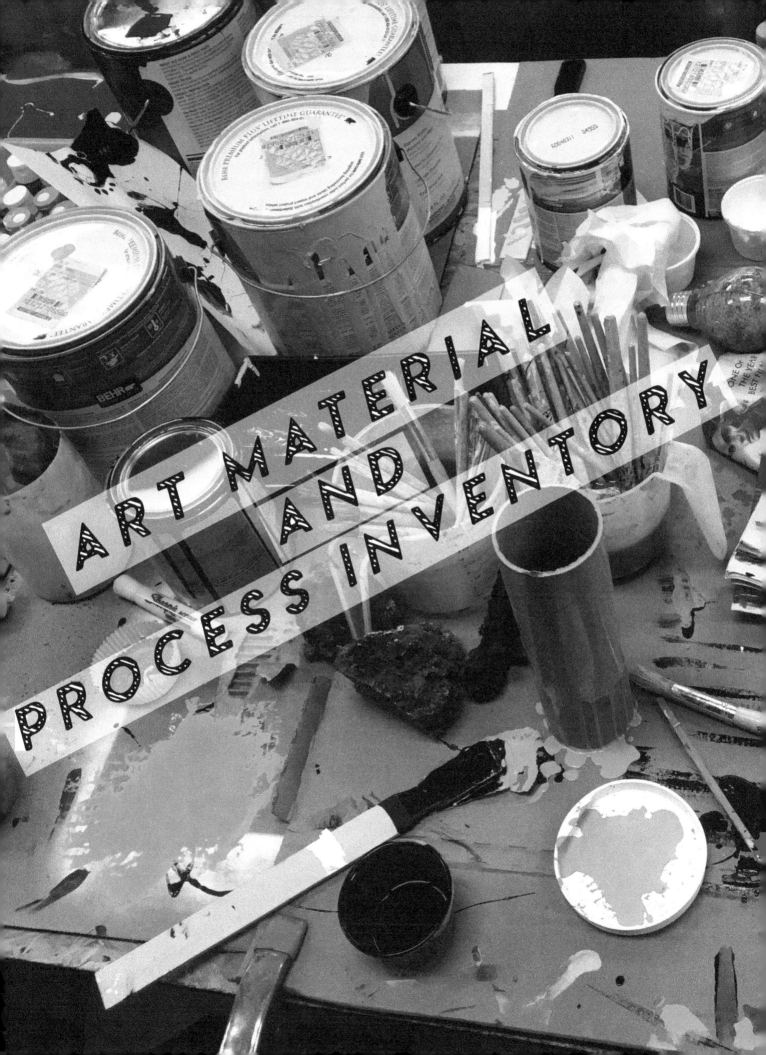

ART MATERIAL AND PROCESS INVENTORY

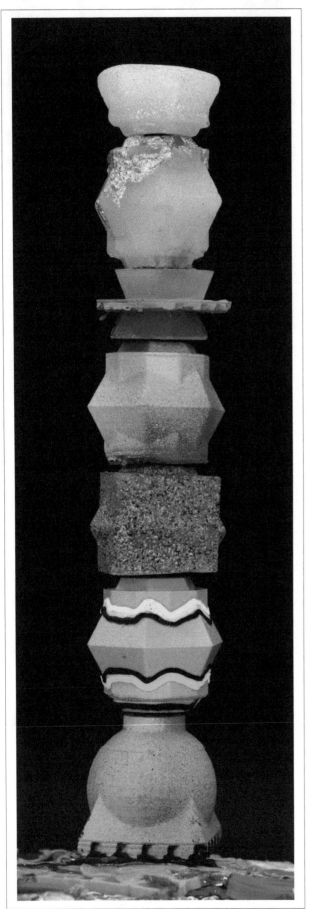

Having digital fabrication capabilities in schools invites the combination of art material know-how with new tools for making. This chapter is a visual library of material options that work well with digital fabrication machines and have parallel process in the art studio. With this expanded material and process inventory, artists, designers, and makers can share meaningful vocabulary across disciplines.

CASTING AND FORMING

The 3D printer is an exciting tool for creating 3D forms but can feel limited, material-wise, if the only output is plastic. However, if 3D printing is used as a first step in a casting process, a wider variety of materials can be explored. Silicone molds are a great choice for casting. Silicone can withstand heat and flexes to remove rigid positives.

After making your positive, 3D-printed shape, consider making a silicone mold and cast in a variety of materials listed here:

1. **Hot glue:** Hot glue casts well and has the added benefit of drying quickly. Its translucency makes it a suitable material for embedding LED lights, adding glitter or any additional materials for color and texture. Gummy bear silicone molds are the perfect size for standard LEDs. Sharpie marking was discovered by one student as a way to introduce color and detail.
2. **Wax:** Soy wax chips can be melted in a double boiler with good results. Wax makes nice candles or, for sculpture applications, additional materials can be added. After casting, wax can be reworked by scraping and carving.
3. **Concrete:** Concrete is beautiful material for casting. The heavy, solid form is a nice contrast to 3D-printer filament.
4. **Plaster:** Plaster is another traditional art material for sculpture that combines well with digital fabrication. Like wax, after casting, plaster can continue to be worked by sanding and carving. Plaster takes to wet media well. We have found it to be a terrific surface for marbling.

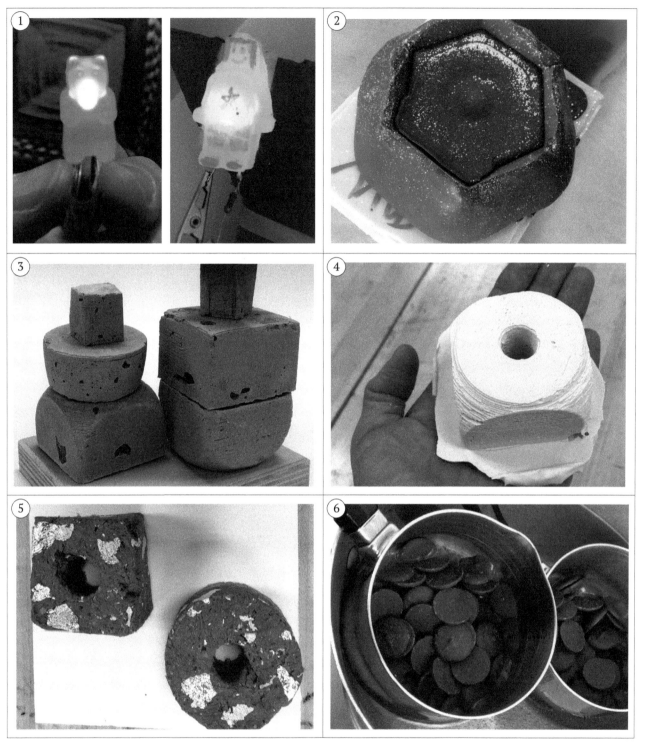

5. **Papier-mâché:** CelluClay, a brand of papier-mâché pulp, is another material that can be used for casting. It's non-toxic and kid-friendly. Mix it up in a ziplock bag with water for a mess-free container. The corner of the bag can be snipped off and the mushy pulp squished into the mold.

6. **Chocolate:** Food-grade Smooth-Sil 940 silicone and a double boiler can be used for casting chocolate.

3D SURFACE TREATMENTS

Another way to use art materials to expand the variety of visual expression is through surface treatments of the form. Most current 3D printers use PLA or ABS plastic filament. The following are some surface treatments you may want to consider for 3D prints.

7. **Pour paint:** After giving your 3D-printed piece a light priming with gesso, you can drip, drizzle, and pour acrylic paint over forms. This technique requires a good deal of drying time, but the results are exciting.

8. **3D filament pen:** Using ABS filament in a pen, which has a higher melting temperature than PLA, applied over the top of PLA adheres ABS onto the surface of PLA-printed forms. This tool can be used to create textile-like textures, contour lines, or designs.

9. **Metal leaf:** Metal leaf is a simple process of pressing extremely thin metal films onto a prepared surface with adhesive. This transforms a 3D surface into a shiny, metallic one.

10. **Nail polish:** Nail polish can add detail to print. The lacquer sits on the surface and helps fill texture.

11. **Spray paint:** Matte, gloss, and "stone effects" spray paint varieties are available to apply over the top of 3D shapes. Lightly sand then gesso or prime forms first for the best result.

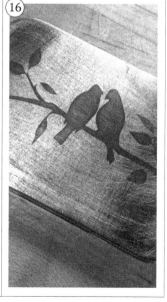

2D SURFACE TREATMENTS

Certain materials and processes lend themselves to 2D applications in digital fabrication. The following are some surface treatments you may want to consider for flat surfaces.

12. **Marbling wood:** Plywood is porous and can be marbled and laser cut. The marbling can be done on the wood after cutting. Use a carrageenan solution with Higgins waterproof inks for marbling.

13. **Cyanotype fabric:** Laundered lightweight cotton works well for cyanotype printing. Photographers' Formulary Liquid Cyanotype Printing Kit comes with a Solution A and B you mix and apply to fabric in a dark room. Once dry, the fabric is exposed to UV light. You can use a variety of materials and stencils from your digital fabrication scraps.

14. **Screen printing:** Cut vinyl can be a screen-print stencil. Either mask a traditional screen or an embroidery hoop with stretched silk. There are lots of options with silkscreen including ink on a T-shirt, paper, or glaze onto leather hard clay.

15. **Embossing clay:** Laser-cut paper or poster board can used to emboss clay. For handmade tiles, roll paper designs gently into the surface to create a negative.

16. **Etching metal:** Etching metal using a vinyl-cut stencil, battery, and salt water speeds up the oxidation process. Use this technique for etching metal tins, aluminum, and copper.

17. **Collaged or papered surface:** Sticker paper, labels, or patterned paper adhered to a surface can act as a base layer that can be engraved or scored on the laser.

18. **Charcoal rub and spray paint:** Paper stencils are the negative for spray paint or charcoal rubs. Charcoal can be sealed with hairspray or matte spray sealer.

19. **Metal leaf over laser etch:** A deep engrave provides relief texture for metal leaf applications. A coat of brick-red paint after laser etching and before metal leaf application gives the surface an antique look.

20. **Crackle paint:** Apply acrylic paint over a thin layer of white glue. They each dry at a different rate resulting in a crackle effect.

21. **Engraving leather:** Raster or vector graphics engrave well on leather.

22. **Engraving canvas:** Unprimed canvas which is light in color does best with a vector graphic—preferably black and white for contrast. Images can be etched and sealed with matte medium as a foundation for painting.

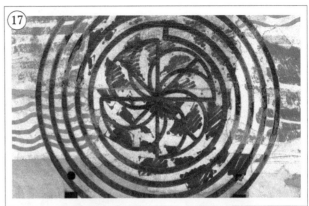
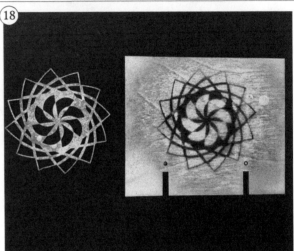

The Art of Digital Fabrication

LIGHT

Light is a favorite design element to incorporate into art projects. Whether the light source is from LEDs, Chibitronics Circuit Stickers, or microcontroller driven NeoPixels, a light chamber or material for diffusion is a good choice. Listed are some ideas for materials that pair well with light.

23. **Glue and embedded objects:** Regular white glue dries to a filmy-white translucency. Glue is slow drying, but during warm months, when poured glue can be left in the sun to dry, this makes a great technique for creating light windows. Cover one side of a laser-cut window with packing tape, making sure the edges are sealed. If you want to embed objects in glue, add them directly to the window and pour glue over the top, up to the edge of the material. Once dry, the packing tape can carefully be pulled off the back to reveal the glue window.

24. **Packing tape:** Packing tape can be used for forming shapes, and the crinkly nature of the material diffuses light beautifully. Packing tape can also be used as a casting material with the following process: (1) cover original form with plastic wrap to protect surface, (2) cover plastic wrap film with several layers of tape, (3) carefully cut plastic shell free of positive shape, and (4) retape seam.

25. **Stacked laser-cut papers of different translucencies:** Glue laser-cut papers of different translucencies to provide shadow contrast in projects. Try standard railroad board, rice and marble paper, and tissue.

26. **Removed paint layer designs:** Colored acrylic is expensive, but as an alternative you can prepare clear acrylic with spray paint. When the spray paint layer is rastered away, it can be used in light applications.

FUSING

In an effort to make a move towards a sustainable lab, we are always looking for ways to upcycle materials. Here are some examples of fusable scrap or recyclable material.

27. **3D printing on fabric scraps:** Use a very thin meshy material as a base layer for 3D printing. The holes capture the material, and the heated bed fuses it to the fabric.

28. **Heat vinyl scraps:** The scraps left over from T-shirt projects make wonderful collage scraps. Scraps cut into shapes can be arranged on fabric with the shiny side up on the press. A Teflon nonstick sheet can be used as a barrier to prevent pieces of vinyl from sticking to the press.

29. **Plastic bag fusing:** HDTP, a common plastic used in many bags (recycle symbol "2") is fusable with a household iron. Cut and stack the bags, sandwiching them between paper, slowly running the iron across the paper. It's important to let the plastic cool before removing. This plastic "fabric" sews beautifully!

DRAWING/PAINTING

Studio practices of drawing and painting can take a new turn with digital fabrication and creative technologies. A few processes we have been working with are listed here.

30. **Dry, wet digital media:** Changing scale can provide a fresh eye into the world of art materials. Use a webcam macrosope to explore the science of materials such as oil and water resist, salt effects, paper towel bleeds, and marbling solution ink floats.

31. **CNC drawing:** Every digital fabrication machine has the potential to be a drawing tool. This is an interesting challenge for students to expand their skills and options. The vinyl cutter can be used as a plotter, the 3D printer can be used to print "thins" or shallow reliefs, the laser cutter can draw a score line, and the CNC router can be outfitted with a Sharpie or used for relief cuts on material.

32. **Loose pen:** A loosely secured pen in a machine being used for drawing can make interesting and expressive marks.

33. **Power on the laser cutter:** Adjusting the power of the laser when scoring and rastering can offer another way to express line quality. Higher power creates darker marks, and lower power creates lighter marks. These variations can be used in an artistic way for laser-cutting projects.

34. **Concentrated scoring:** Scoring high-density shapes can create an interesting mark vocabulary that can mimic stippling.

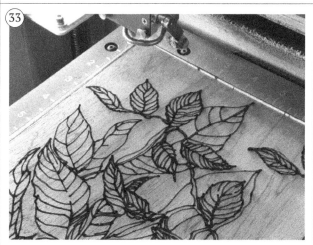

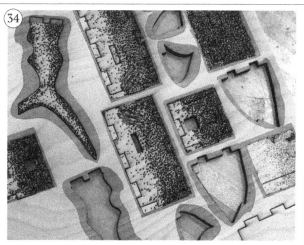

OTHER

There are other processes we use in the lab that don't neatly fit into categories but offer interesting material options.

35. **Baked goods:** Freshly baked gingerbread cuts and scores beautifully in the laser cutter. If the cut doesn't go all the way through, it can easily be separated with an X-ACTO blade.

36. **Flexible sheets:** Printing very thin materials in flexible filament has been a favorite for our students interested in costume design. These sheets can be integrated and sewn into fabrics.

37. **Super thin:** Originally an exercise in learning about slicing software, we have been testing the limits of how thin and fine we can make 3D prints.

38. **CNC rubbings:** As the CNC bed builds up a history on the spoil board, we capture that history with rubbings. This is a great activity before resurfacing the bed.

39. **Mixing up materials:** Students have been exploring mixing materials within the same work. Material mash-ups with wood, acrylic, cardboard, 3D prints, and fabric can make exciting hybrid pieces. Claudia Choi's work from the CTC program at Teachers College is shown here.

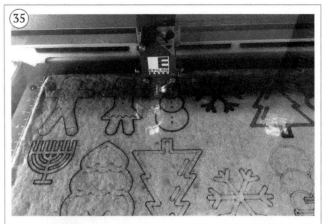

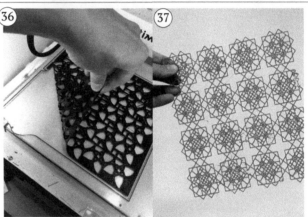

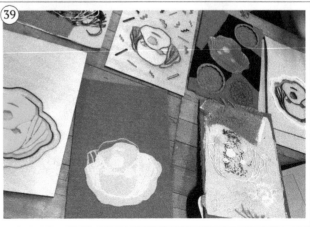

RESOURCES

Cardboard Inventory Checklist

Name _ _ _ _ _ _ _ _ _

- ❑ Straight cuts
- ❑ Flange
- ❑ Curves
- ❑ Tab
- ❑ Score
- ❑ Foot
- ❑ Score bend
- ❑ Movable link
- ❑ Smooth bend
- ❑ Expose corregation
- ❑ Notches
- ❑ Laminating: glue and clamp
- ❑ Smooth joint
- ❑ Join using dowel

Explore Tinkercad Checklist

Name _ _ _ _ _ _ _ _ _

- ❑ Make a 3D shape
- ❑ Fit view to selection
- ❑ Take a measurement
- ❑ Adjust size/scale of shape
- ❑ Change file name
- ❑ Customize a shape
- ❑ Align multiple shapes
- ❑ Group multiple shapes
- ❑ Make a hole
- ❑ Export an STL

Explore Photoshop Checklist

Name _ _ _ _ _ _ _ _ _

- ❑ Open a new document, size your canvas, set resolution and color
- ❑ Create the five basic shapes and use shift key to control the aspect ratio
- ❑ Turn a vector shape into an editable raster shape
- ❑ Set the color for foreground and background
- ❑ Place and crop an image
- ❑ Select and delete
- ❑ Isolate an object by deleting the background
- ❑ Make a new layer and fill background
- ❑ Move a selection
- ❑ Clone a selection

Explore Illustrator Checklist

Name _ _ _ _ _ _ _ _ _

- ❑ Open a new document and size your artboard
- ❑ Create the five basic shapes and use shift key to control the aspect ratio
- ❑ Change color and outline using stroke and fill
- ❑ Use different selection tools to delete points, sections, and whole shapes
- ❑ Change a shape by dragging points
- ❑ Combine shapes with the shape builder tool
- ❑ Delete a path and reclose a shape
- ❑ Turn text into outlines
- ❑ With pen: draw square, delete point to make triangle, make curves, make a circle
- ❑ Rotate and reflect shapes

3D Slicing Checklist

☐ File naming and version control
 Project name
 Your name
 Version

☐ Model on platform

☐ Nozzle size
 0.4 mm standard, use 0.6 mm for faster printing

☐ Does your model need support?

☐ Adhesion
 Brim, to prevent warping and curling
 Raft, for models that require more surface area to stick

☐ Infill
 20% standard infill

CHECK YOUR PRINTER

☐ Is the bed level?

☐ Do you have enough filament to complete your print?

☐ Monitor the start of your print. Has the print successfully deposited the bottom layers?

3D Modeling Checklist

☐ File naming and version control
 Project name
 Your name
 Version

☐ File type
 OBJ and STL

☐ Units
 mm or inches

☐ Dimensions
 Build volume for Ultimaker 2+
 223 x 223 x 205 mm

☐ Check for non-manifold geometry

☐ Wall thickness
 Minimum wall thickness for 0.4 mm nozzle is 0.8 mm

☐ Design considerations for printing and construction
 Consider balance and weight distribution of final piece
 Does your project need to be printed in parts?

☐ YHT rule
 Look for overhangs and angles

☐ Fit and clearance

Laser Cutter Checklist

SAFETY CHECK

❑ Is the vector bed clean?

❑ Are the lens and mirrors clean?

❑ Is the lens focused?

❑ Exhaust ON

❑ Air assist ON

MACHINE OPERATION

❑ Confirm file is formatted properly for laser and organized in layers

Raster (Raster or vector file with no hairline)
Score (RGB black (0, 0, 0) stroke line, hairline 0.001 pt.)
Cut (Raster or vector file with no hairline)

❑ Confirm art board size is the same as material size

❑ Send files to laser in the following order: raster, score, cut

❑ With the files running, check for the following, and ⟶ *DO* this

Is there flaming/smoke? →
 Check focus/air assist

Are cuts not separating from material? →
 Increase power and/or reduce speed

Is material warped? → Refocus throughout job, cut material in half before cutting file

CNC Checklist

SAFETY CHECK

❑ Is the area around the CNC clear?

❑ Is the material fastened securely in three places?

❑ Is key removed from spindle power?

❑ Ear and eye protection ON

❑ Dust collection ON

MACHINE OPERATION

❑ Create toolpaths in CAM software

Fastener toolpath (create countersinks between shapes for screws)
Drill toolpath (use upcut tool for safety)
Pocket profiles
Inside profiles
Outside profiles

❑ Turn on machine or reset open CNC software

❑ Load tool into collet

❑ Zero x, y, and z using Z-zero plate
Return zero plate and alligator clip to holder

❑ Open file. Check G-code for:

The correct file name
Depth of material and cut
Tool and RPM
Tabs

❑ Turn spindle key to ON position

❑ Run files separately for each tool

After fastener toolpath, attach screws in the areas beween shapes, then run the design files
Run files in the following order:
drill, pocket, inside, outside

Cardboard Technique Inventory

① STRAIGHT CUTS

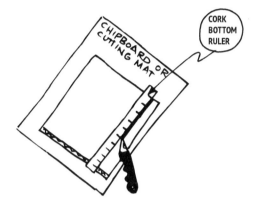

CHIPBOARD OR CUTTING MAT

CORK BOTTOM RULER

② CURVES

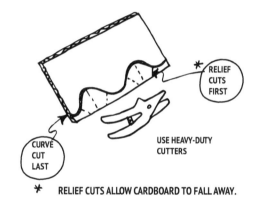

* RELIEF CUTS FIRST

CURVE CUT LAST

USE HEAVY-DUTY CUTTERS

* RELIEF CUTS ALLOW CARDBOARD TO FALL AWAY.

③ SCORE

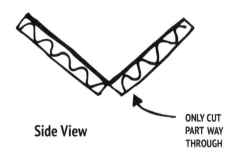

Side View

ONLY CUT PART WAY THROUGH

④ SCORE BEND

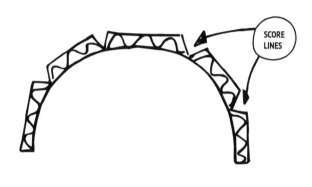

SCORE LINES

⑤ SMOOTH BEND

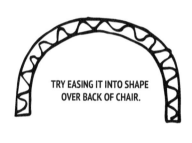

TRY EASING IT INTO SHAPE OVER BACK OF CHAIR.

Side View

⑥ EXPOSE CORREGATION

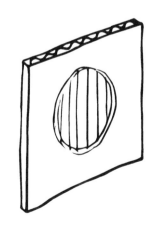

- SCORE
- USE DULL PENCIL TO REMOVE TOP LAYER.

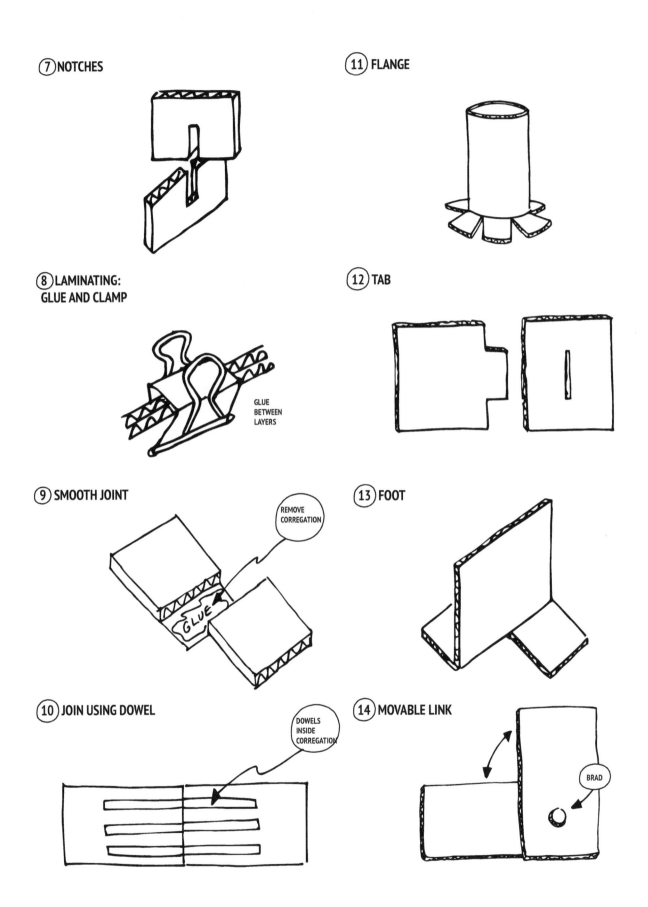

⑦ NOTCHES

⑧ LAMINATING: GLUE AND CLAMP

GLUE BETWEEN LAYERS

⑨ SMOOTH JOINT

REMOVE CORREGATION

GLUE

⑩ JOIN USING DOWEL

DOWELS INSIDE CORREGATION

⑪ FLANGE

⑫ TAB

⑬ FOOT

⑭ MOVABLE LINK

BRAD

Explore Tinkercad in 10 Steps

① MAKE A 3D SHAPE

Under **BASIC SHAPES:**

CLICK → Drag a box onto work plane.

② NAVIGATION

 ZOOM IN

 ZOOM OUT

 GO HOME

 SWITCH TO ORTHOGRAPHIC VIEW

 SWITCH TO PERSPECTIVE VIEW

③ MEASUREMENT

CLICK → Drag a ruler onto workplane to see measurements.

④ ADJUST SIZE/SCALE

CLICK → Drag a box onto your workplane.

HOVER AND **CLICK**

on each of the anchor points (▢) to reduce the height of your shape.

CLICK ON SNAP GRID →

· Change to 5.0 mm.
· Notice how it snaps along grid.

EDIT GRID

CHANGE UNITS FROM MM → IN.

⑤ CHANGE FILE NAME

SELECT TINKERCAD name and replace it with yours.

BRAVE UUSAM-INARI → TINKERCAD NAME

MY TEST MODEL → YOUR FILE NAME

⑥ CUSTOMIZE A SHAPE

CLICK ON CYLINDER

FIT VIEW TO SELECTION

Locate sliders to customize shapes.

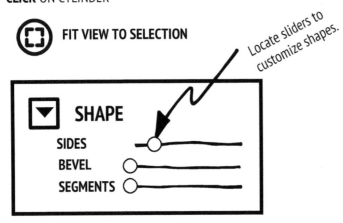

SHAPE
SIDES
BEVEL
SEGMENTS

CUSTOMIZE THE FOLLOWING:

- ☐ BOX
- ☐ CYLINDER
- ☐ PYRAMID
- ☐ SPHERE
- ☐ CONE
- ☐ POLYGON

- ☐ PARABOLOID
- ☐ TORUS
- ☐ TUBE
- ☐ STAR
- ☐ RING

⌘ A → DELETE

⑦ ALIGN

CLICK → **DRAG** box onto workplane.

CLICK → **DRAG** cylinder onto workplane.

SELECT BOTH SHAPES

CLICK

· Notice alignment handlebars.
· Hover and click to see alignment of shapes.

⌘ A → **DELETE**

⑧ GROUP

CLICK → **DRAG** box onto workplane.

CLICK → **DRAG** cylinder onto work plane.

Double cylinder height by clicking on anchor point (▫) and dragging shape higher.

ALIGN

GROUP

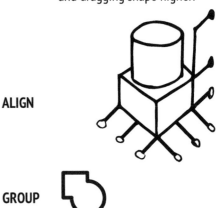

⌘ A → **DELETE**

⑨ MAKE A HOLE

CLICK ⟶ **DRAG** box onto workplane.

CLICK ⟶ **DRAG** cylinder onto workplane.

RESCALE cylinder as shown.

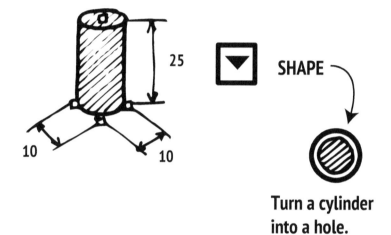

25

10 10

SHAPE

Turn a cylinder into a hole.

ALIGN shapes

⑩ EXPORT AN STL FILE

EXPORT

DOWNLOAD

◎ The selected shape.

.STL

Explore Illustrator in 10 Steps

① OPEN A NEW DOCUMENT

FILE ⟶ NEW

NAME and set **SIZE** of your document.

OK

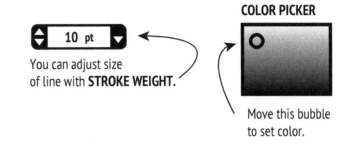

You can adjust size
of line with **STROKE WEIGHT.**

COLOR PICKER

Move this bubble
to set color.

10 pt

② CREATE A SHAPE

In the tool palette find the

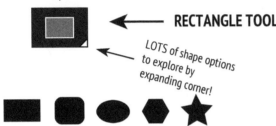

RECTANGLE TOOL

LOTS of shape options
to explore by
expanding corner!

PRESS

shift

and you can make
regular shapes

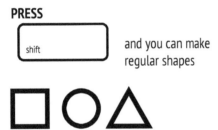

③ CHANGE COLOR AND OUTLINE OF SHAPE

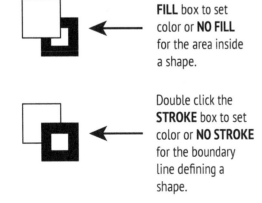

Double click the
FILL box to set
color or **NO FILL**
for the area inside
a shape.

Double click the
STROKE box to set
color or **NO STROKE**
for the boundary
line defining a
shape.

④ SELECT AND DELETE

SELECTION (select whole shape)

DIRECT SELECTION (select part
of shape or even one point)

LASSO (draw around things
to select)

Select whole
.by dragging box.

Select a
point.

Select free-form
shape with lasso.

PRESS

shift

to multiselect

PRESS

delete

to REMOVE

⑤ CHANGE SHAPE OF SHAPE

 Select a point.

 Drag

 New shape

⑥ COMBINE SHAPES

Overlap shapes

+

 SELECT

Choose shape builder tool.

Drag line across shapes to combine.

⑦ DELETE A PATH AND RECLOSE A SHAPE

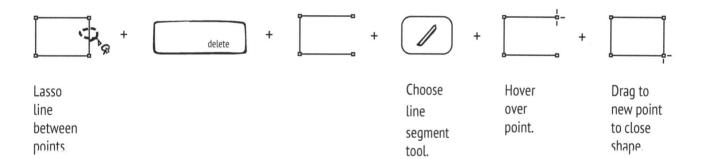

Lasso line between points.

+ delete +

Choose line segment tool.

+

Hover over point.

+

Drag to new point to close shape.

⑧ TURN TEXT INTO OUTLINES

Type some text.

SELECT → OBJECT →
Text Objects

TYPE →
Create Outlines

⑨ DRAW WITH THE PEN TOOL

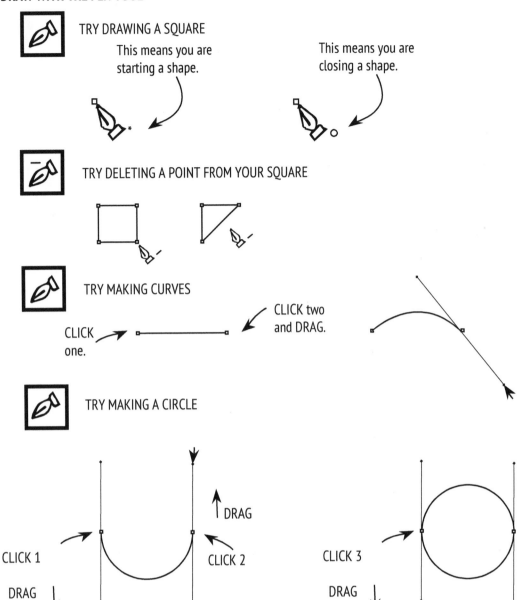

TRY DRAWING A SQUARE

This means you are starting a shape.

This means you are closing a shape.

TRY DELETING A POINT FROM YOUR SQUARE

TRY MAKING CURVES

CLICK one.

CLICK two and DRAG.

TRY MAKING A CIRCLE

CLICK 1

DRAG

DRAG

CLICK 2

STEP 1

CLICK 3

DRAG

STEP 2

⑩ ROTATE AND REFLECT

SELECT SHAPE

Double **CLICK** on ROTATE tool to key in an angle for rotation.

90°

SELECT SHAPE

Double **CLICK** on REFLECT tool in a horizontal or vertical orientation.

90°

Illustrator to Inkscape

Inkscape (inkscape.org) is a free vector design application. The following set of tasks in Inkscape roughly mirrors the Illustrator 10 Steps Design Guide and can be used to orient a new user to the software.

1. OPEN A NEW DOCUMENT

File → New will open a document.

File → Document Properties opens a window to set size, units and orientation.

2. CREATE A SHAPE

Rectangle
Create a new shape by dragging. Holding the **Control** key will snap to an integer aspect ratio (1:1, 2:1, 3:1).

Ellipse
Create a new shape by dragging. Holding the **Control** key will snap to an integer aspect ratio (1:1, 2:1, 3:1).

Star
Create a new shape by dragging. The **Control** key acts as a radial control and will snap in 15 degree increments.

Corners
Key in a number for corners.

Handles
The star has two handles. Anchor points have an inside radius and an outside radius. These can move independent of each other to create interesting shapes.

Polygon
Create a new shape by dragging.

Corners
Key in a number for corners.

Handle
The star has one handle for creating concave and convex sides.

3. CHANGE COLOR AND OUTLINE OF SHAPE

Object → Fill sets inside color. **Stroke** sets outside line color. **Stroke style** sets stroke weight.

Choose your color system and opacity.

4. SELECT AND DELETE

Top button on the toolbar on the left shows the selection arrow. Click on a shape to select and delete.

5. CHANGE SHAPE OF SHAPE

After selection you can scale the object by moving any of the handles. Holding down **Control** key will preserve the aspect ratio.

6. COMBINE SHAPES

Path → Path Operations

Union	Ctrl++
Difference	Ctrl+−
Intersection	Ctrl+*
Exclusion	Ctrl+^
Division	Ctrl+/
Cut Path	Ctrl+Alt+/
Combine	Ctrl+K
Break Apart	Shift+Ctrl+K

7. DELETE A PATH IN A SHAPE

 Create your shape.

Path → Object to Path

This will convert your shape to a series of paths and editable nodes. Click on Nodes. You will see each path is connected with a node.

 Multi-select (hold **Shift** key) the nodes on each side of the path you are deleting. Break path at selected nodes. Select path and delete. You will now have a side with the path removed.

8. RECLOSE A SHAPE AND DRAW WITH BEZIER CURVES

 Click on **Draw Bezier curves**. Hover on open node and click on node to join the open shape. Click on the other open node to close the shape. Continue to engage your mouse/track pad to pull a curve.

9. TURN TEXT INTO OUTLINES

 Click on **Text Tool**. Type your text. Select your font and size. **Path → Object to Path**. This will convert your text to a series of paths and editable nodes.

10. ROTATE AND REFLECT

After selection, click a second time. The handles change to allow for rotation. The **Control** key acts as a radial control and will snap in 15 degree increments. In the **Object→**

 Transform menu you cannot key in a specific degree of rotation. Flip objects horizontally (H) and vertically (V) using reflection icons located on the main toolbar.

Explore Photoshop in 10 Steps

① OPEN A NEW DOCUMENT

FILE ⟶ NEW

- **NAME** and set **SIZE** of your document in inches.
- Set your **RESOLUTION** to 300 pixels/inch and **COLOR** CMYK.

OK

② CREATE A SHAPE

In the tool palette find the

⟵ **RECTANGLE TOOL**

LOTS of shape options to explore by expanding corner!

PRESS

shift

And you can make regular shapes

③ TURN YOUR SHAPE INTO AN (EDITABLE) RASTER SHAPE

WINDOW ⟶ LAYERS

Layers	
👁 🔘	Ellipse
👁 ⬜	Background 🔒

LAYER ⟶ RASTERIZE ⟶ SHAPE

Now you can use any Photoshop tools to alter the shape.

④ SET YOUR COLORS

Double click to **SET FOREGROUND.**

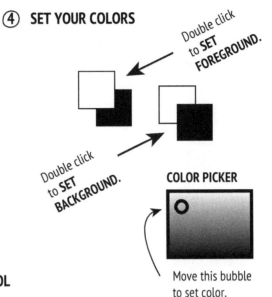

Double click to **SET BACKGROUND.**

COLOR PICKER

Move this bubble to set color.

⑤ PLACE AND CROP AN IMAGE

FILE ⟶ PLACE ⟶ RETURN
EMBEDDED

CROP

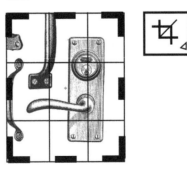

⑥ **SELECT** AND **DELETE**

 Rectanglular marquee tool (rectangular selection)

 Magic wand (similar color selection)

 Lasso (freehand selection)

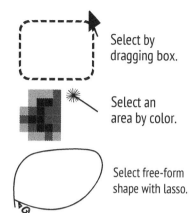

Select by dragging box.

Select an area by color.

Select free-form shape with lasso.

PRESS

shift

to multiselect

PRESS

delete

to REMOVE PIXELS

⑦ **ISOLATE AN OBJECT BY DELETING THE BACKGROUND**

delete

delete

⑧ **MAKE A NEW LAYER AND FILL BACKGROUND**

DRAG and DROP Layer 1 into new file icon to create a copy of Layer 1.

MOVE new layer to position below top layer.

EDIT ⟶ FILL ⟶ BLACK

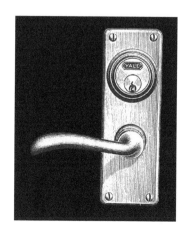

⑨ MOVE A SELECTION

SELECT SHAPE

 Use ELLIPTICAL MARQUEE TOOL to select a circle shape.

MOVE SHAPE

 Use MOVE tool to move selection.

⑩ CLONE A SELECTION

SELECT SHAPE

 Use ELLIPTICAL MARQUEE TOOL to select the area you will place your clone.

PRESS

SELECT target area for cloning.

MOVE SHAPE

 Use CLONE STAMP to fill in shape.

JOINERY

Joinery enables students to put together flat material and transform it into three-dimensional creations. Joinery ensures a strong connection between parts and can be used with or without glue and hardware. Hinges can be used to make flexible and movable parts such as lids. These are the most common types of joints and hinges students use in their projects.

HINGES

Offset hinges screws and nuts	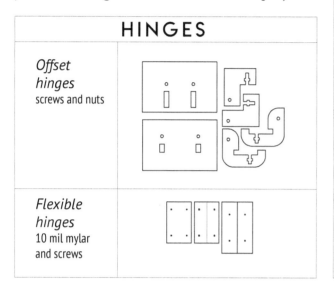
Flexible hinges 10 mil mylar and screws	

JOINTS

Finger joints glue	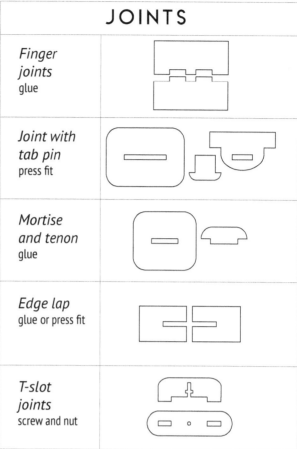
Joint with tab pin press fit	
Mortise and tenon glue	
Edge lap glue or press fit	
T-slot joints screw and nut	

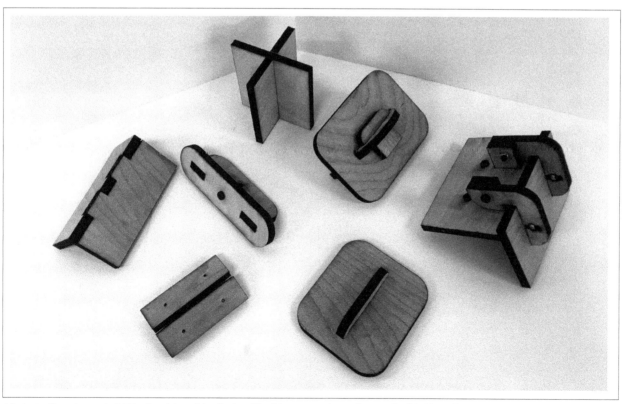

(clockwise from top center) Edge lap, joint with tab pin, offset hinges, mortise and tenon, flexible hinge, finger joints, t-slot joint.

Laser-Cutting Process

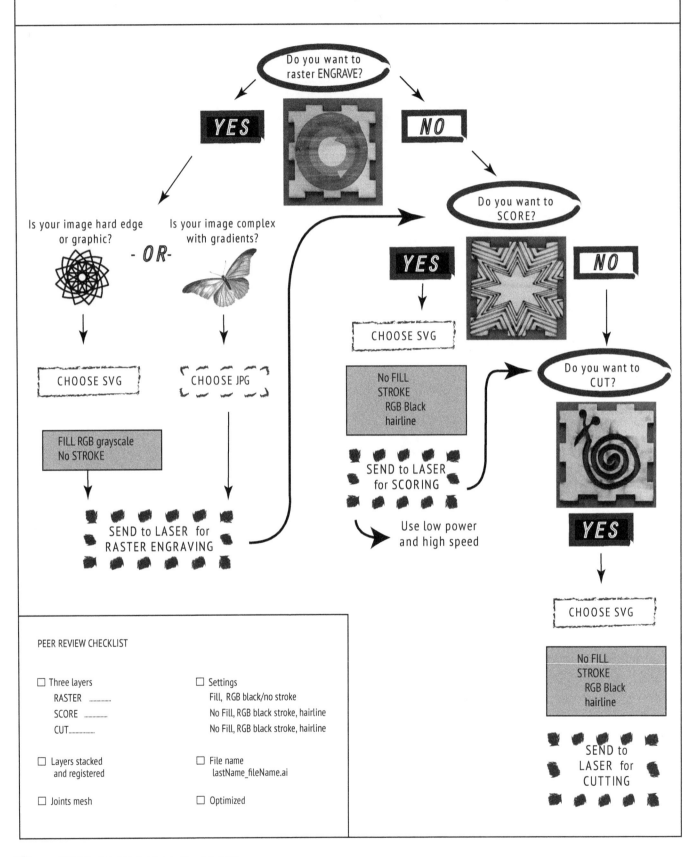

Do you want to raster ENGRAVE?

YES

NO

Is your image hard edge or graphic?

- OR -

Is your image complex with gradients?

CHOOSE SVG

CHOOSE JPG

FILL RGB grayscale
No STROKE

SEND to LASER for RASTER ENGRAVING

Do you want to SCORE?

YES

NO

CHOOSE SVG

No FILL
STROKE
RGB Black
hairline

SEND to LASER for SCORING

Use low power and high speed

Do you want to CUT?

YES

CHOOSE SVG

No FILL
STROKE
RGB Black
hairline

SEND to LASER for CUTTING

PEER REVIEW CHECKLIST

☐ Three layers
 RASTER
 SCORE
 CUT.............

☐ Settings
 Fill, RGB black/no stroke
 No Fill, RGB black stroke, hairline
 No Fill, RGB black stroke, hairline

☐ Layers stacked
 and registered

☐ File name
 lastName_fileName.ai

☐ Joints mesh

☐ Optimized

Plan Your Laser Cutting

Write a description of what you want to do with your material on the laser cutter.

--

--

PLAN YOUR STEPS

1. _____
2. _____
3. _____
4. _____
5. _____

FOLLOW THESE GUILDELINES TO ORGANIZE YOUR DESIGN FILE

Stack your layers as shown here:

Organize files in layers according to the process you would like to execute. Run the shallowest layers first in this order: Raster Engrave, Score, Cut.

Raster Engrave	Score	Cut
RGB black fill No stroke	No fill Stroke RGB black hairline	No fill Stroke RGB black hairline

Raster Engrave

Score

Cut

NOTES

Learning, Making, and Art

Costanza, Jack. "Early Artificial Intelligence Projects: A Student Perspective," projects.csail.mit.edu/films/aifilms/AIFilms.html (accessed August 8, 2018).

Hoetzlein, Rama. "What Is New Media Art?", ramakarl.com (accessed August 1, 2017).

Maeda, John. "Design in Tech Report 2018," www.slideshare.net/johnmaeda/design-in-tech-report-2018 (accessed March 15, 2018).

Art Leadership in STEAM

National Core Arts Standards: nationalartsstandards.org

Common Core State Standards Initiative: corestandards.org

Next Generation Science Standards: nextgenscience.org

Buechley, Leah. "Stem Is Everywhere." Lecture, FabLearn Conference, Palo Alto, CA, October 22, 2007.

Flores, Christa. Making Science: Reimagining STEM Education in Middle School and Beyond. Torrance, CA: Constructing Modern Knowledge Press, 2016.

Gaskins, Nettrice. "Techno-Vernacular Creativity and Innovation." NAEA National Convention, Seattle, WA, March 23, 2018.

Maeda, John. "STEM + Art = STEAM," (2013) The STEAM Journal: Vol. 1: Iss. 1, Article 34. DOI: 10.5642/steam.201301.34

Rolling Jr, James Haywood. "Reinventing the STEAM Engine for Art + Design Education." (2016): 4-7.

Root-Bernstein, Robert, Lindsay Allen, Leighanna Beach, Ragini Bhadula, Justin Fast, Chelsea Hosey, Benjamin Kremkow et al. "Arts Foster Scientific Success: Avocations of Nobel, National Academy, Royal Society, and Sixma Xi Members." Journal of Psychology of Science and Technology 1, no. 2 (2008): 51-63.

Digital Fabrication Tools and Learning

Sorby, Sheryl A. "Educational Research in Developing 3D Spatial Skills for Engineering Students." International Journal of Science Education 31, no. 3 (2009): 459-80. doi:10.1080/09500690802595839.

The Power of Making What You Can Imagine

Riley, Erin E. "Think Like an Architect, Draw Like an Engineer." In P. Blikstein, S. Martinez, and H.A. Pang (Eds.), Meaningful Making: Projects and Inspirations for Fab Labs Makerspaces (pp.72-74). Torrance, CA: Constructing Modern Knowledge Press, 2016.

"Ten Rules Poster" Sister Corita Kent: corita.myshopify.com/products/ten-rules-poster

Machine Drawing

Beetle Blocks, beetleblocks.com

Beetle Block Primer beetleblocks.com/static/bb-primer.pdf

LogoTurtle, joshburker.com/logoturtle/LogoTurtle.html

Paper Models of Polyhedra, korthalsaltes.com

Processing IDE, processing.org

Axidraw, evilmadscientist.com

Upcycled Laser-Engraved Book

Go to artofdigitalfabrication.com for files from this chapter

High-Low Tech, highlowtech.org

Image Resources

creativecommons.org

digitalcollections.nypl.org

Resources for electronic materials

bareconductive.com

chibitronics.com

Design with Rules

Conditional Design, conditionaldesign.org

Plotter Pen, store.shopbottools.com

Pen Tool, youtube.com/watch?v=aTGbHoBa070

Sol Lewitt, lewittcollection.org

Living Hinge Sketchbook

Go to artofdigitalfabrication.com for files from this chapter

Obrary Living Hinge Swatches. Retrieved from obrary.com/products/living-hinge-patterns

epiloglaser.com/resources/sample-club/living-hinge-laser-cutting.htm

3D Filament Relief Drawings

Wonderlane. (2010) "Beautiful Greek Woman Statue," Flickr photo, taken 30 November 2008. (Accessed June 29, 2017). Licence at https://creativecommons.org

Tinkercad, tinkercad.com

Patterning

Burker, Josh. The Invent to Learn Guide to More Fun. Torrance, CA: Constructing Modern Knowledge Press, 2018.

Josh Burker's Blog of Musings. Patterning, joshburker.blogspot.com/2013/01/turtleart-islamic-tiles.html

TurtleArt
turtleart.org

TurtleArt Converter, playfulinvention.com/taconverter/v2

Pattern Nodes 2, lostminds.com/patternodes2/

Silkscreen Clay

MET Museum
metmuseum.org/art/metpublications/Islamic_Art_and_Geometric_Design_Activities_for_Learning

Etched Tins

The Noun Project, thenounproject.com

Roland CutStudio PlugIn
adobeexchange.com/creativecloud.details.15901.html

3D Puzzles

3D printing resources
formlabs.com/blog/3D-printing-tolerances-for-engineering-fit/
3dhubs.com/knowledge-base

Interactive Gingerbread

Arduino, arduino.cc

bit:Booser, lectrify.it/bitbooster

Linear Servo Actuators from
potentprintablesthingiverse.com/thing:3170748

Makerbit makerbit.com

Micro:bit, microbit.org

Seeed Studio Grove Sensors, seeedstudio.com

3D-Printed Stacks
3D modeling
> tinkercad.com
> openscad.org/cheatsheet/
> https://en.wikibooks.org/wiki/OpenSCAD_User_
> Manual

3D Modeling and Math
Fusion 360, autodesk.com
Screws, McMaster-Carr item number 90048A020
YHT Rule, joes3dworkbench.blogspot.com/2014/05/3d-
> printing-tip-designing-with-supports.html

Animal Box
Omni Animal, tltl.stanford.edu/project/omni-animal
MakerCase, makercase.com

Break Out of the Box
CNC joinery, makezine.com/2012/04/13/cnc-panel-
> joinery-notebook
Laser Cut Like a Boss, lasercutlikeaboss.weebly.com
Laser Cut Joinery, instructables.com/id/Joinery-Joints-
> for-Laser-Cut-Assemblies
The Cabaret Mechanical Theatre, cabaret.co.uk
The Tinkering Studio, tinkering.exploratorium.edu/
> cardboard-automata
Gear Template Generator Program, woodgears.ca/gear
HDPE, inventables.com/categories/materials/plastic/
> hdpe

3D Prototyping and Scaling
McMasterCarr, mcmaster.com, M3 x 20 mm low-profile
> screw, M3 square nuts
McMasterCarr, mcmaster.com, Recessed Hex Head Joint
> Clamps for Wood, 91560A120

Pixel-Art Paintings
Pixel by numbers, openblackboard.com/processing/
> pixelbynumbers/
Free clip art, Freepik.com

Embroidery Patch
The Noun Project, thenounproject.com
SewArt: sandscomputing.com/products-shop/sewart-
> embroidery-digitizer/

Glitch Art
Justice, Sean. "Prompting for a Serendipity Mindset with
> Simple Digital Tools." NAEA News, 59, no. 2, (April-
> May 2017):18.

Webcam Macroscope
Eames Office. "Powers of Ten." Filmed [1977]. YouTube
> video, 09:00. [Posted Aug 26, 2010]. https://www.
> youtube.com/watch?v=0fKBhvDjuy0.
BioHack Academy, (2017), GitHub repository, https://
> github.com/BioHackAcademy/BHA_Webcam_
> Macroscope
Jansen, P. (2010) Laser Cut CNC Linear Axis. Retrieved
> from https://www.thingiverse.com/thing:3554
Petri Dishes 60 x 15 mm, carolina.com
Hardware for macroscope
> 14 mm M3 screws McMaster-Carr Item #93070A071
> 8 mm M3 screws McMaster-Carr Item#93070A064
> M3 nut McMaster-Carr Item #91028A411.
> Wing nuts McMaster-Carr Item #94300A120
> Washers McMaster-Carr Item #90965A130
> Adhesive-Back Bumper McMaster-Carr Item
> #95495K22

Art Material and Process Inventory
Concrete
> Mold Star 30, smooth-on.com
> QUIKRETE ProFinish 5000, countertop mix white,
> contact local hardware store
Plaster
> DAP Plaster of Paris, dickblick.com
Papier mâché
> Celluclay Instant Papier Mâché, dickblick.com
Casting chocolate
> Smooth-Sil. 940, smooth-on.com
3Doodler, the3doodler.com
Metal leaf
> Imitation Metal Leaf, Amazon.com
> Speedball Mona Leaf Adhesive Size, Amazon.com
Spray paint
> Krylon Gesso Spray, dickblick.com
Marbling wood
> Jacquard Carrageenan, dickblick.com
> Butcher Tray Palette, 17" x 24", dickblick.com
> Higgins Drawing Inks, dickblick.com
Cyanotype
> Photographers' Formulary Liquid Cyanotype Printing
> Kit, bhphotovideo.com
Screen printing
> Multifilament Polyester Screen Fabric, dickblick.
> com
> Oracal 651, uscutter.com
Ceramic
> S105GNT No-Talc White Clay w/ Grog, S417 Red
> Earthenware, ceramicsupplyinc.com
> Amaco "LUG" liquid Underglazes, Amaco Low-Fire
> F-10 Clear Transparent, ceramicsupplyinc.com
Metal Etching
> Blank Altoid Tin, Amazon.com
> 6-Volt Lantern Batteries, Amazon.com
> Beeswax for Candlemaking, dickblick.com
> Multipurpose 110 Copper Sheet, Softened Temper, 2"
> x 24", 0.0320" Thick, mcmaster.com
> Manual Tool for Blind Rivets, mcmaster.com
> Rivets Item # 97447A015, mcmaster.com
Heat Vinyl
> SISER EasyWeed Heat Transfer Vinyl, uscutter.com
Flexible Filament
> Ultimaker TPU 95A, ultimaker.com

Joinery
3 mm 1/8" x 12" x 12" Premium Baltic Birch Plywood by
> Woodpeckers, Amazon.com
3 mm MDF Fibrex #027387 formaldehyde-free, contact
> local hardware store
McMasterCarr, mcmaster.com, Alloy Steel Low-Profile
> Socket Head Screw, Black-Oxide, M3 x 0.5 mm
> Thread, 8-14 mm long
Stainless steel square nuts M3

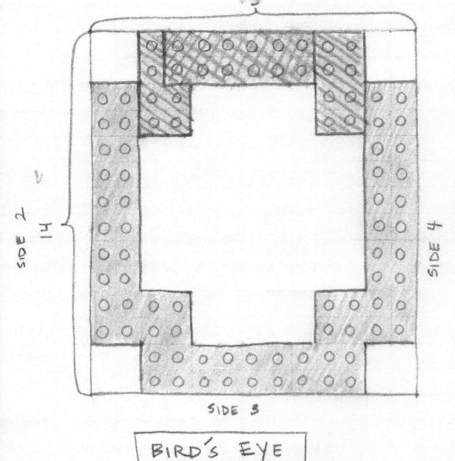

SIDE 2

14

SIDE 4

SIDE 3

BIRD'S EYE

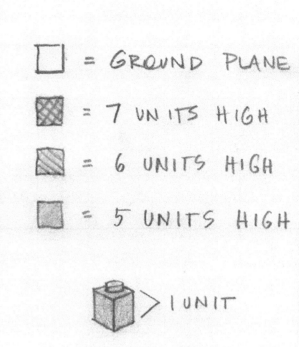

= GROUND PLANE

= 7 UNITS HIGH

= 6 UNITS HIGH

= 5 UNITS HIGH

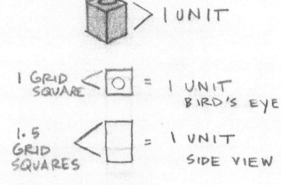

> 1 UNIT

1 GRID SQUARE < ⬜ = 1 UNIT BIRD'S EYE

1.5 GRID SQUARES < ⬜ = 1 UNIT SIDE VIEW

13

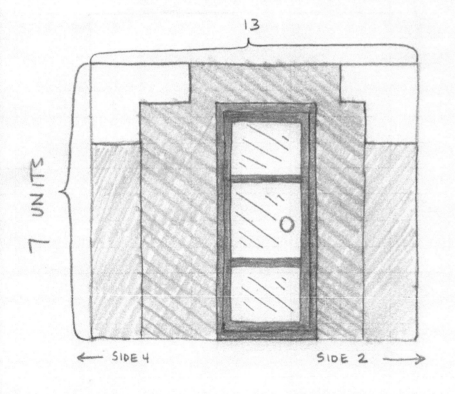

7 UNITS

← SIDE 4 SIDE 2 →

FRONT VIEW

= NEAREST PLANE

= NEAREST PLANE – 2 UNITS

COLO

⊛ ALL BRICKS ARE ORANGE

✳ DOOR AND WINDOW FRAM ARE RED

✳ DOOR MOLDI IS BLACK

14

7 UNITS

← SIDE

= NEAREST PLANE

= NEAREST PLANE
– 2 UNITS

= NEAREST PLANE
– 4 UNITS

ABOUT THE AUTHOR

Erin Riley is the Mr. and Mrs. Alexander Jackson Director of the Engineering and Design Lab at Greenwich Academy, where she teaches classes and facilitates projects with faculty at the intersection of engineering, design, and art. Additionally she teaches a studio course in creative technologies at Columbia University's Teachers College in the Art and Art Education program. Erin is among the first cohort of Senior FabLearn Fellows at Columbia University, where she writes on the topic of maker education and curriculum design, and creates tools and resources for educators. During the summer, Erin works with middle school-aged students on STEAM projects at REACHPrep, an educational access organization for underserved students. Erin holds an MFA from Maryland Institute College of Art.

photo credit: Andrew Henderson

14

SIDE 2

SIDE 3

UNDERSIDE
FOOT PRINT

Books from CMK Press
www.cmkpress.com

Invent to Learn: Making, Tinkering, and Engineering in the Classroom

"The maker movement in schools now has a bible."　(All New Second Edition)
- Larry Magid, San Jose Mercury News

Invent to Learn Guides

The Invent to Learn Guide to Making in the K-3 Classroom
Exciting STEM/STEAM project ideas from a veteran primary school teacher.

The Invent to Learn Guides to Fun & MORE Fun
Incredibly clever, whimsical, and fun project ideas for the classroom using Makey Makey, Scratch, Turtle Art, LEGO bricks, and more!

The Invent to Learn Guide to 3D Printing in the Classroom
Practical project ideas for 3D printing across the curriculum.

The Art of Digital Fabrication: STEAM Projects for the Makerspace and Art Studio
Learning by making with the heart of a scientist and the critical eye of an artist.

Education Leadership

Education Outrage
A collection of can't-put-down essays by scientist, academic, entrepreneur, and artificial intelligence pioneer Roger Schank.

Making Science: Reimagining STEM Education in Middle School and Beyond
Anthropologist turned science teacher shares activities and lessons for authentic, inclusive science.

Meaningful Making (Vol. 1 & 2)
Columbia University's FabLearn Fellows, educators from around the world, share inspiration and projects for meaningful making in and out of school.

The Inner Principal: Reflections on Educational Leadership
Remarkably candid reflections by one of the most consequential school leaders of the past 50 years.

Sylvia's Super-Awesome Project Book: Super Simple Arduino
Kid maker and YouTube star shares simple and fun Arduino programming projects.

For special sales, out of US, and volume purchases visit cmkpress.com

CPSIA information can be obtained
at www.ICGtesting.com
Printed in the USA
LVHW071158050519
616376LV00004B/3/P